rites of passage

Stuart Morgan and Frances Morris

rites of passage

ART FOR THE END OF THE CENTURY

With contributions by

Stephen Greenblatt

Julia Kristeva

Charles Penwarden

Tate Gallery Publications

Exhibition sponsored by Beck's

CELEBRATING 10 YEARS
OF ARTS SPONSORSHIP

in association with

*The***Guardian**

With additional assistance from the
Canadian High Commission, London, and
the Quebec Government Office in London

cover:
Louise Bourgeois, 'Red Room (The Child)'
1994 (no.7)

ISBN 1 85437 156 8
A catalogue record for this publication is available from the British Library

Published by order of the Trustees 1995
for the exhibition at the Tate Gallery 15 June – 3 September 1995
Published by Tate Gallery Publications, Millbank, London SW1P 4RG
Designed and typeset by Caroline Johnston
© Tate Gallery 1995 All rights reserved
Printed in Great Britain by Balding + Mansell,
Peterborough, Cambridgeshire on 135gsm Parilux Silk
Works by Joseph Beuys and Louise Bourgeois © DACS, London 1995
All other works © the artist or the estate of the artist 1995

Contents

7 Foreword

9 Sponsors' Forewords

11 Introduction
Stuart Morgan

21 Of Word and Flesh
An Interview with Julia Kristeva
by Charles Penwarden

28 Liminal States and Transformations
Stephen Greenblatt

31 Catalogue
Stuart Morgan and Frances Morris

Miroslaw Balka; Joseph Beuys;
Louise Bourgeois; Hamad Butt;
John Coplans; Pepe Espaliú;
Robert Gober; Mona Hatoum;
Susan Hiller; Jana Sterbak; Bill Viola

142 Artists' Biographies and List of Works

Foreword

Diversity and fragmentation have characterised the art of the last decade. More than ever before artists are engaging with new types of practice and claiming an ever-wider vocabulary of materials as available to art. *Rites of Passage* is an exhibition which celebrates this variety and breadth of experience in art today.

Works by eleven artists are brought together. In almost all cases these works date from the last ten years, a decade which has brought us to the brink of the next millennium. The exception is Joseph Beuys, who died as the decade began but whose legacy continues to endure and who is represented here, appropriately and powerfully, by an apocalyptic work which symbolised, for him, the 'definitive collapse of a world which belongs to the past'.

The exhibition raises questions about many aspects of our lives. It is less about the particular issues addressed by each artist than about the question of how such works of art function in a period of personal and global vulnerability.

The exhibition has been selected by Stuart Morgan, writer and critic, and Frances Morris, Curator in the Modern Collection. Both have written essays for the catalogue. We are particularly grateful to Stuart Morgan for sharing his wide knowledge and long experience of contemporary art and for his eloquent Introduction. The catalogue also contains a contribution from Stephen Greenblatt, Professor of English at the University of California, Berkeley, and an interview with Julia Kristeva, well-known psychoanalyst and critic. We are honoured that both scholars were able to find time to consider the exhibition and respond to it in such interesting ways. Interviews are always a collaboration and we are very grateful to the critic and translator Charles Penwarden for researching and conducting such a thoughtful interview.

We owe a very special thanks to the artists, who have responded with such enthusiasm to the project. Their active interest and involvement has been of invaluable help at all stages.

We should also like to thank the families and friends of Hamad Butt and Pepe Espaliú, whose recent deaths have tragically ended creative lives of enormous potential. In particular we are grateful to Hamad Butt's brother, Jamal Butt, and his friends, the artists Diego Ferrari, Dan Hay and Angela Bulloch who have helped us to reconstruct 'Familiars'. Juan Vicente Aliaga was extremely helpful in locating works by Espaliú and we are particularly grateful to José Cobo for allowing us to reconstruct one of Espaliú's most ambitious and beautiful works. A number of works have been lent to us from public or private collections. Without the generosity of these lenders we could not have mounted the exhibition and we thank them most sincerely.

In constructing these installations, involving both complex video works and sculptures made from vulnerable and unstable materials, we have drawn upon the expertise of many people both inside and outside the Gallery. To all we extend our thanks for their advice and help.

This is the third occasion that Beck's have sponsored an exhibition at the Tate Gallery and we are most grateful for their renewed commitment. Our thanks go too, to *The Guardian*, which has also supported this project.

Nicholas Serota
Director

Sponsors' Forewords

Beck's

During 1995 Beck's will be celebrating ten years of art sponsorship in Great Britain. Over the past decade the Beck's Arts Sponsorship Programme has expanded its commitment to new and challenging work in the areas of dance, theatre, films and the visual arts, resulting in a mutually beneficial partnership which has been a role model for business sponsorship in this area.

We are delighted to renew our relationship with the Tate Gallery by sponsoring its major 1995 summer exhibition, *Rites of Passage*, which includes work developed during the past decade by eleven international artists. The association is indeed significant and appropriate for Beck's, which has become synonymous with contemporary art over the same period.

We hope visitors will take this opportunity to see this highly original exhibition, which promises to stimulate debate on the role of contemporary art as we approach the end of the twentieth century.

Richard Gibb
Marketing Director
Scottish & Newcastle Breweries Ltd

The Guardian

Rites of Passage is an exhibition of art which tries to make sense of the world we live in at the end of the twentieth century. It is a troubled and confused age, and these works are an honest attempt to reflect its complexities. It is an appropriate exhibition for *The Guardian* to be involved in since we – in a different way – also do our best to report on and interpret the world at the end of the millenium. The art you will see here is both innovative and internationalist. So is *The Guardian*. I am very pleased that we have joined forces with the Tate Gallery to make an important exhibition possible.

Alan Rusbridger
Editor of *The Guardian*

Introduction

Stuart Morgan

GONE ARE THE DAYS OF SAP AND GLASS
AND WALLED ORCHARDS TO STEAL FROM
WITH SOME FRIEND ...
TODAY I AM LOST, LIKE THOSE TORTOISES
WHO NEVER RETURN TO THE SEA AFTER SPAWNING,
AND MOVE INLAND, IN THE OPPOSITE DIRECTION
TO DIE EXHAUSTED
AT SOME DISTANT POINT ON THE HORIZON.

THE SKY HAS BECOME DENSE
LIKE A MOUTH OF BLACK CLOUDS
RAINING MEN WITH SWORD PROFILES
AND IN ITS YAWN I DISCOVER
A WRONG I BELIEVED FORGOTTEN.
LIGHT HAS BEEN STOLEN FROM US,
THEY HAVE STEPPED ON OUR FRAIL FRAME.
TRYING TO SAVE SOME REMNANT
OF THE WORLD THAT WE LOOSE,
I KNOW TODAY THAT THE ONLY AND TERRIBLE ENEMY
IS THE PRESENT, AND THAT IN IT,
ONLY BY NOT LIVING
ARE YOU ABLE TO LIVE TWICE.

IN THIS NEW AND ENORMOUS WELL
BETWEEN ECHOES OF OLD TIMES
(AN OPEN PATIO, A BLIND MOSQUE)
I AWAIT IN THE OPAQUE THRESHOLD
OF THIS NO MAN'S HOUSE
A DAMP AND LONG CALL
... THE LAST DAYS

Pepe Espaliú[1]

Describing the French scholar Michel Foucault, his colleague Michel Certeau called him a *passeur* or 'man of passage': a person who 'moves people or things across borders or into forbidden zones', in other words a ferryman.[2] Although it is an unusual way to describe a man of letters, the term has much to recommend it, particularly the suggestion of access: crossing borders, for example, 'opening doors' for other people, above all granting permission, intellectual or emotional – in Foucault's case perhaps even sexual. For Certeau, the *passeur* could be defined as a person of power who uses that power in the service of others. Indeed, his description resembles that of a priest, or a psychiatrist, the twentieth-century alternative to a priest. *Passeurs* could even be artists. But does this argument imply that Western art has inherited some of the traditional duties of religion or medicine? The question might be naive, a matter not of what has been bequeathed but of what has been lost. After all, in many non-Western cultures, art, religion and medicine have always been regarded as a single activity.

In 1908 in his book *The Rites of Passage*, the Dutch anthropologist Arnold van Gennep examined what he called 'life crises' and the ceremonies that accompanied them. Such ceremonies, he proposed, move through three phases: separation, transition and incorporation. In the transitional phase when the individual is neither in nor out of society, he or she exists in what van Gennep called a 'liminal' state, *limen* being Latin for 'threshold'. Though Western societies may have abandoned many of the practices accompanying such changes of life, it is still possible to apply van Gennep's descriptions to our own culture. In the West as well as elsewhere, for example, those responsible for conducting such rituals command respect. For having experienced their own processes of separation, transition and incorporation – in other words having themselves been delivered – their work in future consists of helping to deliver others. The exhibition *Rites of Passage* proposes that artists have an important role in society: that they be considered as *passeurs*, priests (perhaps) of that secular religion that art has become.

Joseph Beuys was attacked throughout his career. 'World Fame for a Madman?' read the cover of one German weekly when his retrospective exhibition opened at the Guggenheim Museum in New York. In the pages of the American art magazine *Artforum*, the art historian Benjamin Buchloh questioned the veracity of the photographs of Beuys's plane crash when he was a Second World War fighter pilot.[3] (Buchloh was to launch another attack on Beuys later, this time on the grounds of his outdated aesthetics.[4]) Strong reactions to Beuys's work were not

infrequent. Another charge levelled against him was one of blasphemy;
for example, when he was punched on the nose by an enraged member
of the public for lifting a crucifix into the air during one of his perfor-
mances. Yet for Beuys any reaction seemed welcome; his aim was to
communicate. And, given the response that he wished to elicit, the fact
that he purloined or subverted religious imagery should not have come
as a surprise. (He also borrowed from American history, from folklore,
from literature.) Yet the reason for his unpopularity – and also, para-
doxically, for his popularity – was the legend of his recovery from
almost certain death when he was discovered after several days in the
snow following a plane crash in the Caucasus.

Whether tribesmen found him, took him to their tents and nursed
him back to health, as he maintained, seems less significant than the
myth of the hero to which Beuys was subscribing. As he saw it, the expe-
rience gave him power which he could use to help others. It was based
on love, hence the use of the symbolic materials fat and felt, which sug-
gested protection, human warmth. Throughout his career he insisted
that his meanings should be interpreted in a more general sense than
current definitions of art would permit. 'My understanding of sculpture
always had to do with life', he maintained. 'Then you are obviously a
long way from the ideology of the "visual arts", which has only to do
with sight, despite the fact that you have to deal with all senses which
are active in people's business, in their work'.[5] In other words, Beuys
sought a much wider audience for his art, and a far less limited signifi-
cance than a purely artistic one. In addition, he saw artists as figures
with responsibility and power in the world.

There is little in Beuys's home-made autobiography – the Beuys leg-
end – that cannot be found in Mirca Eliade's *Shamanism: Archaic Tech-
niques of Ecstasy*, one of the key books of the twentieth century. But the
images of ourselves that we try to present to the world never correspond
with facts, though they could not exactly be called lies. They are simply
stories we tell, and the telling is the most important part. Perhaps the
myth of Beuys, drawing as it did on other myths – the boxer, the gang-
ster, the shaman, the teacher, the politician – constituted a deliberate
attempt to gain ground for art, to draw it back into the centre of a cul-
ture which has everything to gain by marginalising it and depriving it
of its power for change. Only after Beuys's death, with the ambitious
event *Art Meets Science and Spirituality in a Changing Economy* in
1990 in Amsterdam, was it possible to hold the kind of meeting that he
had always envisaged, between scientists, religious leaders, artists and

economists.[6] Perhaps that week-long series of discussions proved more significant as a symbolic move than as a step towards policy-making. Yet the idea of witnessing Robert Rauschenberg debating with the Dalai Lama was Beuysian in the extreme; Beuys had always felt it his duty to make paths where none existed.

By the time that Beuys died, his works were being placed in glass cases, a retrograde step perhaps, since nowadays even museums themselves, public edifices in which worshippers worship at the shrine of culture, are increasingly recognised as a barrier to viewing art. The design of *Rites of Passage*, a museum within a museum, deliberately counters this by leading visitors through a sequence of spectacles; light gives way to dark, spaciousness narrows to confinement, noise is followed by silence. At the entrance, John Coplans's colossal photographs (nos.14–21) offer an updated but by no means satirical equivalent to a Greek frieze, while at two points, with installations by Susan Hiller and Bill Viola (nos.28, 33), visitors are brought to a dead end and challenged to make sense of the noises and images which surround them. The display is self-referential, sometimes consciously so: Jana Sterbak has even decided to include a work by Beuys in her own installation, with the mixture of homage and competition that that implies (no.31). Yet the exhibition is also concerned with ideas of fragility; rarely has the Gallery housed so many works of such vulnerability. Conservation, an important talking-point in current museology with ramifications far beyond the museum, becomes a major theme.

Sterbak's addition to her own work is one of Beuys's felt suits, a reminder of that strong emphasis on the body which distinguishes much current art. But why? The modern body, wrote the French social anthropologist David LeBreton, can be defined as 'The index of a rupture between man and himself, a break between one man and the others, and a division between man and the cosmos'.[7] So, he concluded, the corporeal is the residue of these three withdrawals. In *Rites of Passage*, the body is often presented as incomplete: scarred or fighting for survival in the early figures of Miroslaw Balka or for equilibrium in those of Pepe Espaliú. In the late nineteenth century the partial figure was a forerunner – perhaps *the* forerunner – of abstract sculpture. Given her academic training, it is hardly surprising that Louise Bourgeois has so often made or cast hands, breasts, legs, feet and heads. Sterbak's work, often taking the shape of the body, has been associated with the *vanitas* theme: a reminder that beauty inevitably leads to decay. Little wonder, then, that her works seem to betray an obsession with control as well as

Pepe Espaliú, 'Carrying II' 1992. Iron.
La Máquina Española, Seville

with being out of control, for the ageing process cannot be resisted.

Without addressing the issue of mortality no study of contemporary rites of passage could be considered complete. That two of the artists included in this exhibition have died of Aids-related illnesses is by no means irrelevant. Since the entire concept of 'life expectancy' has had to be revised, for nowadays the experiences of 'three score years and ten' may need to be packed into a far shorter time span, ways of coming to terms with death have had to be found. Previously a quiet, reserved person, Pepe Espaliú found a new voice after his diagnosis, and made explicit reference to his own predicament in his political activities and implicit reference to it in his art. For example, he designed sculptures that resembled closed, black vehicles with parallel poles at either side, like sedan chairs used during a plague, though in this case the chairs seemed capable of flight or of moving through walls. His involvement in politics was an unexpected aspect of his new life. Despite his shyness, permeating Espaliú's performances and writings during the time after his Aids status was confirmed was the theme of mutual support. In contrast, only Hamad Butt's family and a few close friends were aware of his condition. His art became his way of exploring the moral aspects of his situation as a young person whose longterm partner had already died of an Aids-related illness. Like Espaliú, Butt thought long and hard about plague in history. Yet as a commentator on his own condition, his triumph was never to lapse into moralising or to underestimate the attractiveness of danger. Those 'Familiars' (nos.11–13) to whom he devoted so much thought – forces he imagined were ready to do his bidding – resembled Shakespearean sprites: beautiful, tetchy, ungovernable.

Butt's thinking, like that of every artist in *Rites of Passage* to a greater or lesser extent, was informed by Conceptual art, a set of propositions formulated in the late 1960s which depended on a *faux-naif* (even, in its British form, *faux*-academic) approach to traditional aesthetics. Do artworks need to be constructed from brute matter? Do they need to be constructed at all? Can an idea be art? And what defines an artwork? The use of conventional cues, like a stage or a frame or a signature? Or the setting in which it is placed – a gallery, for example, or a museum? Conceptual art persists as an influence; although it has reached a late stage, its ramifications are not completely exhausted. Any important movement has its backlash, however, and recently a reaction against Conceptual practice has been felt, as the status of flesh has been re-examined, often by women, as a subject of crucial impor-

tance in the light of current political debates about ethics (torture, explored in Elaine Scarry's study *The Body in Pain*), religious belief (the issue of transubstantiation), or justice (the rights of the unborn child). In *Rites of Passage*, the tension between matter and whatever its opposite may be is felt powerfully in the work of, for example, Jana Sterbak, with her distinction between the lightness of the flesh (controlled automatically in a motorised crinoline in one of her best-known works; fig.33 on p.124) and the dead weight of her meat dress, with its taint of murder and burial alive (no.32).

In contrast, Mona Hatoum invites viewers to watch a moving image of the inside of her own body. The unwelcome intimacy of 'Corps étranger' (no.27), in which the viewer is granted the same degree of freedom over another body that a surgeon is permitted, tests his or her instincts. Will curiosity triumph over disgust, or will resistance build up against the human aspect of the spectacle, so that we all become doctors, setting aside our instinctive reactions in the cause of – what, exactly? Art? Medicine? Truth? Perhaps the reason for doing so is less important than our presence in that confined space. There is a first time for everything, the installation suggests. And that first glimpse of something taboo teaches us more about ourselves than about what exactly is being looked at. Morals are suspended; this experience seems to span contradictions: disgust and the sacred, trauma and rapture.

For ancient Greeks, attending tragic drama with its function of catharsis, a collective emotional purgation, was regarded as a civic duty, an acknowledgment of the demands of society. As a student, Miroslaw Balka's graduation piece, 'Remembrance of the First Holy Communion' (no.1), concentrated on the very process of gaining citizenship by accepting his place in a community of the faithful and a realisation of his own role in the church, capable as he now was of taking the sacrament and of shouldering the responsibility of an adult Christian male. The Passion, a model to Christians, was re-enacted on a smaller scale by both him and his examiners, who obeyed his instructions to the letter by sticking pins he had provided into a cushion which stood for his heart (see pp.32–4). A less religious event is presented by Susan Hiller in 'An Entertainment' (no.28), ironically titled, because it is no such thing. It presents highlights from a Punch and Judy show, which traditionally involves irrational behaviour, wife-beating, sacrilege and child murder. Here the refusal of catharsis creates sensations of grotesque and pathos, and an overwhelming sense of doom. While Hiller depicts domestic turmoil, however stylised, Bill Viola's installation, 'Tiny Deaths' (no.33),

ostensibly more muted, involves the premature extinction of people we have only just met. Whereas one installation concentrates on emotional violence, the other focuses on a more literal violence of a kind which might well be censored if it were televised at a peak viewing hour. Both address urban patterns of behaviour: watching television and enjoying harmless seaside entertainment. Yet even the change of scale that these artists have decreed alters the significance of the events that meet our gaze. Those strange sounds which accompany Viola's 'Tiny Deaths', with its sinister clankings and mumblings, and Hiller's 'An Entertainment', with Punch's swazzle, both serve to alienate the viewer.

The liminal involves a revision of the sense of individuality, it seems, which is naturally strongest at the point of birth or death. Or rather, in the course of either, for increasingly the idea of a 'point' of our entrance and exit is seen as misleading. During that time ritual replaces mundanity, experience is heightened and ceremony is substituted for instinctive behaviour. There are other situations in which the ritual prevails, such as imprisonment or torture. Born in Beirut and stranded in Britain during the war in Lebanon, Mona Hatoum embarked on a series of works using her own body as an element in her work. 'The Negotiating Table' 1983 featured empty chairs facing a table on which the artist was lying in a body-bag. Some years later at the Riverside Studios in London she used corrugated iron to seal off an alcove in which visitors could spy on her through a hole ('Matters of Gravity' 1987). Oddly, the hole had a lens which reversed the image of the artist, serving to increase the level of alienation. In contrast, John Coplans's large-scale photographs of himself (nos. 14–21) can be regarded as images of dignity and freedom, consciously drawing on the radical simplification of image in American Abstract Expressionist painting and later – his debt to late Philip Guston is increasingly evident – a meditation on the version of primitivism described in Robert Goldwater's writings.[8] The greater the insistence on the flesh in these giant works, the more the emphasis switches to the spirit and to qualities of endurance that our bodies do not possess.

Insistence on matter also underlies the work of Robert Gober, which involves fabrication of shapes and images connected with daily life. As he subjects these to incessant correction or distortion, a critique of factory production emerges. Wallpaper is hand-painted, the disembodied male legs protruding from walls are hand-made – every hair inserted separately – above all, imagery is repeated with subtle changes from one installation to another, like a bad dream it is impossible to escape.

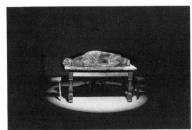

Mona Hatoum, 'Bars, Barbs and Borders: The Negotiating Table'. Live work: 5 December 1983. *The Western Front, Vancouver, B.C.*

As his critique of mass-production has continued – satire, perhaps, on Ronald Reagan's dictum 'Art is another form of business' – Gober's anarchic instinct reached a new level. When a bag of donuts – with both bag and donuts simulated by the artist – was sold and the buyer returned it with a complaint that they were uneatable, a subtle, profoundly illogical extreme had been reached. The status quo is savaged by Gober, whose works include hand-painted cushions for dog-baskets and wallpaper with a pattern depicting a white boy sleeping while his black counterpart dangles by the neck from a tree. But Gober's nightmares can be regarded as mere overtures to more general concerns.

Domestic disruption is also pictured by Louise Bourgeois, whose two-part installation 'Red Rooms' (nos.7, 8) recalls her early life with her parents, as so much of her work does. A drawing shows her parents, side by side, smiling benignly. Instead of bodies, however, they have loosely plaited wool or thread. Sewing and general handiwork also recur in her imagery and in her drawing technique. (Many sketches are made from strokes repeated rhythmically across the paper.) In her own mind, Bourgeois is pointing out, they take the form of pure material, to be worked and reworked by her fertile imagination. (The novelist Henry James used a similar metaphor; when he invented characters whose only role was to help the plot, he called them *ficelles*, or 'threads'.) The past, as we think of it, changes constantly, but those changes are determined, however obscurely, by us. They vary as moods vary or as weather alters from one moment to the next. The key is the rhythm but the rhythm is ours alone, dictated by memory. Yet for Bourgeois, memory, which others picture as a bucket descending into a well, exists in a state of flux. For much of her career, she has thought deeply about her childhood and her family. No wonder that they have turned into creatures of myth and legend, and that as they have, the very idea of 'knowledge' of them recedes.

In the 1940s in New York, when Bourgeois was a member of the group that became known as Abstract Expressionists, a school was mooted, to be called 'Subjects of the Artist'. What the idea of 'subject' could mean in art is problematic in the extreme; members of the group decided that it would mean the unfolding of the artwork from itself: the way it formed, which was determined to a great extent by self-reference. The result was a way of considering art as either subjectless or self-regarding. 'Subjects of the Artist' was offering a model for thinking – based on the workings of the art, which so often seems to generate itself – to take control of the artist, who submits to its demands as it takes

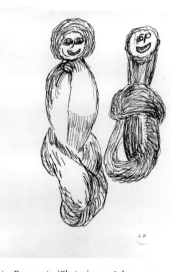

Louise Bourgeois, 'Skains' 1943. Ink on paper. *Private Collection, Boston. Courtesy Robert Miller Gallery, New York*

shape. (One example they admired was that of a jazz musician, improvising on a melody and rhythmic pattern already divulged, but making a new composition from it and doing so as a natural process.) Now, at the end of a century, indeed, at the millennium, a shift of attitude may be taking place. Increasingly, art is 'about' issues in the world in general. It is not that art is there to solve our problems, but that the particular mode of problem-solving which art can undertake may be of more use to us than the day-to-day workings of (say) politics, our model for one way the world changes. The 'Subjects of the Artist' school was not proposing any direct relationship between life and art. Perhaps the artists in *Rites of Passage* are.

The artists represented here offer a range of approaches to their practice. Craft techniques are juxtaposed with state-of-the-art technology, even in the same career as in the case of Susan Hiller; apparently simple statements like Robert Gober's are placed alongside the baffling technologies of, for example, Bill Viola, and the phenomenon of Joseph Beuys – politician, medicine-man, maker – is presented in more than one light. At the end of the millennium, art seems multi-faceted, contradictory. (Did we ever go to it for 'sense'?) Without using direct biographical material, artists are drawing on their own experiences, admitting their differences and revelling in them, enjoying the complexity of definition of matter that is the legacy of Conceptual thinking and in particular the example of performance, an essentially communal art-form with roots in ritual.[9] Without recourse to biography, they regard their practice as self-reflexive, self-referential – a legacy of Modernism – but, perhaps inspired by the experience to come, they propose a single 'subject' for the artist now: an examination of the liminal stage he or she has reached, a feeling that Pepe Espaliú described as an 'opaque threshold'. Perhaps this is a reflection of the artistic process itself, always on the verge, in a state of becoming. Or could it be a response to that state of mingled excitement and misgiving which everyone feels at the end of an historical period? The French philosopher Jean Baudrillard has argued that the threshold is already crossed: that the millennium has arrived.[10] Most of us think differently, and would welcome a *passeur*. But it might occur to us that it is not a ferry-man we need: and that art, after all, might do the job for us.

Notes

1 Pepe Espaliú, in José Luis Brea, *The Last Days*, Seville 1992, p.112.

2 Michel de Certeau, *Heterologies*, trans. B. Massumi, Manchester 1986, p.259 n.1.

3 Benjamin H.D. Buchloh, 'Beuys: The Twilight of the Idol', *Artforum*, no.28, Jan. 1980, pp.35–43.

4 Benjamin Buchloh and Alain Cueff, 'Broodthaers / Beuys, Le Poète / Le Chaman', *Beaux-Arts* (Paris) no.97, Jan. 1992, pp.62–70.

5 Franz-Joachim Verspohl, *Joseph Beuys, Das Kapital Raum 1970–77: Strategien zur Reaktivierung der Sinne*, Frankfurt am Main 1987, p.21, quoted from an interview in *SPEX-Musik zur Zeit* (Cologne), no.9, Sept. 1982, p.19.

6 C. Tisdall, Louwrien Wijers and Ike Kamphof, *Art Meets Science and Spirituality in a Changing Economy*, The Hague 1990.

7 David LeBreton, *Anthropologie du corps et modernité*, Paris 1990, p.48.

8 In 1938 in New York, Robert Goldwater published *Primitivism in Modern Art*. He was married to Louise Bourgeois.

9 Henry M. Sayre, *The Object of Performance*, Chicago 1989, pp.184 and passim.

10 Jean Baudrillard, 'L'An 2000 ne passera pas', *Traverses*, no.33–4 (1985), pp.8–16.

Of Word and Flesh

*An Interview with Julia Kristeva
by Charles Penwarden*

Julia Kristeva is Professor of Linguistics at the Université de Paris 7-Denis Diderot and Visiting Professor at Columbia University, New York. A practising psychoanalyst who trained with Jacques Lacan, she has published on a broad spectrum of cultural and social issues. Her books include *Revolution in Poetic Language*, *Powers of Horror: An Essay on Abjection*, *Black Sun: Depression and Melancholia*, *Nations without Nationalism*, *New Maladies of the Soul*, and, most recently, *Proust and the Sense of Time*. She is also the author of two novels, *The Samurai* and *The Old Man and the Wolves*. All her works are published by Columbia University Press.

What is your reading of this exhibition?

My overriding impression is that we have never been in such a state of crisis and fragmentation, in terms of both the individual – the artist, and the aesthetic object. The crisis is such that not only do we have difficulty with the question of the work of art, but also the question of beauty itself seems unbearable, as does the spiritual destiny of these strange and shocking objects. At the same time the ambient social and media discourse is extremely banalising and either refuses to acknowledge these experiences or evacuates them fairly rapidly with abstract, universal themes such as 'new religion' or 'new spirituality'. These may contain some truth but they seem to me too general in relation to this very painful fragmentation. From what I can see, we have reached a very grave moment in the history of aesthetic consciousness and practice. So the questions to be asked are 'Why do they do this? Who is doing this? What are the experiences behind these objects, objects which work with the impossible, with the disgusting, the intolerable?'

I do not think you can approach these questions without referring to the experience of the analyst. For, if one describes these objects as expressing a state of crisis, then the only person who considers that crisis is endemic to the human being is Sigmund Freud, who says our hell is the unconscious and that beneath our apparent placidity is an extremely problematic and abyssal being. For Freud these states of being are subjacent, are constantly with us.

In your own works, notably Powers of Horror, *you use the term 'abjection' to describe similar states. Could you define this idea and its relation to the works here?*

In the dictionary 'abjection' signifies a state of crisis, of degradation, of self-disgust and disgust towards others. It is both psychological and theological: when one sins, one is in a state of abjection. In my use of the term I insist on the privative aspect: 'ab-ject', which means for me that one is neither subject nor object. When one is in a state of abjection, the borders between the object and the subject cannot be maintained. In other words, the autonomy or substance of the subject is called into question, endangered. I am solicited by the other in such a way that I collapse. This solicitation can be the result of fascination, but also suffering: the other disgusts me, I abhor it, it is — we are — waste, excrement, a corpse: it threatens me. What is interesting is that this crisis of the person, which I call abjection and which is a state of dissolution, can be experienced either as suffering or as rapture. I think that it has always existed but it has been more or less covered and perhaps transcended by belief in an ideal which in the last instance was religious: God is there and I confess my abjection to God and from that moment I am absolved, I recover my unity and all my sublimity. And so in Flemish or Gothic painting you can see corpses and monsters representing the hellish element, but as a counterpoint to the state of beauty. Modernity is characterised by the suspension of this religious ideal and also of ideological, political ideals. It is no coincidence that we should be seeing such an exhibition after the fall of the Berlin Wall and the crisis of the revolutionary movements which, in a sense, took over from religion.

Of course, people say there is a kind of theological revival, a return of religion. But very often these religions take a form that is fundamentalist, dogmatic, nationalist and refuse to recognise this crisis, whereas the language of the objects in this exhibition attempts

to come as close as possible, almost to accompany this state of abjection, this permanent oscillation between subject and object. In this sense, these objects have a cathartic value. The artist who produces them is able to find a temporary harmony in his state of malaise, one that is close to that malaise, that does not seal it off or ignore it.

As for the public, they can react in two ways. There are those who repress this state of crisis, who refuse to acknowledge it, in which case they either don't come or they find the works disgusting, stupid, insipid, insignificant, and wonder why the curators bothered. Others may be looking for a form of catharsis. When they look at these objects, their ugliness and their strangeness, they see their own regressions, their own abjection, and at that moment what occurs is a veritable state of communion.

The works have a quasi-religious effect, then, but the fragmentary nature of the language means that this is bound to be very limited both in time and in terms of the people affected?

The etymology of the word religion goes back to r*eligare*, to bind, to make a community. We have reached a point of extreme personal solitude, so if communion does occur then it is fragmented, solitary. It is very difficult to imagine a religious institution which could channel this experience without lapsing into dogmatism. Perhaps the museum is one place which can provide a context for it.

I was struck by the parallel between certain passages in Powers of Horror, *the idea of the rite of passage and the liminal states which artists evoke or put themselves in.*

Yes, one could compare the subconscious workings of such a practice. I don't think that artists necessarily have the sacred in mind. Perhaps some do. For others it may be the only way to live, to keep their psychic space open and alive, or simply not to commit suicide.

In *Powers of Horror* I talked about all kinds of rituals, not only rites of passage. When you look closely at religious rituals throughout history you see that, though the forms are different, they are all purification rites. What is being purified? One finds two essential elements: murder – the violence that threatens the living being, and not just society – and menstrual blood, fertility, the power of the

feminine, which the social consensus sees as dangerous and difficult to control. It is no surprise, therefore, that in certain unconscious resurgences of these cathartic objects – objects that purify abjection in the work of certain artists – we can see a relation to violence, death, the corpse, to the fragmented body, to decomposition and sexuality and particularly the intolerable aspect of the female organ, of the vagina – a dress which covers the sex but which is animal (Jana Sterbak), and which suggests a way of covering a danger.

If one goes a step further, as anthropologists have, it is not only murder, excrement, menstrual blood that are dirty, but anything which endangers a structure. When you have a coherent system, an element which escapes from this system is dirty. It begins with something fairly anodyne. Tears, for example, are considered dirty because they escape the limit of the body.

I think that in a lot of the objects in this exhibition the artist is trying to draw our attention to something which changes or endangers a structure, a coherence, to what is marginal, incoherent, incongruous. There is even a kind of insistence in this quest for the eccentric.

We live in a society which is both ultra-conformist – that is perhaps what people will say of our century: that we are hyper-bourgeois, hyper-conformist, we cocoon, are afraid of sex, and so on – and where at the same time, as a consequence of this, there is a great deal of exclusion, both mental and social. I think this desire for eccentricity manifested by the artists on show does stem from the concern that is at the heart of sacred rites – to take into account that which is marginal to a structure, dirty: 'I am going to concentrate on this dirtiness so as to find a representation of it, and when I have found a representation for this eccentricity, it is a form of harmony.'

We have reached a kind of degree zero of harmony. We are incapable of attaining beauty, that is the point that needs underlining. True, some of the works here do achieve a form of beauty through a harmonisation of eccentricity and of horror, but it is extremely paradoxical.

You have described modernism and postmodernism in terms of different psychological conditions, with the former representing a kind of 'pre-narcissistic' pulverising of the image, and the latter an attempt to recover a kind of harmony. Perhaps the idea of postmodernism is no

*longer what it was, but does this opposition strike you as pertinent
here? Is the opposition at play within each work, or between different
works?*

I think there is still a desire to accompany this extreme fragmentation,
abjection and ugliness with a search for meaning. We don't necessarily
have to call it postmodern.

What can this meaning be? It can no longer be 'Long Live the
Future,' Communism or the Third World – all those ideas we have
lived with during the twentieth century and which have accompanied
the avant-gardes. No, it means addressing oneself to the state of the
world in a way which remains dubitative, inconclusive. One notable
example is the use of video. Artists show images concerning current
events, history, Nazism, an illness, the history of art, images which
have no direct relation with the object on display, but which provide a
background and make us think. It would seem, then, that
contemporary art does not try to achieve the kind of synthesis that we
see – for example, in the work of a Rubens or a Titian, between formal
inquiry and a religious, humanist message. They maintain a duality –
on one side the most violent fragmentation and abjection, on the other,
in the background, an inquiry into the state of the world. It is up to the
spectator to make the connection for himself or herself.

There is no preconstituted link, but there is perhaps an analogy
between these two forms of crisis – a more intimate, formal, subjective
crisis on one side, as shown by the dresses, the photo of the fingers
and bodies (John Coplans) or, say, a mass of scrap metal or cloth, and
on the other side the political crisis. For most of these artists there is
an obvious analogy between the objects they present and the state of
the world.

*How do you think the very contemporary questions of Aids,
biogenetics and virtual reality can be read into these works?*

I think these works reflect the sense that pictorial signs, images, have
become banalised by the history of art, that they have lost their
sensorial and instinctual force, as if they were no longer able to speak
of corporeal experience and remained neutral. The artists seem to be
trying to react to this banalisation or extenuation of the image. There
is a whole tradition of twentieth-century art which fights against the
abstraction of signs, whether verbal or pictorial. It is a revolution back

towards the base of our culture. We say that Christianity is a religion of the word, but it is the word made flesh. Perhaps we have forgotten the message contained in the foundation of this religion, that of the permanent joining of the body and signs. Many artists – Proust or Joyce, for example – considered that the purpose of art should be to take up the concern of the Mass, transubstantiation, whereby what is symbolic becomes corporeal and what is corporeal becomes symbolic. Proust wrote in his letters that he imagined literature as a transubstantiation.

The situation is that much more urgent today, when the state of crisis is accompanied by a kind of robotisation of the individual. We are all more or less reduced to virtual images – through the images propagated by television, video games, and so on. The reality of the world and even our own reality is slipping out of our grasp. On top of this the threat of grave illness focuses attention on the body. Finally – though one could no doubt think of other factors – this weakening and banalisation of signs means that we are subject to psychosomatic reactions. We cannot express our anxieties in signs – they seem too insubstantial – so the whole burden of aggressivity is borne by the body and our bodies become ill to signify that there is a conflict somewhere. It is in this context that artists use the body – or something close to the body; as a sign. It is never a pure body, it is always subverted, transformed, an object at the frontier of subject and object, of word and flesh.

How would you compare the use – or evocation – of the body in the works here and the significance of the body in the art, say, of the 1960s?

They are rather different. In body art there was a kind of enthusiasm and perhaps a utopian sense of being able to achieve a kind of completeness, a power, a totality which would bring together signs and the body. Whereas here there is a distance, a greater formal sophistication, a play with absence, the sign of something impossible. There is an awareness of suffering – not necessarily a belief in its value – which leads to a kind of appeasement, of serenity. But this is very different from the juvenile view of the 1960s, of pleasure at all costs. A feeling of impossibility has blown through.

If the neurotic tends to confuse what is internal with what is external, could one say that artists in a sense simulate the neurotic?

I would go further than that. It is not so much neurosis as a state close to psychosis, to that of borderline patients on an unstable frontier between the inside and the outside. There is an exchange between the internal and the external which is more characteristic of psychosis and which, as I said in my book *New Maladies of the Soul*, is an increasingly common symptom. The frontiers between sign and body, inside and outside, self and other are threatened. I think that the artists here work with these limits.

So one could say it is a kind of 'psychotic art', one which simulates psychosis?

It is certainly a catharsis of psychosis, if we are to use that term. I am reluctant to do so because these are nevertheless messages, works of communication. We should not medicalise them. At the same time, I would not reject such a usage because it shows the extent of the malaise. I think the crisis we are living through is deeper than anything since the beginning of our era, the beginning of Christianity.

You have described the need for a 'suspension of meaning' in order to recover meaning.

In my novel *The Old Man and the Wolves* I compared our crisis, in which human behaviour has attained an extreme degree of baseness and animality, to the end of the Roman Empire. The difference is that I cannot see any signs of a new promise. Perhaps one needs to stand back a little, and perhaps it is not so desirable anyway if one looks at the ossification, inflexibility and dogmatism of religion. Heidegger said only a religion can save us. I would say 'only an experience can save us'.

Perhaps the experiences on show in this exhibition are crude and will disappoint many spectators, but they are pointing in the right direction. In other words, we need to come as close as possible to the crisis, to accompany it and produce individual works because that is the predicament we are in, in a kind of pulverisation and solitude. It would be a mistake to try and obliterate the fact with misleading promises of a new and easily obtainable community.

Liminal States and Transformations

Stephen Greenblatt

Virtually all of the works of art in this exhibition are death-haunted and with good reason: rites of passage are rites of dying. In a rite of passage, something is extinguished, something becomes extinct: if not you yourself, in your bodily being, then something you are, a status or position in which you have been fixed, from which you have drawn your identity, to which you referred your experiences in order to give them some coherence and meaning. And then, either through choice or through something over which you have no control, the status crumbles, the position disappears, the identity is no longer your own. You have entered, in Arnold van Gennep's famous conception, a 'liminal period' from which you emerge transformed.

A rite of passage is something that happens to an individual – and as such, is a particularly intense personal experience – but it is at the same time social and in most cases institutional. A private rite of passage is like an unattended wedding: it can mime the form of the ritual, but it misses the mark. The significance of the transition derives from collective understandings that accumulate around the performed acts. Those acts are often focused on the body and in many societies the skin may be painted or scarred or tattooed; alone or in a group, the participant may be expected to wander in the wilderness or to eat special foods or to chant certain phrases. Pain, fear, disgust, hunger – these are characteristic emotions of rites of passage, along with pride, exaltation, and insight. And the emotions too are collective, in the sense that they follow certain paths laid down by those who have gone before and those who actually or in imagination are the spectators of the ritual actions. But this is a strange form of spectatorship, not only because the participants are often hidden from view but also because, even when they are visible, those who are undergoing the rite of passage are in some sense masked, occulted, unrecognisable. The participants have a recognisable position

before the rite and after the rite, but the rite itself renders them strange, even to themselves.

The artists included here are not, it seems to me, very interested in either the originary position or the new position; they are interested in the limen, the threshold or margin, the place that is no-place, in which the subject is rendered invisible – a shadow, a negative, a mutilated fragment, the empty space in an unworn, unwearable set of clothes. And that no-place – u-topia – is the place at once of art and of dying.

It is the place as well of religion, more precisely of religion estranged, recalled across an abyss, twisted into grotesque shapes. This is why so many of the images and objects in this exhibition directly or indirectly invoke religious themes, though always distorted as in a dream or a heresy. So if we are to look into the past for an imaginative matrix from which these rites of passage can be thought to emerge, if we are to find any spurious precedents for these attempts to express the unprecedented, we should invoke not the rituals that formed the core of Western religious practice, the sacraments that governed the passage from one status to another in Christianity, but rather the rituals of other peoples and other countries as they were viewed by the West. It is after all, no accident that the most important modern scholarly work on rites of passage, *The Forest of Symbols*, by the anthropologist Victor Turner, centres not on his own culture but on that of the Ndembu of Zambia. To those in the West, rites of passage in their purest form always appear to be other and elsewhere.

Where to look? Apparently, in the middle of the fourteenth century an English knight from St Albans, Sir John Mandeville, voyaged to the East. On his return he wrote an account of his journeys, *Mandeville's Travels*, which became the most popular secular text of the Middle Ages: its author's lasting fame is attested by the plaque in his honour that is still affixed to the wall of St Albans Cathedral. In a country called Marabon, Mandeville witnessed the rite of passage to surpass all rites of passage. An enormous idol, richly adorned with gold and precious stones, was placed on a chariot and drawn through the streets of the city of Calamy. Pilgrims would come from all over the country and, in a frenzy of devotion, cut off pieces of their own flesh to offer to the idol, and throw themselves to be killed beneath the chariot's wheels.

What is taking place? The devout have left their homes, they have given up their positions, and have come into the presence of the sacred object. The object is itself temporarily not in a fixed position: it has been taken out of its honoured place in the temple and set in motion. And it is

precisely when the idol, as well as the worshippers, is in motion that the most extreme acts of devotion take place, acts that decisively change the status of the worshipper.

To describe dying as a 'change of status' may seem inappropriate, but the friends and family of such a martyr believed that something extraordinary had happened to him, as Mandeville remarks:

> Then his friends offer his body to the idol, singing and saying, 'Behold what thy loyal servant has done for thee! He has forsaken wife and children and all the riches and pleasures of this world, and his own life, for love of thee. He has made sacrifice unto thee of his own flesh and blood. Wherefore, we pray thee, set him beside thee among thy dear friends in the joy of Paradise, for he has well deserved it. And when they have done thus, they burn his body and everyone takes a portion of the ashes and keeps them as relics. They say it is a holy thing, and through the virtue of these ashes they shall be saved, and kept from all kinds of danger. And when they lead their idol around the city in procession, as I told you, next in front of the chariot go all the minstrels of the country with all the kinds of musical instrument, and make melody.

The mutilated body had thus been turned into a sacred object, a relic with the power to ward off danger, and the suffering and death of the devout serves as the occasion for a communal outpouring of artistic expressiveness: song, music, poetry, prayer.

Is there any truth in this spectacular report of a rite of passage? It is difficult to say. As far as anyone can tell, there was no Sir John Mandeville from St Albans. The author of *Mandeville's Travels* seems to have been Frenchman and he probably had never left home, and may even have lived in a monastery. The work is a tissue of plagiarisms. The account of the idol on its chariot – the Juggernaut, a crude image of the Hindu Krishna – was lifted from the travel narrative of Friar Odoric of Pordenone, who claimed to have witnessed the horrific procession in India. But since Odoric also claimed to have seen demons, some scepticism may be in order, or rather, some sense of being in the presence not of truth but rather of exalted, disturbed fantasy, the fantasy of broken bodies, of flayed skin, of liminal states and transformations.

Catalogue

Miroslaw Balka

Water is both life-enhancing and life-threatening. It is also a medium of transformation. Immersion of the body in water forms a central part of important rituals of passage, through life and beyond. In Greek mythology the river Styx divided the world from the underworld. Charon, son of Erebus and Nyx, guided the souls of the dead across the water. Those unprepared for the passage were forced to wander along the shores for a hundred years before being granted safe passage.

'River' 1988–9 (figs. 1, 4; no.3), was the last figurative sculpture Miroslaw Balka made before his move to

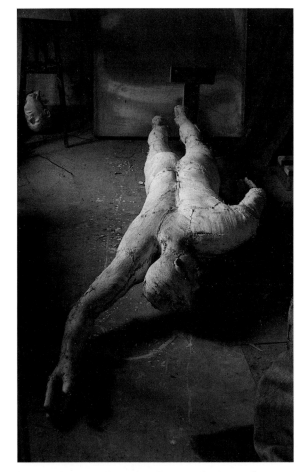

fig.1 'River' 1988–9, in the artist's studio in Otwock, a few months before it was shown for first time. Steel, wood, jute, neon and ashes. *Stedelijk Van Abbemuseum, Eindhoven*

abstraction, and it seems appropriate that it should evoke metaphors of liberation and death through the image of an individual's movement through water. The body of a man, unclothed but with his nakedness generalised by the rough surface of plaster whitened with paint and chalk, is stretched across the floor. His head is lowered, and angled to the side as if about to take a breath, and his arms are poised in propulsion. Beyond him, and sweeping over his head and shoulders, is the brilliant ripple of an illuminated neon wave. Behind him, as if on a distant shore, is a small three-dimensional representation of a house.

At the end of James Joyce's *A Portrait of the Artist as a Young Man* the hero, Stephen Dedalus, makes a decision to cut his ties with Ireland, with family, nation and religion, and seek his destiny away and alone. Images of moving water and of the air run through the narrative, and it is in seeking finally the protection of his namesake Daedelus, and thus in the shadow of Icarus whose flight to freedom floundered in the waters of Delos, that Stephen reaches for his liberty: 'Old father, old artificer, stand me now and ever in good stead.'[1]

Like Joyce's *A Portrait of the Artist as a Young Man*, a book that has had a long influence on the artist, Balka's first mature works – those made as an artist rather than as a student – explore the imprint of the artist's past on his adult persona. For Balka, as for Joyce, autobiography is of central importance. The emphasis on the self in his sculpture, as much in the recent abstract work as in his early figurative work which is the subject of this essay, has a political dimension, which Balka explains: 'For years in Poland everything was collectivised, everything belonged to the nation. So I turned inwards to my own personal situation.'[2] When Balka graduated in 1985, Poland was under martial law. According to the Polish curator Anda Rottenberg the long struggle for political liberation had by the mid-1980s exhausted many of those who might have been, under different circumstances, in the vanguard of oppo-

sition to the regime. Balka himself took an oppositional stance, both to the official regime and to the underground church, but his commitment manifested itself less in political activities than in a turning-in towards himself.

The work that Balka produced for his graduation show recalled an earlier decisive moment of maturation: the step from childhood to adolescence, symbolised and ritualised within the ceremonial, liturgical traditions of the Catholic church: First Communion. 'Remembrance of the First Holy Communion' 1985 (fig.3; no.1) is a powerful reminder, or relic, of what is both a private act of commitment for the communicant and a communal act of memory and reaffirmation for the witnesses. Balka's show was staged in a small abandoned house at Zuków, outside Warsaw (fig.2). It was a simple two-room dwelling, empty but for the ephemera of its previous occupants and the thoughts and memories that such things evoke. In one of the rooms Balka placed his sculpture. A diminutive figure stands beside an occasional table. He is tidily dressed, with a white shirt buttoned neatly at the neck, and the suit of a boy, with short rather than long trousers; on his lower legs he wears long white socks, pulled up but nevertheless a little wrinkled. One of his knees is a little bloody. The boy is seemingly in command of himself, standing poised, with one hand resting on the table. His head is turned in expectation. His shoelaces are undone. Two things disturb the image. On the table, embedded in the surface, as if in a gravestone, is a photograph of a child: First Communion, which after all witnesses the birth of the adult, equally signifies the death of the child. Above the boy's left breast, like the pocket handkerchief of a dandy, is an aperture filled with soft red fabric: a pin cushion, an open wound, his heart.

Balka's audience travelled by bus out along the main road from Warsaw. As they made their way across a meadow from the road to the house, the artist bicycled past them on a child's bike. His face was whitened and he was wearing white gloves. Balka's journey was apparently through time, moving back to his youth and drawing his audience back with him. As the walkers arrived at the house they were met by boys of a similar age to the young man represented by the sculpture. Dressed for a religious occasion, these acolytes made the event contemporary. The universal nature of such rituals as well as the transience of our passage through life was thereby brought to the fore: the young boys were living reminders. Neither could visitors remain mere voyeurs:

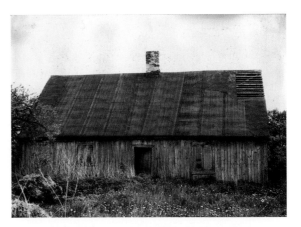

fig.2 The abandoned house in Zuków, Poland, where 'Remembrance of the First Holy Communion' was first shown in June 1985

as witnesses and participants they were given pins. The invitation to stick them into the soft red heart remained unspoken but implicit.

What did this strange and disturbing collaborative gesture signify? The sacred heart of Jesus has been through history the site of many woundings. Devotion to the Sacred Heart had been followed informally in many communities before it was officially recognised with a feast day by Pope Pius VIII in 1856. The Collect for that feast day speaks of His heart wounded by our sins. The blood red aperture in Balka's work might also refer to the wound in Christ's side inflicted by one of the soldiers attending the Crucifixion (John 19: 31–7) which is frequently depicted in biblical imagery of the Middle Ages as blood or wine leaking from His side and collected into chalices or mouths. Such images analogise the idea of transubstantiation; the conversion, in the Eucharist, of the very substance of bread and wine into the actual body of Christ. There is a thirteenth-century fresco in Orvieto depicting the Miracle of Bolsena in which the Host is depicted as bleeding in the hands of a priest who doubts the miracle of transubstantiation.

Much of the meaning of 'Remembrance of the First Holy Communion' and of Balka's early figurative pieces resides in the artist's relationship with the church in Poland, his upbringing as a Catholic and his later complicated move away from Catholicism. Balka himself has expressed his interest in 'exploring notions of faith in both an oppositional and celebratory way. Also to reconnect faith with reality, the mythic or symbolic figures of a martyr such as Saint Wojciech [St Adalbert] with the human figure.'[3]

The performance or collaborative element of

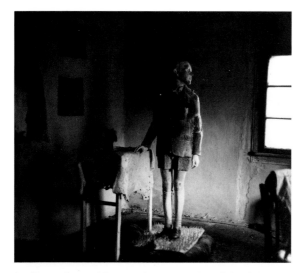

fig.3 'Remembrance of the First Holy Communion' installed in the house in Zuków, 1985. Steel, cement, marble, textile, wood, ceramic and photograph. *Muzeum Sztuki, Lodz*

'Remembrance of the First Holy Communion' was something Balka continued to explore for the following year or more, inventing strangely moving scenarios to be acted out on particular feast days and public holidays. In time, however, these gave way to sculptures which function within the more traditional context of object and viewer.

One such early work, made only a year after his graduation, was 'Fire Place' 1986 (no.2), in which a pale and dismembered torso sits on top of a brick-built hearth. Representing the body as a fragment is commonly seen as an act of violence, but torsos, following the influence of antique art especially such models as the Graeco-Roman Torso Belvedere, are generally seen as symbolic of the whole, and powerful, signifying a physical unity beyond their truncated form. Balka's torso is neither whole nor powerful but it is somehow complete. It has a slightly hunched back and yawning hollows at neck and shoulder. In the neck void is a head, partially submerged. The head itself has a smooth crown, pointed ears, a narrow face and elfin features – a face from fairytale or folklore. The set of its features and the droop of its posture suggest untold sadnesses. The torso of this fellow is the chimney breast and the hearth below is made in brick. Inside the chimney is a light bulb glowing softly. Obituary notices cut from recent papers have been pasted on the outside of the bricks. Like the young men attending 'Remembrance of the First Holy Communion' these notices provide a contemporary focus to the inevitable evocations of the past. Balka's 'Fire Place'

stands on a dirty and stained carpet. The carpet, which is at least thirty years old, is upside down. It forms a threshold, a zone of comfort between the outside and the hearth, and it symbolises the house and its role as provider of shelter and warmth. The carpet is also a zone of danger and fear, heralding the presence of fire and destruction.

Just beyond the edge of the carpet is a pair of shoes, pointed lace-ups with a curiously old-fashioned appearance. They are made from concrete, yet are clearly fragile. Inside each one is an insole: soft, slightly fluffy and probably synthetic. One takes off shoes to enter spaces dedicated to religion; for many people it is customary to take off outer footwear when entering the home. Shoes also remind us of what we leave behind in death. There they are, in contrast to the transience of the human body, signifying the longevity of the humble trappings of our existence. For Balka these trappings are important signifiers – they carry our past forward, they are the means by which we all co-exist with our history. Since the revelations of the Holocaust, empty shoes have inevitably come to invoke the annihilations of the Nazi camps. Unmistakable associations of cremation make this notion particularly strong. Here, in this work, as in the Polish villages and towns that bordered those camps, genocide co-exists with the domestic.

The imperative to assert a historical existence in the present is strong in all Balka's work. It is particularly well expressed in relation to his use of found objects: 'I choose them because they carry a history which I connect with when I touch them. It is like kissing the hand of history. My touch represents the contemporary … For me the history of materials is more important than the history of art. I don't make any connection with Arte Povera, but rather base my decisions on my own private experience. These are the materials I encounter in my studio, they constitute my personal landscape.'[4]

To Balka the layers of meaning in his work are a consequence of his attitude to history. For him our consciousness of life is imbued with the continuous flow of past and present. His intuitive working process in no way precludes the bringing to bear of complex meanings. As the artist explained, 'Deeper meanings come out of this personal history. But I don't like to start my work from the dictionary as some artists seem to do, taking meaning and then making an object to illustrate it. I do it the other way round. At first I make a table and then you can look in the symbols dictionary.'[5]

Few of Balka's figurative sculptures offer themselves for unambiguous interpretation, but rarely are they as ambiguous and unsettling as 'Shepherdess' 1988–9 (no.4). In French history shepherds (*les pastoureaux*) were the peasants who rose in rebellion in the thirteenth, fourteenth and eighteenth centuries. They were leaders of men, individuals with inspiration. In biblical terms the word shepherd is used of God in relation to Israel or the church and of Jesus in relation to men. These were spiritual leaders, providing a vision and a means of fulfilment. In Balka's 'Shepherdess' the guardian figure has no hands and no face. This absence is drawn to our attention by large apertures where the features should be. The figure is thus merely a loose fitting garment, hooded, and with an undoubted air of sanctity. In the sleeve of one arm a light can be seen. The arm functions as a torch, restoring to the sightless figure the role of visionary or guide. On the ground a little way from the figure is a small disembodied head: the shepherdess's solitary flock. What is the meaning of this strange work? Is it exploring a division between body and soul, between the physical and spiritual, between uncertainty and faith? Certainly Balka is ascribing an active role to the body as protector and guide, but what kind of guidance and protection can this faceless creature provide?

When Stephen Dedalus, Joyce's youthful hero, left Ireland he called on his namesake, a God-substitute, to guide him in his flight to freedom. Like Joyce, Samuel Beckett also created a world to which Balka has responded deeply. But Beckett created no guides and no guardians. Instead Beckett's characters ruminate continuously on their hopeless fate. Both Beckett and Joyce found freedom for themselves by leaving Ireland and by crossing water. Poland, like Ireland, is a land which has been fiercely contested throughout history. While its southern borders are defined by mountain ranges, to the east and west it is rivers that have provided thresholds to defend. Balka, himself absorbed in the ever-presence of the past, has chosen not to cross the threshold. Just as his 'Shepherdess' may have been unequal to the task of negotiating Poland's wilder mountain pastures, so too the strong swimmer of 'River' never reached the far shore. 'River' was followed by a simple, almost abstract sculpture, in the form of a container. The shape of the container matched the outline of the swimmer's body and the connotations of a coffin are unavoidable.

The spectre of death, and our movement towards it, are ever-present in Balka's work. At a stage in the recep-

fig.4 Detail from 'River' at the Labyrint 2 Gallery, Lublin, Poland

tion of his sculptures the deeply personal becomes a universal experience. Like his hero Beckett, awareness of death, of failure, is both a burden and a source of liberation. Balka is thus able to confess: 'I understand life as a constant approaching of death. My work is also concerned with this problem. Each of my works may be my last.'[6]

Frances Morris

Notes

1 James Joyce, *Portrait of the Artist as a Young Man*, 1916, ed. London 1977, p.228.
2 Miroslaw Balka, interview with Iwona Blazwick, in *Possible Worlds: Sculpture from Europe*, exh. cat., Institute of Contemporary Arts and Serpentine Gallery, London 1990, p.17.
3 Ibid.
4 Ibid., p.16.
5 Ibid.
6 Miroslaw Balka, interview with Jaromir Jedlinski, 1991, in *Miroslaw Balka*, exh. cat., Van Abbe Museum, Eindhoven 1994, p.66.

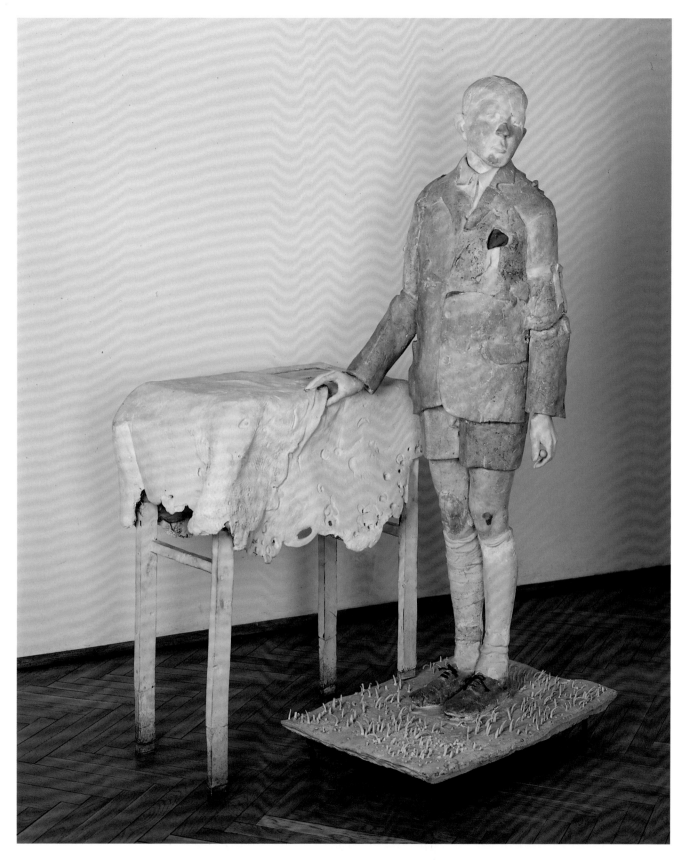

no.1

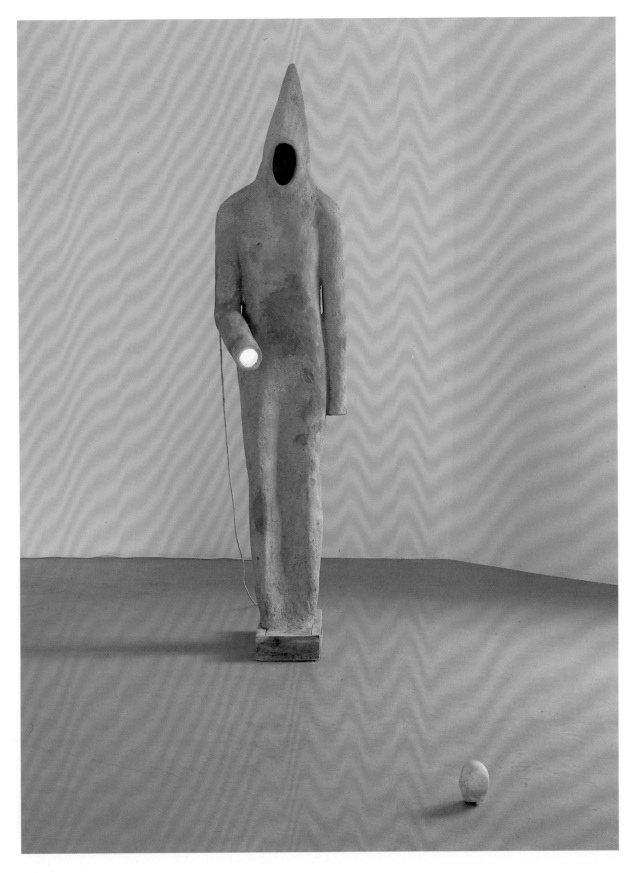

no.4

following double pages: no.2 and no.3

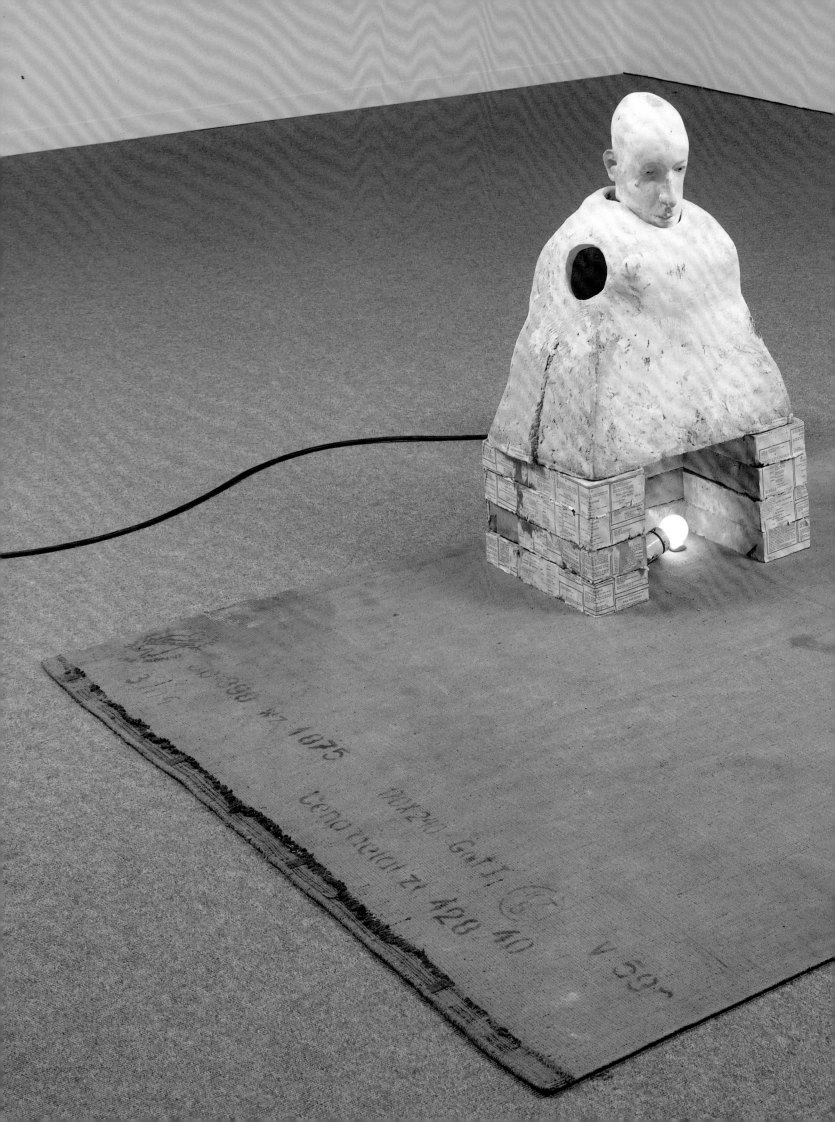

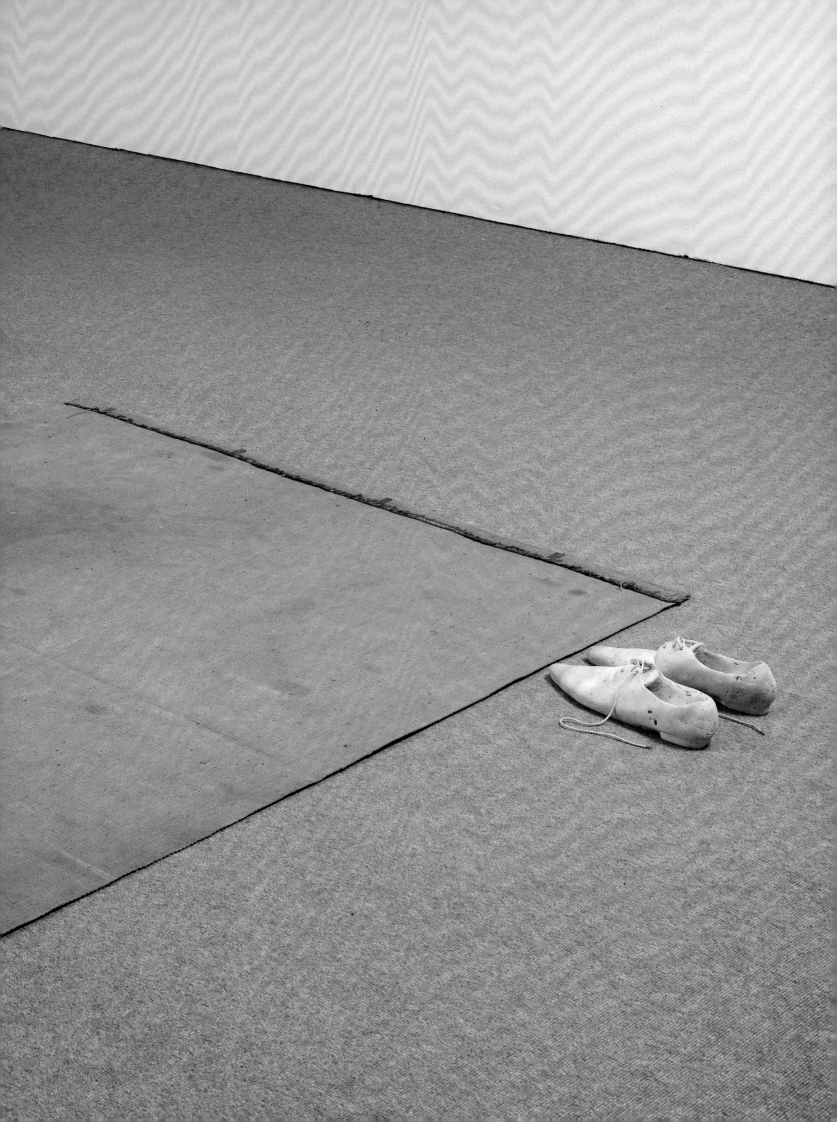

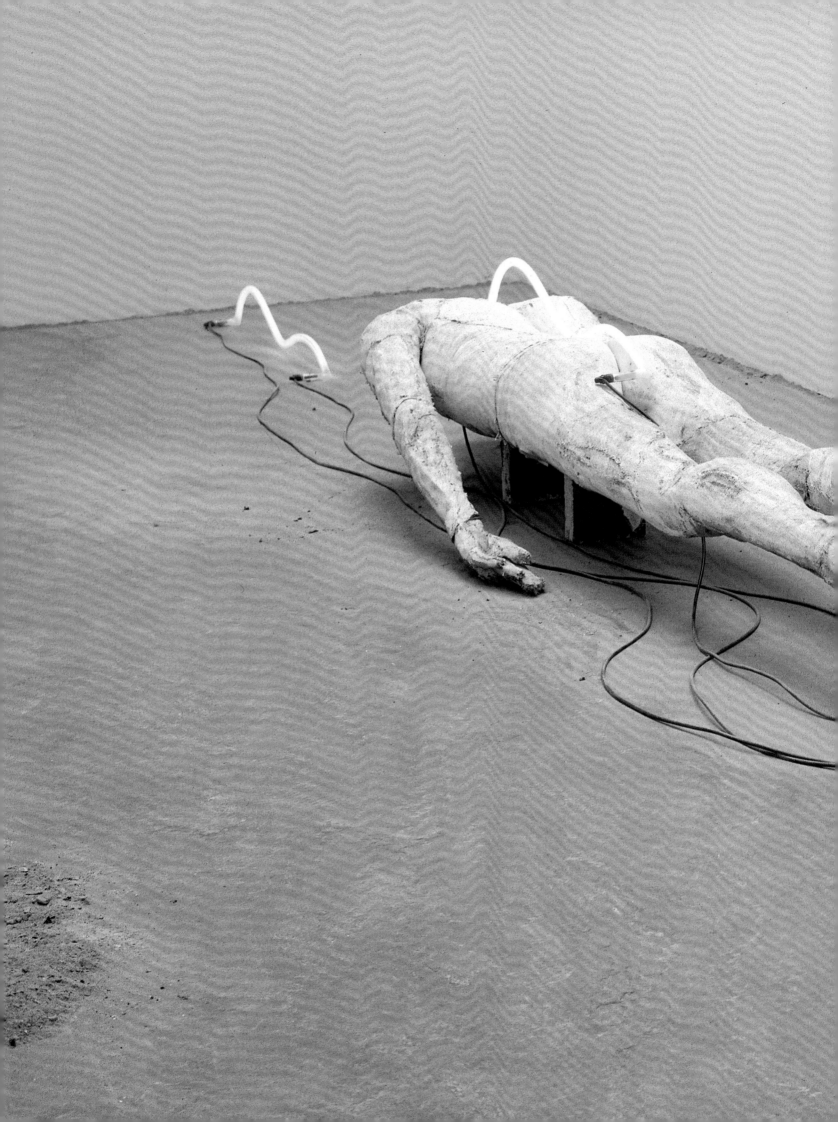

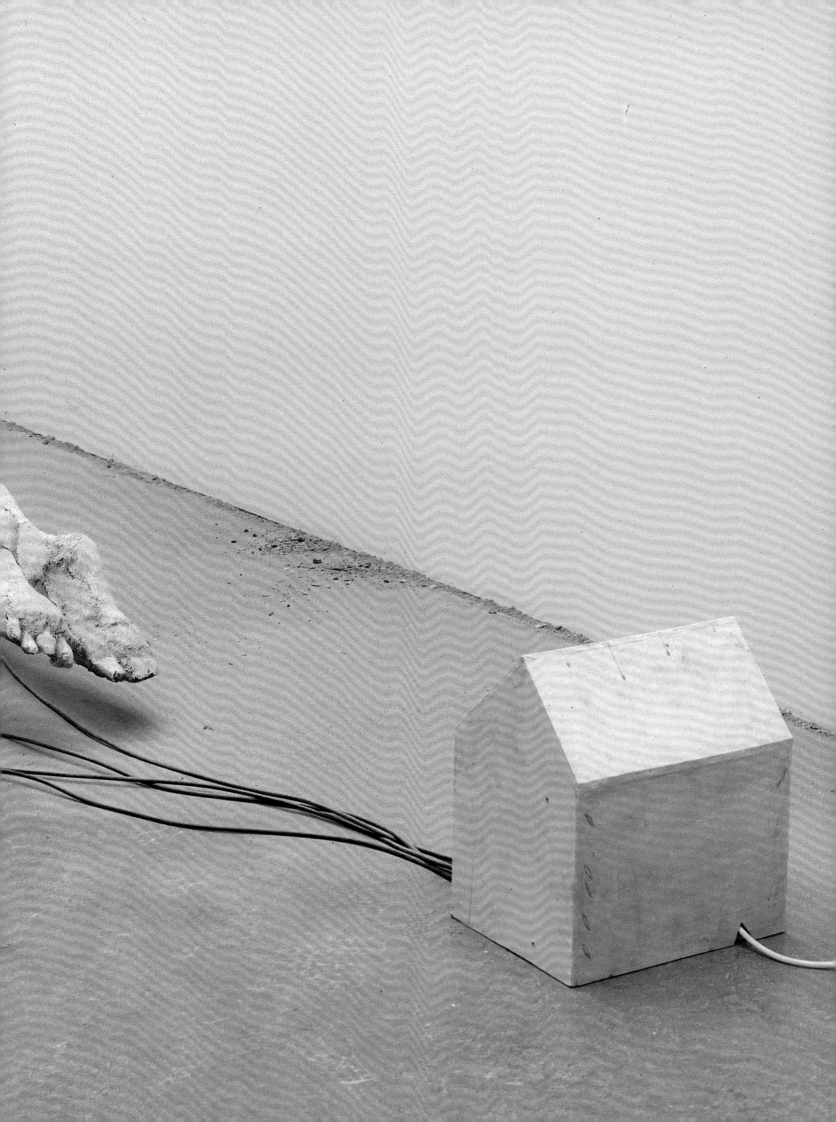

Joseph Beuys

Each and every man has the most precious building
in the world in his head, feelings and free will.

Joseph Beuys[1]

By 1985, Joseph Beuys was a sick man. He had lost his
pancreas and one kidney, his body was full of shrapnel
from war wounds, one of his lungs was defective and he
suffered from poor circulation. Sometimes he had to
sleep standing up. Realising that time was running out,
he travelled to Naples to visit the gallery-owner Lucio
Amelio, to bid farewell to his favourite city and to give
his life some sense of conclusion. Yet his journey was
also the fulfilment of a promise; over fifteen years before,
he had planned a cycle of four installations at Amelio's
gallery, the Modern Art Agency, later renamed the Lucio
Amelio Foundation. Preceded by a poster that read
'Joseph Beuys will discuss the transformation of Euro-
pean society', the first, titled 'We Are the Revolution',
consisted of drawings, films, videos and objects. The
second, a year later, called 'Arena – Where Would I Have
Got if I Had Been Intelligent!' consisted of exactly one
hundred glass-framed panels on which Beuys had
arranged photographs of his career, photographs which
hovered between documentation and artworks in their
own right (fig.5). As an historical record, 'Arena' was
enigmatic and tantalisingly incomplete; like the cata-
logue which accompanied the Guggenheim Museum ret-
rospective, it suggested that his work existed in a state of
permanent flux. Though the printing was perfect the
effect, as desired, was messy; while some images had
been drawn or painted on by the artist himself, others
were ripped or poorly developed. Handmade glass fram-
ing interfered even further with the reading of the work.
(In many cases, even the object of attention was in doubt.
One photograph of Beuys performing, for example,
leaves him in deep shadow, focusing instead on a boy
who has witnessed the spectacle and is no longer looking
at him – lost in thought or simply waiting.) The metal-
framed collages were put on show exactly as the packers

fig.5 'Hand Action/Corner Action' 1968, detail from 'Arena –
Where Would I Have Got if I Had Been Intelligent!' 1970–2.
Courtesy Dia Center for the Arts, New York. Photo: Cathy Carver

had delivered them, piled against the walls; Amelio
described 'Arena' as 'a mysterious container of all the
artist's ideas', but also 'The battlefield, the weapon by
which the artist invests faith in every human being.'[2]

Called 'Terremoto in Palazzo' (Earthquake in the
Palazzo) (no.3), the third work made for Amelio related
to a group of sculptures about politics, some of which
resemble printing presses surrounded by those black-
boards Beuys would cover with diagrams during his
marathon lectures (fig.8). In general the 'Earthquake'
series recalled revolutionary politics of the early twenti-
eth century, a type of activism still practised in Naples,

not only by Amelio but also by Beuys, who contributed articles to Neapolitan newspapers. In one, titled 'The Concept of the Palazzo in the Human Head, Questions and Demands' and written for *Il Mattino,* he compared the incipient earthquakes in Naples and the surrounding countryside to the destruction of capitalism, which would be replaced by 'a healing solution or rebirth based on self-determination and social democracy'.[3] From early in his career, when he pictured mental activity, eruption for Beuys had corresponded to tumultuous states of mind: a condition of catharsis and resultant change. Once more, decisions about the installation were made casually; elements were left as they had been delivered. Then an accident happened. Beuys had been alone in the gallery. Amelio described what happened: 'I went out because I wanted to buy a little bread. I was hungry. When I came back, Beuys said "You missed the best part of it…" He had made a glass tower and it had suddenly started shaking, then it fell and broke.'[4] In contrast, Beuys's last work for Amelio, 'Palazzo Regale', seemed serene, elegiac, straightforward, a presentation of Beuys's shamanic objects in two vitrines. One vitrine (fig.6) contained cymbals like those used in his performance of 1969 when he conflated Goethe's *Iphigenie in Tauris* and Shakespeare's *Titus Andronicus,* sharing the stage with a white horse; the head of the revolutionary Anacharsis Cloots from a monument in his birthplace Kleve (which Beuys also declared as his birthplace), cast by Beuys for an installation called 'Tram Stop', shown at the Venice Biennale in 1976; his own fur coat, and a conch shell bought in Capri in 1972, which he had used to rally his students during troubles at the Düsseldorf Academy. Around the walls were seven large 'mirrors', panels covered with gold: a possible reference to the alchemists' dream of transformation, a state of purity attainable (it is suggested here) by death. In short, 'Palazzo Regale' mourns the death of the shaman, whose tools are laid to rest. Like the turning-point of a play, then, 'Terremoto in Palazzo' occurs as a climax to events which involve an apparent catastrophe, which ends by being accepted in all its disorder: a state of emergency, temporariness captured. The interior is brightly lit, the floor littered with sparkling, broken glass, making movement perilous. A disaster has taken place, yet the result could have been predicted. (Disasters have rules of their own, after all.) Everything in the room has been shattered except a wooden structure with a long back, like a vaulting-horse except that its legs are splayed and

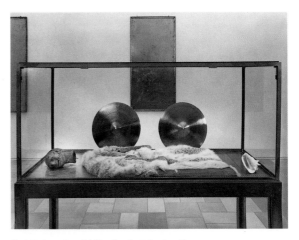

fig.6 'Palazzo Regale' (detail) 1985. Mixed media.
Kunstsammlung Nordrhein-Westfalen, Düsseldorf

each foot rests securely on a separate, unbroken glass jar. It is as if two levels of reality were proposed simultaneously: one other-worldly, the other terrestrial.

Something similar happens in one of Beuys's most ambitious ensembles, 'Lightning with Stag in its Glare' (fig.7) – finished in 1985, though its oldest element was completed as early as 1958: a cart which is a found object dating from the First World War, when it would have been used in a foundry. The work is preoccupied with origins. Obsessed by the idea that political change occurred on the site of creation itself – hence his respect for Warhol, who (he believed) willingly delegated artistic responsibility to assistants – Beuys had finally made a tableau *about* origins, called 'Work-place'. In 1983 he had put his own work-place on display at the Martin Gropius-Bau in Berlin, where the public was allowed to watch progress on a large composite sculpture, the equivalent of New York office workers who spend their lunch-breaks looking at building sites. One side of a large mound of earth was cast, producing a shape which was narrow at the top but broad at the bottom: a flash of lightning. Next to it he placed an older sculpture of an ironing-board top resting on four blocks, had it cast in aluminium and named it 'Stag'. A metal cart from a foundry was slightly modified to produce a bronze 'Goat' and the floor was covered with thirty-five fecal shapes, also in bronze, each with the tip of a simple tool protruding. Finally, on an old sculpture modelling base he cast the contents of a wooden plant box which he had kept long after the earth within it had hardened. It had been dug out at Manresa, where St Ignatius meditated. Its title was 'Boothia Felix', named after the peninsula in

north-west Canada where Cape Murchison lies, the most northerly point of the American continent. On top of the cast of the upturned pot and earth he attached a small compass. The tableau hovers between physicality and the metaphysical. Watched by a goat, a flash of lightning reveals and transfigures a stag, that sacred, shape-changing creature of folklore. Caught in the glare, primordial animals wriggle as they are partially transformed. Meanwhile space and time are measured but flouted; this is metaphysical space, immeasurable time, but also the moment of creation, the split-second of transfiguration when art *becomes* art, and the attempt to capture and perpetuate that becoming.[5] Read through this late ensemble, 'Terremoto in Palazzo' presents a less other-worldly panorama, apparently involving an accident. Yet that moment when most debris is produced from an earthquake is also the time when an apparent miracle can happen; when the strange animal can stand its ground or even succeed in striding forward through the wreckage, which may represent the remains of an older order giving way to the new. And if the four-legged beast can be paralleled by the stag, then more than a ray of hope exists. Kings and palaces are a thing of the past,

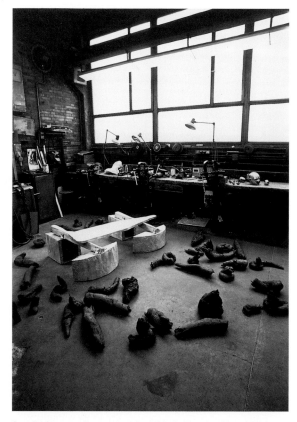

fig.7 'Lightning with Stag in its Glare' (detail of 'Stag' and 'Primordial Animals' in the workshop of the Noack Foundry, Berlin) 1985. Mixed media

after all; revolution is the theme of this work. Indeed, it was the theme of all four elements of the Amelio quartet: a shaking to pieces, an end to stable thought.

But what, after all, does this mean? Discussing the 'Earthquake' series and relating it to early Beuys drawings, Anne Seymour noted that 'the heads that Beuys used to draw in his early years suggested the power of words and speech, but also the aspect of spirituality and ecstasy, though they also perhaps depict mankind struggling through the darkness, strongly affected by shifting balance and continual upheavals of society.'[6] A moral dimension is also present. The young Beuys had been heavily influenced by Rudolf Steiner, whose *Appeal to the German People* of 1919 contained these words:

> Half a century after setting up its imperial edifice, the German nation was confident that it would endure for ever. In August 1914 it believed that the catastrophic war, then beginning, would prove that edifice to be indestructible. Today that edifice lies in ruins. After such an experience it is time to take thought. For this experience has revealed that the thinking of half a century, and in particular the ideas dominant in the war years, were a tragic error … The survival of the German nation … hangs on its ability to ask itself, in all seriousness, one question: how did I go wrong?'[7]

Given his serious injuries and the time he spent in a prisoner of war camp during the Second World War, similar doubts must have assailed Beuys. (A novel such as *The Bread of Bitter Years* by Beuys's friend Heinrich Böll, with whom he set up the Free International University in Düsseldorf in 1974, paints a bleak picture of city life and the completely disheartened state of the German population during that period.) Whether shamanistic or Steineresque, Beuys's personal change of heart represented a personal calvary; like the traditional representation of the life of Christ, his Guggenheim Museum retrospective was divided into sections called 'Stations'. Nor did he discourage events which linked his life to that of Jesus. Adopting the red cross as an alternative signature; taking the blame for the snowfall on six days of February 1969 – detractors called it his 'Jesus kitsch'. As in the work of Yves Klein, whom Beuys knew and with whose work he was familiar, sacred and profane interacted, sometimes with explosive results. Beuys knew he was courting danger and was prepared for the consequences. He counted on a greater understanding of his

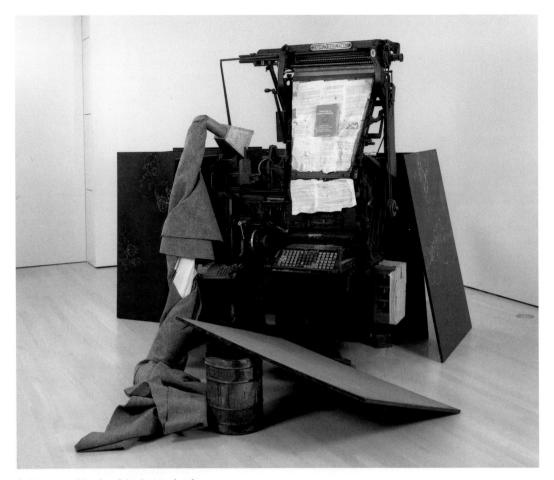

fig.8 'Terremoto' (Earthquake) 1981. Mixed media.
Solomon R. Guggenheim Museum, New York. Photo: David Heald
© The Solomon R. Guggenheim Foundation, New York

work as time went by and must have realised the potency of the abject, abandoned elements he chose to use. (How often he had turned back to his equivalent of the found object: the object set aside on shelves in garages or attics, waiting to be used.) One of his self-appointed roles was to encourage the German people to confront their past and to transform it. And if that demanded the mental equivalent of an earthquake, after which rebuilding would take place, then he was prepared for that eventuality. In the series for Amelio and the 'Stag with Lightning in its Glare' Beuys's spiritual and political ambitions come to the fore. A dangerous mixture, but one that is easily understood. Each work by Beuys depended on his tapping the collective memory, that dingy store-room which never gets cleared – the edifice, as Steiner put it, that lies in ruins. Each work was designed to bring about change, and each depended on Beuys's famous dictum that everyone is an artist.

Stuart Morgan

Notes

1 Anne Seymour, 'Transformation and Prophesy', in *Beuys Klein Rothko*, exh. cat., Anthony d'Offay Gallery, London 1987, p.17.
2 Pamela Kort, 'The Neapolitan Tetralogy: An Interview with Lucio Amelio' in Lynne Cooke and Karen Kelly (eds.), *Joseph Beuys: Arena – Where I Would Have Got if I Had Been Intelligent!*, New York 1994, p.50.
3 Seymour 1994, p.17.
4 Kort 1994, p.51.
5 For full documentation of this work see H. Bastian, 'A World almost Lost', in *Blitzschlag mit Lichtschein auf Hirsch: Lightning with Stag in its Glare 1958–1985*, Berlin 1986 [n.p.].
6 Seymour 1987, p.18.
7 Rudolf Steiner, *Appeal to the German People*, quoted in Heiner Stachelhaus, *Joseph Beuys*, trans. D. Britt, New York 1991, p.36.

following double pages: no.5

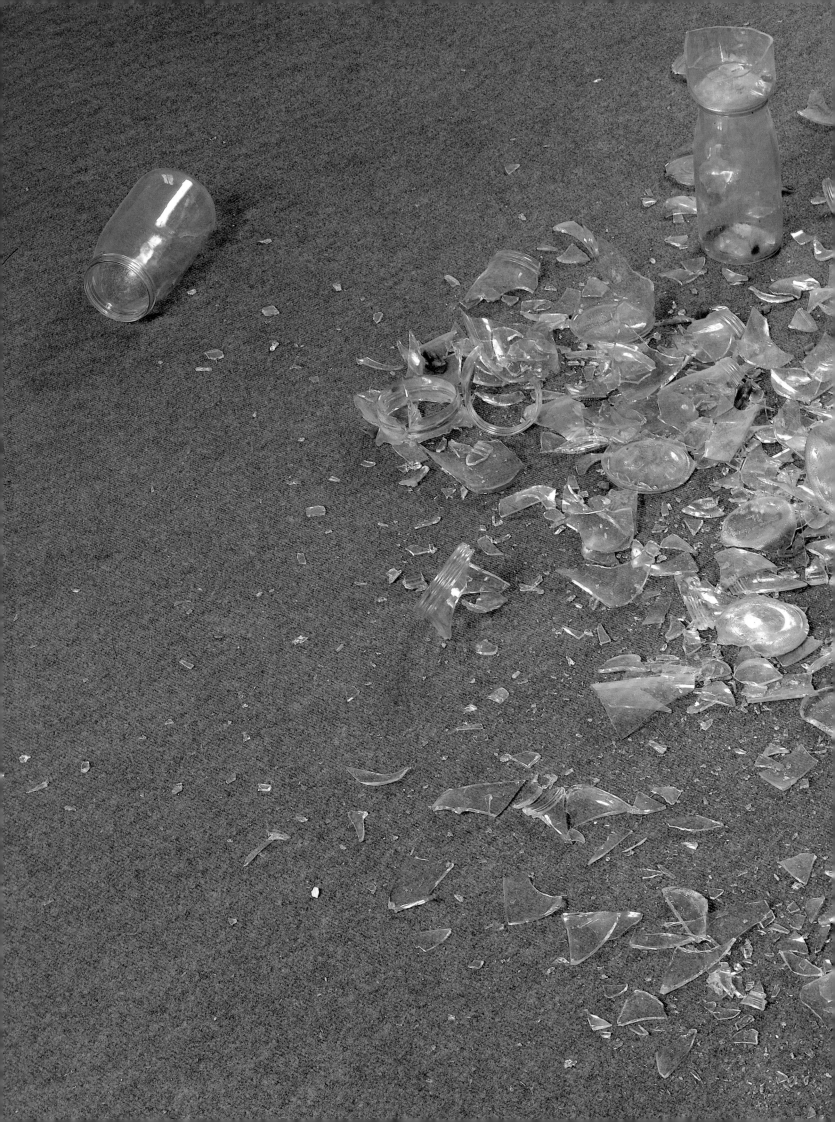

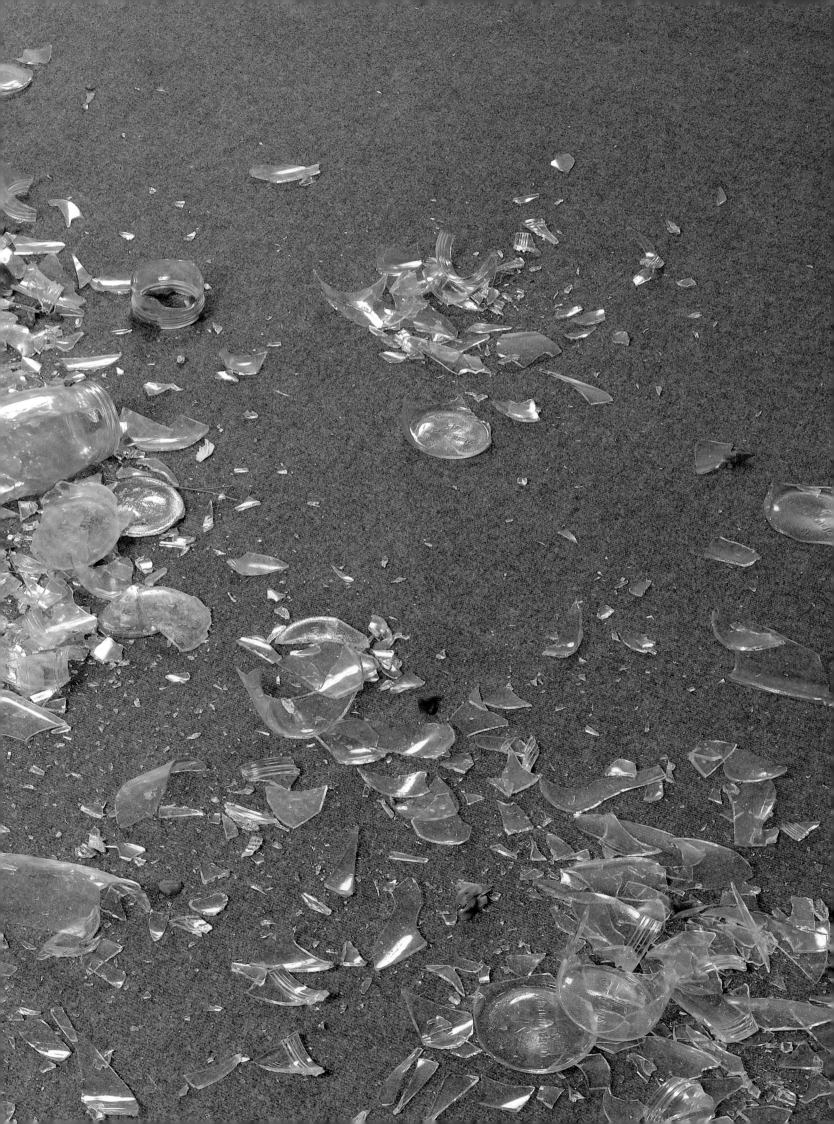

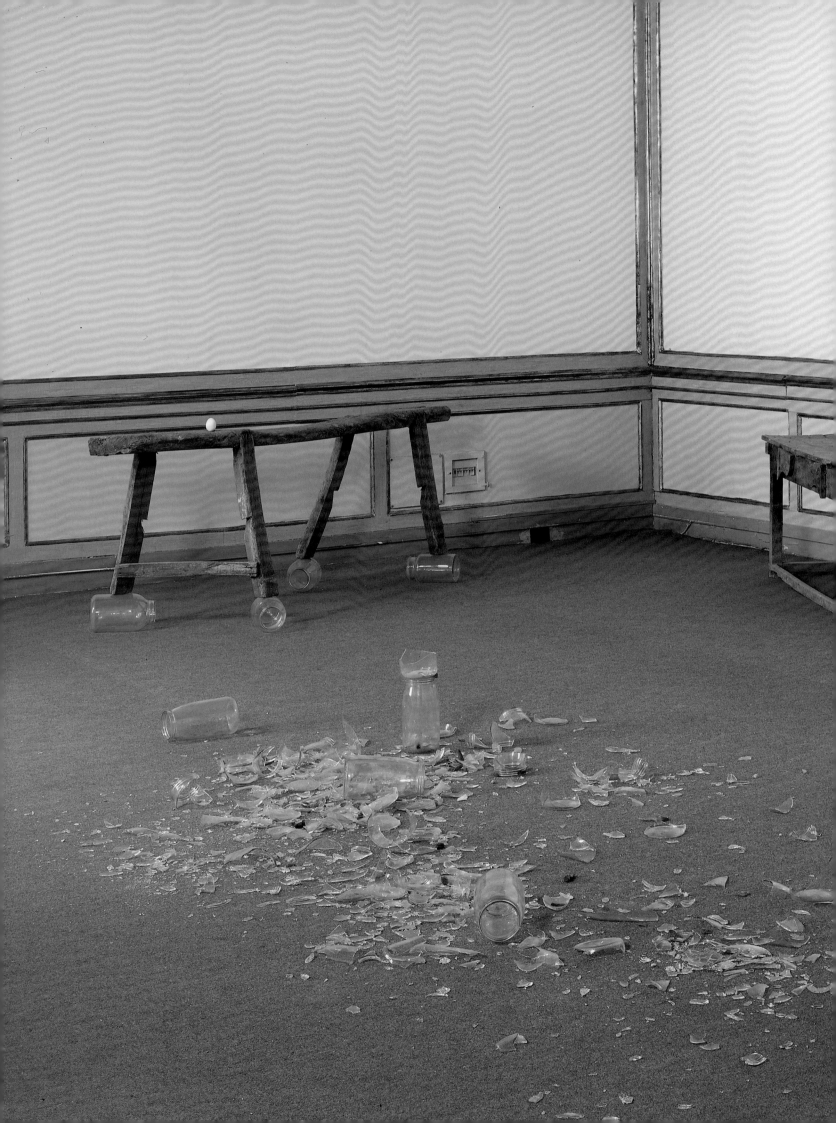

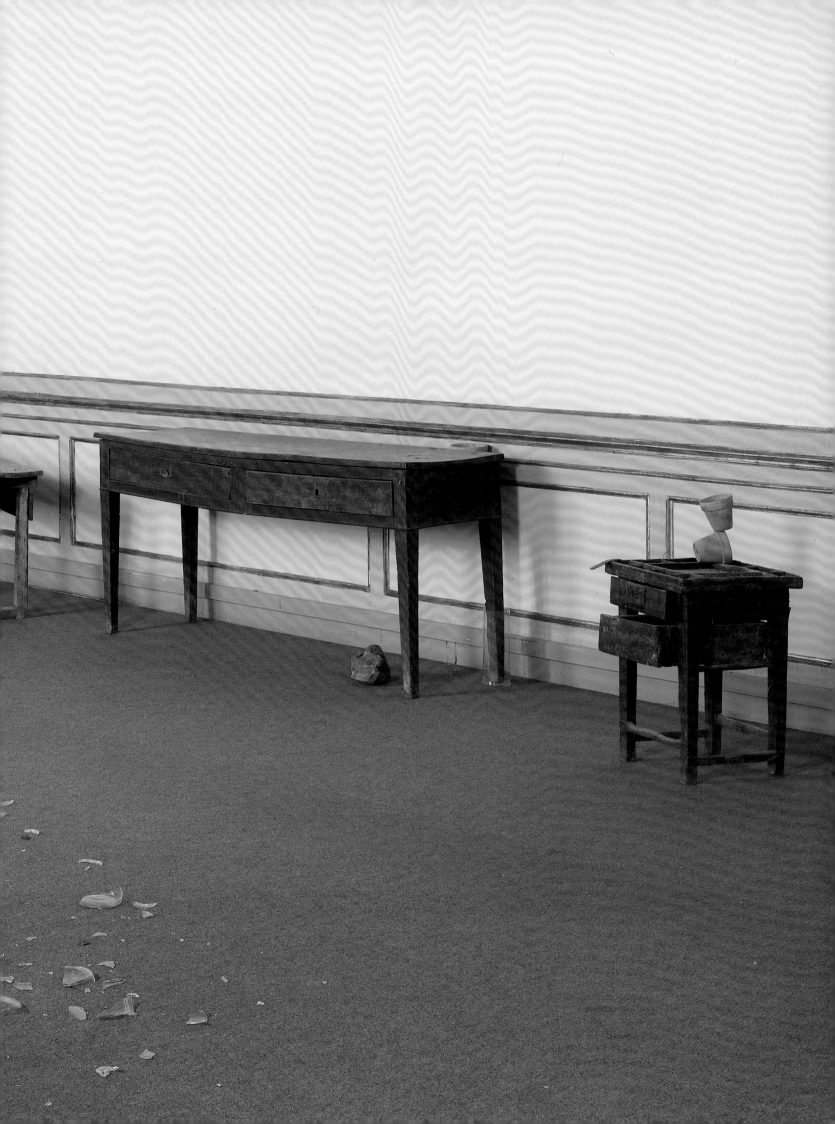

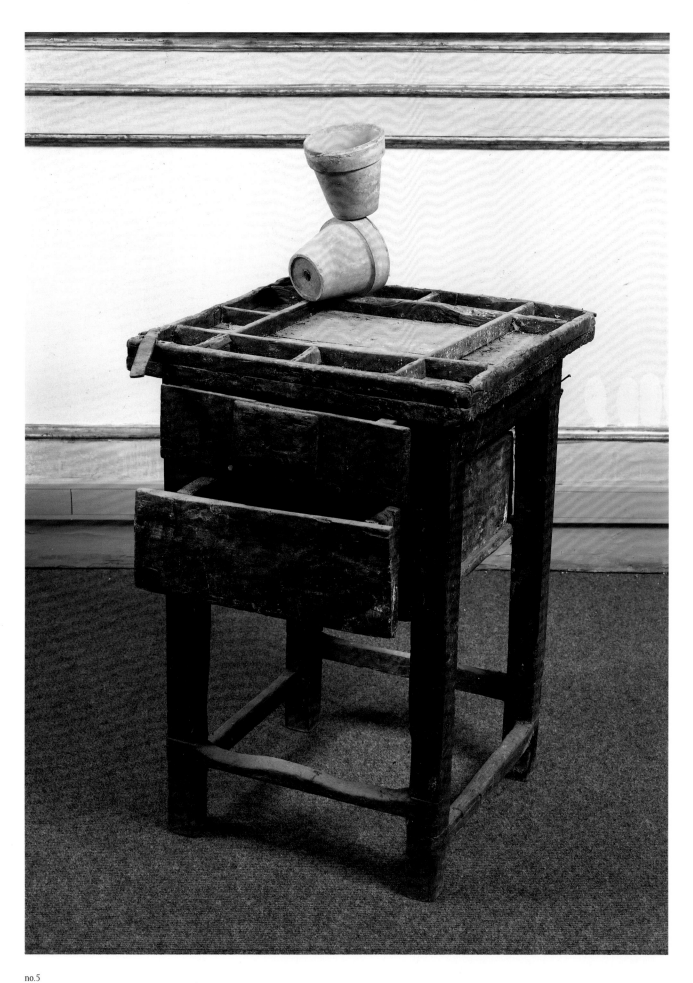

no.5

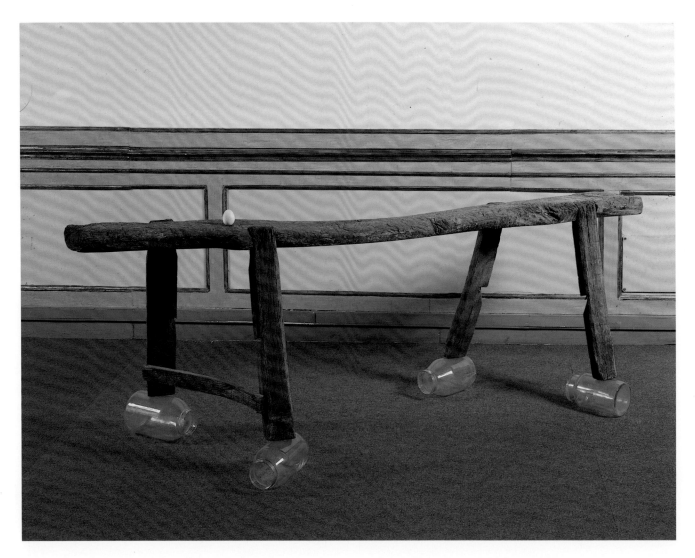

no.5

following double page: no.5

Louise Bourgeois

Art is not about art. Art is about life, and that
sums it up.

Louise Bourgeois[1]

The discovery of Louise Bourgeois is one of the oddest
events of recent years. Odd, because she had been there
all the time. And, since she talked to Constantin Bran-
cusi, knew Alberto Giacometti, organised an exhibition
with Marcel Duchamp, was a friend of Joan Miró and
lived in Isadora Duncan's house where André Breton
held his first Surrealist exhibition, the very idea of
realigning Bourgeois with art history seems imperti-
nent. Instead, what is needed in order to provide her a
place in the art-historical canon is nothing less than a
redefinition of art history itself. More confusing is Bour-
geois's abiding theme, for what she considers in her
practice is her changing position within her own history.
Perhaps the process she records is one of recovery.
(Recalling her experience as a child helping her parents
restore Gobelin tapestries, she admitted that a 'sense of
reparation is very deep within me'.[2]) Using her work in
various media to examine situations and emotions of the
present, Bourgeois returns compulsively to the past. The
result is a mending, or so she believes. 'ART IS THE
GUARANTY OF SANITY', read a band of text running
around 'Precious Liquids' 1991 (Centre Georges Pompi-
dou, Paris), a large installation in the form of an appro-
priately circular room.[3] Ironic or not, it may be true. And
for Bourgeois, sanity involves her relations with other
people. Her work achieves that communication in vari-
ous ways. Combining traditional carving methods with
text; offsetting drawing with sculpture; employing
found objects; making machines; moving into perfor-
mance; shifting from the visual to writing or simply
speaking – since her conversation has much in common
with her art – Bourgeois has become less a person than
a country, with its own language and procedures, its
semi-private sign system and topics of conversation, a
particular sophistication and naiveté, above all its own

fig.9 'Femme Maison' 1947. Ink on paper. *Solomon R. Guggenheim
Museum, New York*. Photo: David Heald © The Solomon R. Guggenheim
Foundation, New York

dark humour, based on sheer defiance. 'Truth' also
describes what she is seeking. Though Bourgeois has
admitted that she gave up studying mathematics when
she realised that there were more ways than one of prac-
tising it – suddenly, her belief in veracity had been shak-
en, never to be restored – is it truth that she wants her
work to determine? And if so, what kind?

One of the best-known images in twentieth-century
art is Bourgeois's drawing 'Femme Maison' (fig.9). A
nude woman stands facing the viewer, but from her hips
to the top of her head her body is obscured by a house;
only her arms are visible. Her right hand is waving, pos-
sibly to attract attention but more probably because she
is happy. Yet for her, happiness seems equatable with

domesticity. Perhaps the woman has settled for a male image of what women want, a stereotyped conception of her own life and, despite limitations we might regard as crippling, has contented herself with this. Or perhaps she is not as happy as she would like to pretend: not waving but drowning. Not surprisingly, when Lucy Lippard used the image for the cover of her book *From the Centre*, it became synonymous with the feminist cause. Yet despite her support for women's rights, Bourgeois's thinking cannot be summarised so tritely. In terms of her early sculpture, for example, made in New York to remind her of people she missed in Paris, the drawing could simply represent a type — in this case a house-proud person, with everything that that implies. (In 1947, she had made a different work about the same subject: a small ink drawing of a bubble shape in which four heads nestled: those of the artist and her three children.) From the same period, which she privately termed *l'époque du mal du pays* (the period of homesickness) another drawing showed two legless, torpedo-shaped figures, one struggling to escape, the other either grabbing it by the the waist and doing everything possible to prevent its flight or using the companion as a means of locomotion.[4] The result is that the combined impetus of the two has been halved. Bourgeois has often considered extremes of protection and panic, or the difficulty of negotiating a truce between freedom and dependency. Yet the general absence of bitterness or negativity in her work should always be stressed, as well as the fact that her art is neither life nor a surrogate for life but some third thing.

Thomas McEvilley has argued that Bourgeois is a mythic thinker: that just as gods and goddesses gave the Greeks and Romans models to live by, so her deification of her parents heightened their symbolic valency and their potential for good or evil.[5] Her father, for example, emerges as a bully and womaniser, always prepared to tease a daughter who would have pleased him better if she had been a boy. Yet the slowness of the cathartic process cannot be exaggerated. For example, in a public talk in the 1980s, then again in the pages of a magazine, Bourgeois revealed one fact about her early life that had never been discussed.[6] Relations between members of her family had deteriorated when her father employed an English governess called Sadie in order to teach his three children, then proceeded to conduct an affair with her under the noses of his wife and family. Retaliation was immediate; in an act of daring or folly, Madame Bour-

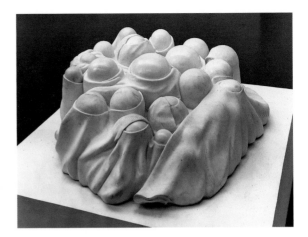

fig.10 'Cumul I' 1968. Marble. *Musée National d'Art Moderne, Centre Georges Pompidou, Paris*

geois suggested that since Sadie was such an excellent teacher and the children liked her so much, she should move into the family home. This attempt to prevent her husband's philandering failed, however; the affair continued unabated, and was guaranteed to hurt everyone except Bourgeois *père*. In a horrific installation called 'Destruction of the Father' 1974 (Robert Miller Gallery, New York) Bourgeois elaborated on this plot. In her version of events, Monsieur Bourgeois appears at the dinner table, with all the family present, is consumed instead of the meal and his bones are strewn across the floor. In one sense, this is in deadly earnest. In another, it is a piece of black humour. The two coincide, like a projection of something she dreaded but nevertheless that she willed to happen. Such emotional ju-jitsu is a staple of Bourgeois's art-making. 'Ernst Kris has written ... that inspiration is the regression of the active into the passive', she told one interviewer. 'So in admitting that we have no power, we become more than ourselves; we think in ways that the mind has no normal access to.'[7]

The dual appeal to origin and instinct aligns Bourgeois with the artists of the 1940s, the period when she moved to New York. Surprisingly, for a woman, she attended Abstract Expressionist meetings, and the radical repetition in her work recalls their use of automatism as an almost meditative practice: a way of locating a theme or of simply allowing it to emerge. It almost seems that any motif will do — cobbles, threads, grass, rain... The treatment involves a kind of passive decision-making, a subtle sense of variation. So at different times Bourgeois's fields of tumuli resemble different things. By means of near-passivity but constant, if slight alter-

ation, the surface varies as waves or weather vary and a feeling of duration is achieved. Clouds in the 'Cumul' series (fig. 10), fingers, breasts, phalli, sewing... All testify to a strong sense of reverie — in other words, permission for unconscious imagery to rise unbidden: a less poignant use of recall which relates to what Julia Kristeva has called 'women's time' as opposed to that of men. It is also spurred by memory, bearing in mind that remembering is never exact; indeed, that it differs from one moment to the next. ('As with myth, the generative principle is metamorphosis', wrote the critic Robert Storr.[8]) Bourgeois registers these changes as sensitively as a seismograph.

In recent years, Bourgeois has focused on small installations she calls 'cells', referring not only to microorganisms but also to confined spaces, like rooms in prisons or monasteries, places in which inmates consider their past lives. Shown first at the Karsten Greve

Gallery in Paris in 1992, for example, 'Bullet Hole' consisted of a set of connected black doors, some with windows, standing upright to form a circle around three large, unevenly carved balls of wood, unseasoned so that in a warm atmosphere they might sprout mushrooms. The three elements lay on the floor in a triangle, just touching each other: an elementary family group but with something badly wrong, as the bullet hole in one of the windows suggested. In addition, there were shutters which could be opened and closed, with words on them. 'LOVE MAKES THE WORLD GO ROUND', one stated. 'WHAT MAKES *YOUR* WORLD GO ROUND?' asked the other. However, this sinister but also almost comic aspect of Bourgeois's thinking is countered by another — shrill, passionate, unbridled: 'Cell (Arch of Hysteria)' from 1992–3 (fig. 11) in which the 'arch' in question is the arched back of a slim, male figure on a bed covered with writing — the words '*Je t'aime*' written

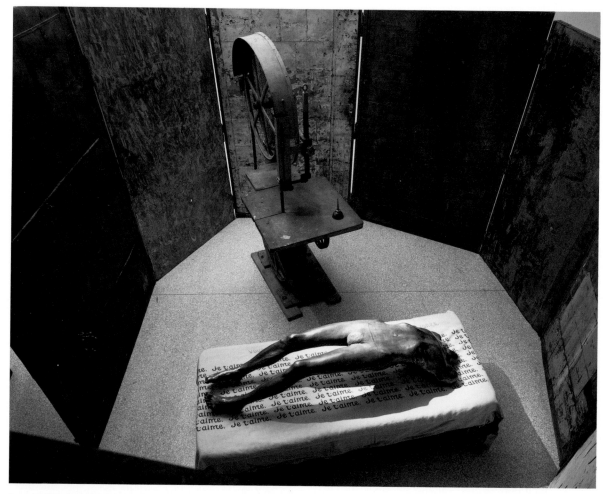

fig. 11 'Cell (Arch of Hysteria)' 1992–3. Steel, bronze, cast iron and fabric.
Courtesy Robert Miller Gallery, New York

over and over again — and opposite it an apparently lethal industrial sewing-machine or saw into which the suffering body will be fed. Who feels what for whom matters less than the accuracy of the portrayal of obsession, a state in which love and hate, self-love and self-loathing, are aligned and one figure is tortured without mercy. For any lover, response from the object of desire is tantamount to a serious offence. Little wonder that this tableau resembles a small, private version of one of the circles of Dante's Hell.

Bourgeois once described her *personnage* sculptures as 'a tangible way of recreating a missed past'.[9] The same principle could apply to the 'Red Rooms', two adjacent cells that correspond to spaces from Bourgeois' childhood: her own bedroom and that of her parents (nos.7–8). The spaces are psychological as well as actual; the sheer proximity of the two kinds of intimacy that bedrooms imply — carnal and innocent — and the impossibility of fathoming grown-up behaviour has provided the basis for spatial decision-making. What cannot be seen is crucial. Redness suffuses the two cells: the colour of blood, the heat of passion. (Still, Bourgeois covers entire surfaces with the litany *Je t'aime*, words which acquire a quite separate significance according to who is writing or speaking, and whose viewpoint is being represented.) Circularity governs the child's space: her time can be measured by spooled thread, whole trees of it still to be unravelled and spun. (Only with 'Woman in the Shape of a Shuttle', the fruit of her *personnage* sculptures, was Bourgeois able to confront the Penelope comparison.) Vermilion glassware billows like clouds or desert storms, enclosing nothing. For in this room things are either empty or are waiting to acquire significance. Bourgeois has called her cells 'lairs'. And indeed, bedrooms are places for temporary privacy, anticipation and planning — least of all, perhaps, sleep. (For sleep there is a nightlight ominously similar to a ship's lantern, harbinger of emotional tempests.) How different from the parents' room: orderly, resolved, with secrets well hidden and a choice between verticality and horizontality as governing principle. Here rites of passage involve physical separation which contrasts sharply with the warmth and safety of the parental bed.

Stuart Morgan

Notes

1 Donald Kuspit, 'An Interview with Louise Bourgeois', in *Bourgeois*, New York 1988, p.81.
2 Christiane Meyer-Thoss, '"I Am a Woman with no Secrets"': Statements by Louise Bourgeois', *Parkett*, no.27, 1991, p.45.
3 For a more detailed description of this work, see the present author's 'Body Language', *Frieze*, no.6, Sept./Oct. 1992, p.34.
4 Alain Kirili, 'The Passion for Sculpture: A Conversation with Louise Bourgeois', *Arts Magazine,* March 1959, p.69.
5 Thomas McEvilley, 'Geschichte und Vorgeschichte in Louise Bourgeois' Werk', in Peter Weiermair (ed.), *Louise Bourgeois,* Frankfurt 1989, pp.31–9.
6 Louise Bourgeois, 'Child Abuse', *Artforum*, no.21, Dec. 1982, pp.40–7.
7 Stuart Morgan, 'Taking Cover', *Artscribe International,* Jan./Feb. 1988, p.30. (In the original, taped interview, Bourgeois even remembered the page number on her edition of Kris's book.)
8 Robert Storr, 'Louise Bourgeois: Gender and Possession', *Art in America*, April 1983, p.136.
9 Susi Bloch, 'An Interview with Louise Bourgeois', *Art Journal*, vol.35, no.4, Summer 1976, p.372.

'Red Rooms' 1994 Installation

opposite: no.8

following double page: no.7

no.10

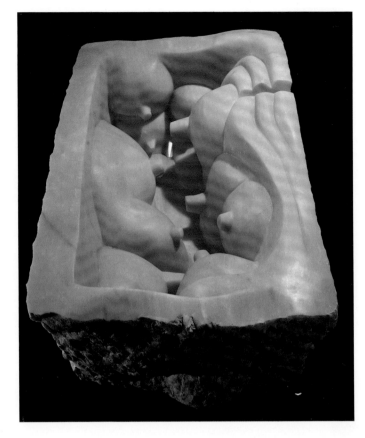

no.9

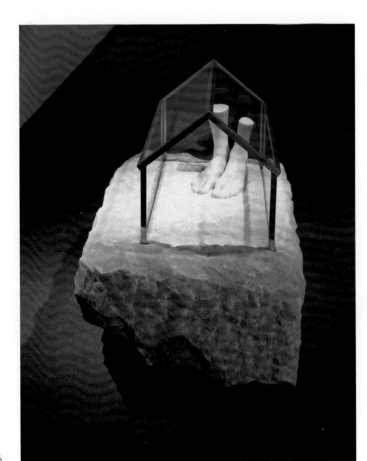

no.6

Hamad Butt

Alchemy offers the antithesis of science: a voyage of the subject into itself.

Hamad Butt, 'Indications'[1]

Entering Hamad Butt's degree exhibition in 1990 at Goldsmiths' College, London, visitors encountered a room within a room. Through a rectangle of stretched white fabric an unearthly light could be seen. Finding a way in, they were subjected to the glare from a circle of bookrests on the floor, each with its own ultra-violet light. The pages of the books they supported were made of glass. Closer inspection revealed that though each book was open at a different place, the same motif, etched into the glass, could always be discerned on one of the pages, giving the impression that the image was constantly rising to the surface and disappearing again. Borrowed from the cover of John Wyndham's novel *The Day of the Triffids* (1951), the motif was a single triffid, a monster bulbous at one end but with a lithe, delving proboscis at the other, its entire outline resembling a giant onion or a cartoon of a mobile penis and scrotum ready to attack the unwary. With all the power of an obscene graffito in a public place – on their second showing in a building in Great Russell Street in London, the circle of books, each with its own light, seemed to refer directly to the low lecterns in the circular Reading Room at the nearby British Museum – the image haunted the installation, to which Butt had given an unexpected title. It was called 'Transmission' (fig.12).

Despite a deep respect for reason, Butt was determined to interrogate the power of the intellect. Nevertheless, his mixture of arcana and popular culture and his suggestion of the overthrow of learning by a malign, though half-comic cartoon figure seemed in deadly earnest. This was an artist calling for nothing less than a revision of the conventional view of scientific knowledge: for what he called 'a critique of the institution of science as, somehow, especially truthful' and a shift to what he described as 'speculative science practice'. In

titling his unpublished essay 'Apprehensions', he was making full use of the different meanings of the word: not only 'concepts' or 'ideas' but also acts of seizure or arrest, or fears of what might happen. The order of the chapter headings suggested a story of vulnerability, worry and finally seduction by an alien body resulting in flight or truce: 'Apprehensions', 'Stress', 'Regard', 'Scream', 'Familiar', 'Subjection', 'Triffid', 'Fluid', and 'Strategic Withdrawal' (with the *double entendre* that that implies). In short, the covert narrative ran parallel to the plot of *The Triffids* or indeed any work of horror, triggered by 'Something from outside, an unforeseen, dangerous event that takes us by surprise, frightens us', as Butt described it in 'Apprehensions'.

The choice of a science-fiction framework was deliberate, a way of distancing the issue for long enough to grasp it. Indeed, 'grasping' an argument is compared not one but three times, each funnier than the last, to grabbing another man's genitals, a gesture emphasised by three diagrams of physical reactions to fear, all more than slightly suggestive. For 'Apprehensions' can be taken too literally. Essentially, the text constitutes an investigation into the power of language itself: what can be said, where and how. One other important function of the essay was autobiographical: as an act of owning up, 'coming out' – in literary terms, at least – satisfying the usual desire of biographers to correct previous misrepresentations. Yet in Butt's case, the only incontrovertible element was his own textual advent, and apart from the jokes, everything else lay in fictional penumbra. Butt described the 'apprehensive quality of apprehending' as 'a point of extreme readiness' which could indicate one of two states. 'Apprehension is not comprehension but slides into that realm by the conviction (the call to order in court) of the grasp: the palpable "laying hold of" that can indicate understanding as it indicates fear.' Here, as often in Butt's work, the underlying theme is seduction, with all its attendant pleasures and pitfalls, for both possibilities include being 'apprehended' by the police. The

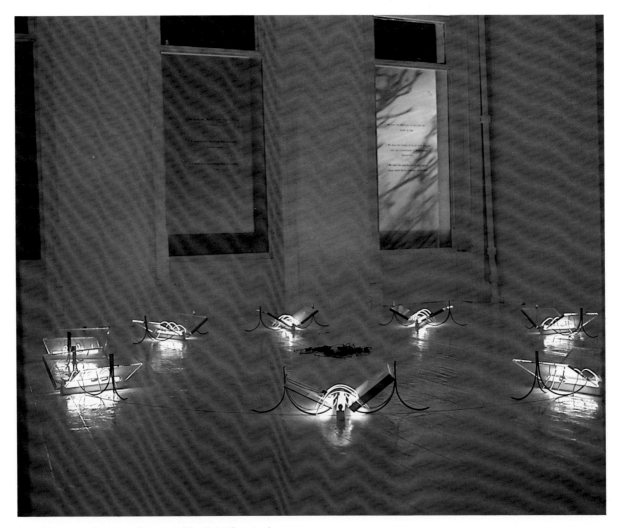

fig.12 'Transmission' 1990. Installation at Goldsmiths' College, London.
Jamal Butt

potential damage to the eyes of reading by ultra-violet light, a danger offset by the fascination of what is seen, turned into a more literal threat in his next work, again inspired by the unknown.

Preliminary experiments, carried out with the help of Dr Garry Rumbles at University College London, established the point at which iodine vaporised. (Later, Butt would take pride in the fact that the problem of the exact vaporisation point had since been included in physics examinations.) Butt had decided to address Conceptual art in physical terms. Properties of matter began to concern him, and he planned three sculptures, called 'Familiars'. As a design for the invitation to the opening he chose an old print of an alembic (fig.13), the furnace alchemists used for purification, an indication that the trio of sculptures which comprised the work refer to his previous experiments, and that the art he was seeking to

make was situated on a cusp. That the cusp was historical seemed to indicate either that contemporary medicine had reached a position of stasis or that it was at a point where anachronism – if only terminological anachronism – could help, or that the point at which the physical aspect of healing gave way to the spiritual was long overdue. At exactly that point, alchemy becomes relevant.

Though its roots, like Butt's, were Muslim, by the sixteenth-century alchemy was considered a Christian practice. Often, however, it was mistaken for heresy – partly, perhaps, because of the secrecy of its practitioners, often men of noble birth who worked in private. Later, when its terminology had become heavily coded and its imagery overly complex, it was ousted by the new scientific spirit. Yet there was a period when both existed at once. (We now know, for example, that Isaac

Newton decided to destroy all record of his decades of alchemical experiment before becoming president of the Royal Society.) In the twentieth century, its most famous adherent was Marcel Duchamp, whose knowledge of alchemic symbolism seems to have been detailed and far-reaching. Duchamp cannot have escaped notice by Butt, whose reaction to the art of the late 1960s and early 1970s was to take the fundamental division on which it rested – that between 'matter' and 'immateriality', or 'object' and 'idea' – and to regard these pairs not as exact opposites but as points on a spectrum of alternatives. This was not academic obfuscation; it depended on the evidence of the eye and the properties of matter. And for 'Familiars', his final work, Butt referred directly to alchemy, a means of bringing about a change of state.

Concentrating on the family of halogens – iodine, bromine and chlorine – and putting them on display in ways which emphasised their natural instability, meant that Butt was taking very real risks. As if inviting participation, giant glass bubbles containing deadly chlorine gas were suspended from the ceiling in sets that resembled Newton's Cradle, the executive toy of the 1980s ('Cradle', no.13), while inside a glass ladder crystals of iodine were heated very slightly and transformed into a gas ('Substance Sublimation Unit', no.11). The bromine was housed in a structure reminiscent of 1950s' science fiction ('Hypostasis', no.12). The title 'Familiars' not only indicates that these elements belong to the same family; it is also the correct term to describe the spirits that accompany witches and do their bidding, sometimes in one form, sometimes another. The word has other meanings, however: 'sexually intimate' is one, 'unceremonious' or 'excessively informal' is another. And an unattributed quotation in Butt's statement about the work reads 'The triumph over melancholy consists as much in the constitution of a symbolic family ... as in the construction of a symbolic object.' Butt's symbolic family consisted of bromine (from *bromos* or 'stink'), chlorine (potentially lethal) and iodine (which when heated becomes a purple gas) and the role of his 'metachemics' (which is to chemistry what metaphysics is to physics) is to 'consider the apprehensions that inform the extent of our acknowledgement of substance'.

By now there were signs that Butt's attitude had changed since the period of 'Apprehensions'. By acknowledging his physical existence in distinctly medieval terms – he quotes the testimony on a tombstone in the church of the Salvatore in Rome: 'I have been

fig. 13 Hieronymus Brunschweig, *Liber de arte Distallandi de Compositis* (1512), f.22v, distillation over a water bath. Image used for the invitation to the opening of *Familiars* at Milch, London 1994

shameful sperm, I have lived as the home of murky dung; in this place I live as food for worms' – Butt was also opening the way to refinement and a bestowal of grace. (What, after all, is a 'Substance Sublimation Unit' but death with a blessing?) The iodine section, 'a broken line which hyphenates the floor and the ceiling', refers to what Johannes Climacus, the Abbot of Mt Sinai, Venice, called in 1570 the 'Santa Scala'; 'That is, the holy ladder to perfection that necessitates abjection of the body'. And, Butt adds in true Duchampian manner, 'Ascension by these means relies on the lightness of regard over the material world.' Was 'lightness of regard' what Butt loved about Pakeezah, the Indian film star, who in one of her roles danced on broken glass? Or was it what he himself was practising when he sent postcards to friends with rows of lines he had drawn as, or instead of, messages?

The philosopher Blaise Pascal called Man 'the glory and scum of the world'. The image of the pot-bellied still that Butt used on the invitation card could be seen as a means of separating the scum from the glory, or perhaps of refining the scum. It was no accident that, once more, it bore a suspicious resemblance to a cartoon version of male genitalia, no less sensuous for being made out of bricks, like a prison denying sensuality while celebrating it, or like a cartoon of a Freudian slip – and in passing a hint that the row of gorgeous dangling baubles invited stroking and perhaps even rougher play, despite the lethal gas that they contained. By this time Butt's art had become, among other things, a meditation on his own medical status, which was to change so quickly from HIV positive to Aids. He recognised only too well that others might choose to ignore this as a factor that subtly altered or even determined the meaning of everything he had done. To him, the artist as alchemist or witch lived in daily contact with an adopted family of shapechangers, like those triffids who looked like children's toys but who might nevertheless overwhelm the earth, and who had a decided advantage over us in their ability to move between various states of matter, like mythical beings or cartoon super-heroes. Understandably, Butt was keener than ever to parley with them and to negotiate terms.

Butt leaves his viewer in no doubt about the rapture of the sexual act. That 'point of extreme readiness' that he describes surfaces everywhere in the work, informed as it is by inquisitiveness as well as by childlike appetite and wonder. Indeed, despite its dangers, belief in sensu-

al curiosity was one of Butt's abiding themes – so much so, indeed, that his constant lightness of touch can become intolerable and, for his viewers or readers, may appear unbearably stoic. After his partner Nick died of Aids and he himself had been diagnosed, Butt felt forced to reconsider the motives for making art. Chief among these, he decided, was as a defence against the prospect of death. 'There is acknowledgement of loss and the numbness of its repetition,' he wrote, 'which moves us in particular to displace fear with some charming dialogue, an ungraspable sleight of hand.'

Stuart Morgan

Note

1 Quotations are from 'Indications' and 'Apprehensions', unpublished writings by Hamad Butt.

following double page: no.13

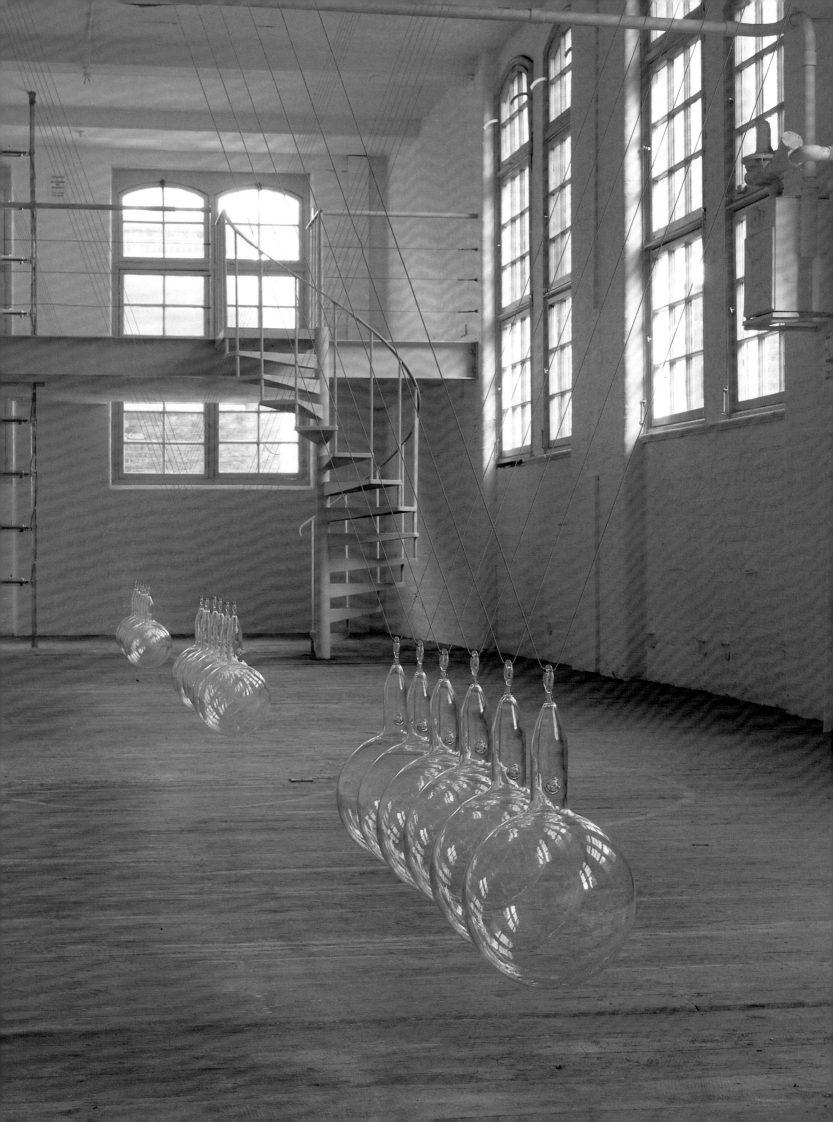

no.13

no.12

71

no.11

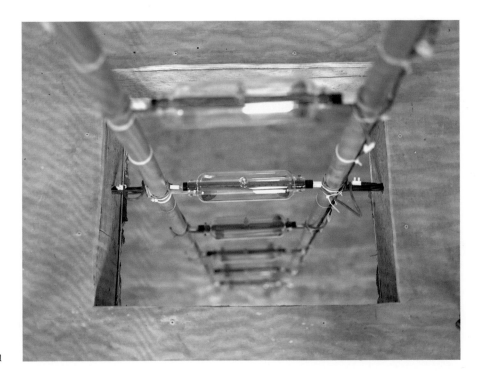

no.11

John Coplans

'A mass of naked figures does not move us to empathy but to disillusion and dismay'.[1] So argued Kenneth Clark in his much revered but equally contested study of *The Nude*. Clark's distinction between the naked and the nude was based on his understanding of the idealising tendency in Greek art, which, between 480 and 440 BC, created a model of physical perfection that was handed down to the Renaissance and on into our own century.

John Coplans's most recent self-portrait photographs unwittingly provide a direct challenge to Clark's view. Naked indeed they are, and in place of the marmoreal surfaces and ideal proportions of the Greek athlete so admired by Clark, Coplans's images parade the profoundly hirsute flesh of an elderly white Anglo-Saxon male body: his own. But although outside the tradition that Clark elaborately constructed, Coplans maintains an ongoing dialogue with that tradition. His most recent work is a wickedly inventive subversion of the Classical frieze. Peopled by characters drawn from art and life and articulated by Coplans through the vivid language of his body, the work contains nothing either to disillusion or dismay. Instead there is a kind of burlesque humour that moves its audience – or at least those willing to be moved – to the contemplation of greater truths and darker realms.

John Coplans began experimenting with photography in the late 1970s, at an age when most people would be contemplating the prospect of retirement. To enter the creative arena at this age, following an extensive career as critic and curator, might seem either an act of extreme bravery or folly. In fact for Coplans this was a return to making art, because it was as a British-born painter, working under the influence of the post-war New York school, that he arrived in the United States in 1960. Swiftly disillusioned with New York, he travelled west and settled in San Francisco. Coplans stopped painting in 1963 following his exhibition ('a kind of hard-edged painting, derived from Newman and Rothko'[2]) at the De

fig.14 'Self-Portrait' 1988. Silver gelatin print.
Marc Jancou, London Projects

Young Museum. He spent the next two decades absorbed in the art world, through *Artforum* which he helped Phillip Leider set up in 1962 and which he edited from 1972 to 1977. He was also active as a curator, directing the Museum of Pasadena from 1967 to 1970 and the Museum of Akron, Ohio, from 1977 to 1979.

Despite the zeal with which Coplans involved himself in new developments in art, he continued to feel distanced from, if not actually outside, the American art scene. Perhaps this was because he was never totally convinced by any of the art he saw being made around him. Coplans would have no truck with dogma and was reluctant to involve himself in the critical debates that so marked the 1960s in the United States. His extensive writings tend to concentrate on the singularity of individuals rather than their position relative to any critical notions of group practice or shared theory. Throughout the period – apart his very close friendship with the artist Robert Smithson up until Smithson's tragic death in 1973 – his deepest intellectual and emotional alle-

fig.15 'Self-Portrait (Feet, Frontal)' 1984 from *A Body of Work* (1987). Silver gelatin print. *Tate Gallery*

giance remained towards Abstract Expressionism, the art that had most inspired him as a young painter.

Coplans was aware of the increasing commercialisation of the American art scene and the distorting effect this had on both the production and consumption of art. By the late 1970s it was, in his opinion, no longer possible to operate, even as a critic, at a safe distance from the influence of the market place. Ironically, rather than leaving the art world he decided to become yet deeper embroiled, as practitioner once again rather than preacher. To return to his position of the 1960s, that is to return to painting, was unthinkable after his years of digesting art as critic and curator. As he explains: 'I was a composite personality without identity. The nature of my composite personality would not be able to find itself through the formal qualities of advanced American painting, abstract painting, so I decided that photography was the medium to try, another medium. It is a medium to build an identity out of a composite personality, to find an artistic identity.'[3]

Coplans first photographed his own, naked, body while still working as Director of the Akron Art Museum. Putting on one side this initiative, which he considered as interesting but a little curious, he experimented with more recognised forms of photographic practice. In the absence of any real feel for conventional genres, however, he returned decisively to his body as subject in 1984.

Coplans was apparently never interested in exploring the intrinsic properties of the medium. Yet he was aware of his own need to find a theoretical base, something to underpin a way of working that was, he realised, essentially intuitive. The base that he eventually constructed brought together his passions: for Abstract Expressionism, for many forms of primitive art, for African culture; it reflected his intellectual curiosity for art, literature, history, psychoanalysis, and so on. What Coplans discerned as threading its way through these seemingly eclectic discourses was a notion of the 'primordial'. The term primordial refers to things that exist at the very beginning of time, but it also encompasses things that are elementary or fundamental. Primordial are the things that link cultures across and through time and which make it possible to speak of universal human experiences. Right from the outset Coplans understood the idea of the primordial as being as much about now as about the ancient world. He had, after all, arrived at his understanding through thinking about Abstract Expressionism: 'In working my way through Abstract Expressionism, I was aware of its roots in primitivism. Several books I read when I went to America were not really available in Europe, like Robert Goldwater's *Primitivism in Modern Art*. The idea of the primordial and its links to Freud and Jung, was absolutely embedded in Abstract Expressionism. Think of the sand paintings of Pollock.'[4] Coplans was not interested in the surface of the primitive – the way, for example, European artists like Picasso and Gauguin made primitive-looking objects – but rather in the spirit of the primitive and its role in an ongoing evolutionary process. He pointed to the way in which Americans like Newman and Rothko conceived the primitive as 'being in touch genetically with the inheritance of mankind as an inner thing, something that we all have within. The genetic code has a memory embedded in it, a memory of our past ancestry. So when I began those photographs, I was very interested in this idea of genetic memory.'[5]

Coplans's first group of photographs was published

under the title *A Body of Work* (1987) (figs. 15, 16). The images tease the memory as Coplans parodies the past with both gravitas and humour. Thus a pair of feet on tiptoes positioned symmetrically and in parallel, in a hieratic style, are at the same time both feet and a pair of Egyptian figures guarding the entrance to a tomb. In recent years photography has frequently been used by artists as a way of quoting from art history, of conjuring up a fictional identity or inventing multiple identities. For Coplans it is largely a matter of locating a universal identity, and a universal human experience, working through our genetic memory. Following *A Body of Work* Coplans made two further series of images in which he confined himself to exploring single parts of the body. In *Hand* (1988) and *Foot* (1989) he set out to maximise the expressive possibilities within a single motif, by isolating it from the limitations of gesture and pose which communicate a message or recall or evoke other things. Coplans saw these single motif projects as owing some of their formal strength (derived from 'isolation, magnification, and framing') to the conventions of 'one-shot' imagery in modern American painting, exemplified in the work of Ellsworth Kelly (on whom Coplans wrote a monograph in 1973). The hand or the foot enabled Coplans to have a less personal presence in the work. In his explanatory note published in conjunction with *Hand*, Coplans explained that 'The hand in this kind of imagistic isolation becomes like a body part rorschach, a free-floating signifier that allows each viewer individual interpretive reading, particularly as narrative in the form of recognisable sign language is suppressed or avoided. The hand thereby becomes a text capable of many and complex interpretations, an agent of evocation, and a malleable instrument of performance with an ever-expanding level of possible meanings.'[6]

With a slight shift in emphasis Coplans then began to experiment with sequential montage, a form of composition he continues to use. He has described this development as to do with his interest in 'the difference between seeing and naming.'[7] The recent montage works are about seeing, about the mechanics of perception, and are based on the fact that what one sees is infinitely richer and more complex than what one can describe verbally. As in his first thrust into photography, the impetus came from his understanding of the primitive: 'It was the idea of the collective unconscious that led me into perception. Perception is an equally collective trait built into

humans. Through perception they build up their consciousness of the world.'[8]

These composite works, of which the recent 'Frieze' series (nos. 16–21) are perhaps the most ambitious, are works which the eye must scan: not only do we see things as we have not seen them before, we also become aware of the mechanism of seeing itself. The challenge, as Coplans would have it, is to bridge the gap – or rather to make us aware of the gap – between really looking at an object, full of perceptual ambiguities and discordances, and merely optically triggering the naming process.

None of this should obscure the fact that Coplans, examining his naked body through the camera's lens, works intuitively, and that when he speaks about perception or about the primitive it is expressed through the vehicle of his own flesh and blood. Coplans believes that the search for expression, for metaphor, is intuitive, and where a reference to past art is made it is done so and is registered intuitively, because art is a resource or 'inheritance … available to anyone and everyone'.[9] Part of the body's expressiveness obviously lies in this inheritance, the way it can be made to speak of generations, of genes. This is not only because of the way Coplans allows the body to reference the past; it is also because the naked body, stripped of its face and clothing, loses the signifiers of class, culture and era.

But the body undoubtedly speaks as much of the future as of the past. Coplans's works are *memento mori* in the traditional sense, in that they are images which remind us of our own mortality. Divested of his personal features his flesh becomes our flesh, his age becomes our own age. In a social context of youth and uncompromised beauty Coplans addresses a taboo; if there is a 'political' agenda to his work it lies here. According to Coplans, 'These photographs refer to "body politics" in the sense that "oldness" is a taboo in American society, which tends to worship beauty and youth, consequently the aging of old bodies must be hidden from view, for they are imperfect, very often diseased and soon perish.'[10]

The cult of youth and beauty, of physical perfection as a paradigm of social well-being, is something that reaches back to Greek art and society. As Kenneth Clark rightly argues, 'The Greeks attached great importance to their nakedness'.[11] So too does John Coplans, but in place of the idealising vision of the Greeks which under-

fig.16 'Self-Portrait (Torso Front)' 1984 from *A Body of Work* (1987).
Silver gelatin print. *Marc Jancou, London Projects*

pins modern Western art we find, in Coplans's work, the scrutiny of our time. Coplans is not alone in turning to the body for metaphors appropriate to our age, to exploring 'identity and anxiety'.[12] However, unlike a younger generation who are using the body as site and subject, Coplans is not really interested in parading the assaults and dislocations of late twentieth-century humanity, be they psychological, sexual, social or political. Coplans's ambitions transcend the fractured body politic. Instead, his purview is the individual as embodied time and experience, both in its own right and as just one in a vast human continuum. His is a nakedness we all share.

Frances Morris

Notes

1 Kenneth Clark, *The Nude*, 4th ed. 1960, p.4.
2 John Coplans, interview by Jean-François Chevrier, *Another Objectivity*, exh. cat., Centre National des Arts Plastiques, Paris 1989, p.99.
3 Ibid.
4 Ibid., p.95.
5 Ibid.
6 John Coplans, *Hand*, New York 1988.
7 John Coplans, interviewed by Jean-François Chevrier in *John Coplans*, exh. cat., Galeries Lelong, New York 1991, p.6.
8 Ibid.
9 John Coplans, artist's statement in *Nude, Naked, Stripped*, exh. cat., Hayden Gallery, List Visual Arts Centre, MIT, Massachusetts 1986, p.34.
10 Ibid.
11 Clark 1960, p.20.
12 John Coplans, Massachusetts 1986, p.34.

no.14

no.15

no.16

no.18

no.17

no.19

no.20

no.21

Pepe Espaliú

I have long had an *entente cordiale* with death.
 Pepe Espaliú[1]

Art, said Pepe Espaliú, moves from the complex to the simple. Not surprisingly, his own works used minimal means to achieve maximum significance. Like parables, they offered a variety of readings and existed to instil wisdom, however indirectly. In addition, the high level of coding in Espaliú's work suggested not only that his art was based on personal experience, but also that it served to examine meaning in general. Underlying this was a subtle intelligence and his view of himself as an avant-gardist with a classical outlook.

In 1987 Espaliú painted a self-portrait. In front of a curtain two hands appeared – one masculine, one feminine – each challenging and challenged by the other, each superimposed with half an image of a broken vase, its adjacent parts bearing positive and negative silhouettes of a single face. Panicked, the female hand remained itself, pallid in comparison with its male counterpart, which had absorbed both the colours and pattern of the curtain behind it and was recoiling in alarm. That the artist's idea that his own self-image depended on a balance between male and female stereotypes was confirmed by ambiguous references in another painting, 'Glove-making (for Javier B.)' of 1988, featuring on the right a neat glove like a sewing pattern and on the left that same shape dissolving or bursting into flames. Play of language – deaf signing – and language within language, perhaps a message to a friend, above all the shadowy presence of the artist himself, hovering over his own work instead of inhabiting it, seemed essential to Espaliú's sense of self-definition. A favourite childhood photograph was of himself riding: 'an adolescent dream of power'[2] or a token of aloofness or self-protection. In other ways Espaliú was not a loner, however; even early in his career his plans involved other people. Exhibitions he organised at La Máquina Española, for example, presented work by artists unfamiliar to Spanish viewers,

such as Louise Bourgeois, Meret Oppenheim, the neglected Catalan Joan Brossa or the Belgian Surrealist Marcel Mariën, and collaborations with other artists took place throughout his career.

'Self-Portrait' is a study in absence. 'For me,' Espaliú explained, 'the subject of the picture is the empty space between the two hands. You define yourself according to what is not inside you.' (The sexual connotations of this remark should not be overlooked.) But what could be done about this absence? To the question 'When *do* people pray?', he replied 'When they are lacking something. When they are unfulfilled.' Who could satisfy the lack they were feeling? 'No-one at all. They say it is justifiable for mental patients to talk to themselves because there is no answer to what they are saying.' Not surprisingly, anticipation, prayer and loneliness loom large in Espaliú's work. While studying the *Mystic Odes* or *Rubaiyats* of the thirteenth-century Persian Sufi poet Jala-ad-Din ar-Rūmi, poems mourning the loss of his friend Shams Tabrizim which rely on the belief that moods of vivid longing or lack can be eased only by repetition of the terms of that lack, Espaliú was reminded of a television series about conjuring that he had seen as a child. 'Two hands would appear at the beginning,' he recalled, 'and the titles of the programme would be spelled out in the empty space between them', an experience referred to in 'Self-Portrait'. Yet Espaliú laid particular stress on the meaning of 'conjure'. For him the sense of trickery was never in doubt. Cards, of course, are used not only for playing games but also as the props for conjurors. Both highly conventionalised, games and conjuring demand such constant repetition that repetition itself acquires ritual significance. Asked whether his art was a form of invocation, Espaliú replied 'That would be the wrong metaphor. Freud wrote about babies playing the game of *fort/ da*, the cotton reel which the mother has but refuses to give back. So the words *fort* and *da* become a kind of demand.'

Secrecy was crucial, and a recurrent idea in his work

is that of absence. In 1988, for example, he drew and constructed hollow structures, made first out of cloth, then leather, cut and stitched by Cordoban craftsmen. 'Concealment is necessary in order to attract,' Espaliú declared, 'for attraction is based on emptiness. Because sculptures are looking for a way of getting something, they go on insisting despite the fact that they are defeated every time. Sometimes they even forget why they began the fight; the aim no longer exists, only the insistence on that aim, which is an emptiness.' One major influence was Jean Genet. 'Genet is a kind of shaman. He brought together things that everybody feels but which no-one dares to admit. Which is a way of saying he is forbidden … His work is about glory. I feel that glory can be touched, if only tangentially and by haphazard means. In Genet's case, it could simply have been by reading Corneille's *Le Cid* at the age of fourteen. For other artists and writers, it could be something else. Shapes and forms are rhetorical. (That is not meant to sound pejorative.)' Invited to demonstrate proof of glory, Espaliú replied 'Even without proof, it is still evident. In theology, it is the only support for faith. God is because He is.' The basis of this theory demanded his espousal of another tradition entirely: one branch of literary Modernism in which self-destruction was aligned with success, artistic or otherwise. For him, a fascination with artistic self-destructiveness, the convergence of the production of art and the artist's death wish provided a sign beneath which it was possible to invoke 'the type of psychosis that makes you do only the things you are afraid of'.

His 'Santos' or 'Saints' resembled the tribal African objects that Espaliú admired; somehow their purpose had been lost (fig.17). Asked why he chose leather, he replied 'I wanted to give the idea that sometimes these objects could be taken for utensils, to sustain the ambiguity between something symbolic and something used.' And, recalling Marcel Duchamp's phrase 'cowardly sculpture', he called the 'Saints' 'intentionally cowardly' drawing attention either to their potential for deterioration or to their mendacity. (In a suite of drawings they sprouted Pinocchio noses.) Comparison with the human body was inescapable. And for Espaliú, body and soul were intrinsic. ('Soul is flesh, Genet argued, and I agree.') The sculptures and drawings from 1990 are deliberately made with minimal means. Frailty and robustness are confused, messages seem all-powerful though they may never be delivered, the clapper of a bell becomes a

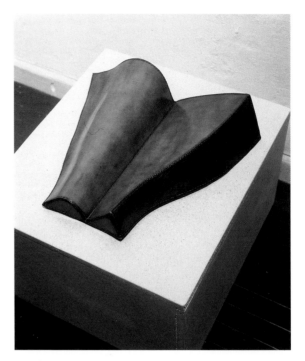

fig.17 'Saint VI' 1988. Leather. *Galería La Máquina Española, Seville*

tongue, a lash, even a head of hair. Adopting Wassily Kandinsky's term, Espaliú spoke of 'resonance' and poetic intensity in his work. 'It's a carapace your body embraces' he wrote in a late poem, 'like a death in miniature | looking at which would deny you | the interior from the exterior.'[3] By the time of 'Untitled' 1990 (no.22), a bronze torso made up of a vestigial head with a skipping rope over each shoulder, the religious significance was undeniable. Yet piety was not power. In a deserted church, St Paul's in east London, Espaliú flooded the altar space and placed cushions above the water like stepping stones. Yet because these hassocks rested on plaster bases which the water gradually dissolved, they began to float, a reference to Peter, he of little faith, who, seeing Christ walk on water, attempted it himself and sank.[4] For Espaliú, faith in himself had begun to depend on faith in others. Despite his weakened state, 'Carrying' (see p.15), a set of closed, black sculptures resembling sedan chairs used to transport the plague-ridden in eighteenth-century Venice, was followed by a simple action, also called 'Carrying' 1992 (fig.18), which involved the artist himself, emaciated now and barefoot, being supported and taken a short distance by two people who in turn would pass him to another pair. In this simple action, designed to draw the attention of the Spanish authorities to the existence and plight of Aids sufferers, the 'carrier' was himself carried.

Militant, angry, the final works focused on movement, impotence and friendship. Crutches and cages had already been used as motifs. In 'Rūmi' 1993, interlocking cages were displayed as staircases for the spirit, while in 'The Nest' (no.25), crutches stood in a circle to enable them to remain upright. Yet both of these are positive interpretations. The crutches make a closed group, while cages remain cages. Or do they? Espaliú's installation for *Edge 92* in the Hospital de la Venerable Orden III in Madrid consisted of three cages hanging side by side, all bottomless, with the result that the bars continued to and across the floor, like roots reaching far and wide, a metaphor for freedom (no.24). This circular motif reappeared in the performance 'The Nest' 1993, in which the artist, now weakened and emaciated, had an octagonal platform built in a tree next to the Gemeentemuseum building in Arnhem, and every day for eight days climbed the ladder and proceeded to walk around the trunk, removing one more of his eight garments, timing his final appearance, naked, to coincide with a visit by the Queen Beatrix of the Netherlands. In a text published after his death, Espaliú wrote: 'Circles in which desire is trapped in a repeated driving movement, desire eroded by the "inability to stop", becoming purer and emptier, as in the movements of the dervishes, the Sufi dancers … A constant whirling of prisoners and mystics, paranoics and homosexuals … all those who live without appropriating anything for themselves but simply in a feverish desire to "rotate" the tautological circularity of "being".'[5]

Espaliú's last work returned to this circularity. At the Gemeentemuseum he had 'adopted' a painting by Pyke Koch. Called 'Nocturne', it showed an old-fashioned public urinal by night, a sight made more dramatic by unearthly light streaming from inside the round structure around which men would circulate (fig.19). This further reference to 'rotation' was taken up by Espaliú, who discovered the sad fate of such classic meeting-places: only two such buildings remained in the whole of Paris. Choosing one in the boulevard Arago, next to the de la Santé prison, he invited some male homosexual friends,[6] instructing them, unknown to each other, to arrive there at various times on the same day, and to scrawl messages on the wall, each replying to the previous writer. After visiting the *pissoir* in question – or, more correctly, the

fig.18 'Carrying' 1992. *San Sebastian, Spain*

vespasienne – the participants met and talked. In a collage made in 1993 (fig.20) a circle/ halo appeared consisting of the words *con o sin ti* (with or without you), and above it a photograph of the building around which men strolled, as he himself had on his solitary platform in 'The Nest'. As in the case of the dervishes, repeatedly going round had led to ecstasy, a release from the body. Espaliú recalled the search for the Beloved resulting from the poet Rūmi's loss of his friend but also the dematerialisation meant to result from the dervishes' act of whirling for God. 'My place is no place, my sign is no sign. I have neither body nor soul, for I belong to the soul of the Beloved.'[7]

Early in Espaliú's career critics had singled out what they regarded as the weakness of his tactics: the preference for rhetoric, for mere play of sign-systems instead of a concern for meaning. Yet as his life continued, his work dealt increasingly with that same apparent vacuity – so much so, indeed, that its opposite was invoked: not absence of meaning but the potential for significance. And as they became more demonstrative, more public, his previous tactics began to make sense in a larger, political context. For the *vespasienne*, the hollow vessels, the cupped hands, the fact of going through the motions all recall conjuring in its proper sense: an attempt to invoke spirits, to produce something out of nothing, as comfort for a loss. Like the dervishes, Espaliú used ritual to invoke two states in particular. One was love, the other prayer.

Stuart Morgan

Notes

1 Pepe Espaliú, *El Periódico de Catalunya*, 20 Jan. 1993, p.31.
2 This and other unfootnoted quotations are from an unpublished interview with Espaliú, Madrid 1988.
3 Catalogue for the van Krimpen Gallery, Amsterdam, quoted by Juan-Vicente Aliaga, 'Speak to Me, Body', in *Pepe Espaliu 1986–1993*, Seville 1994, p.164.
4 For a description of this work see Adrian Searle, 'The Loss of Pepe Espaliú', in *Pepe Espaliú*, London 1994 [n.p.].
5 Aliaga 1994, p.148.
6 See Jan Brand, Catelijne de Muynck, Valerie Smith (eds.), *Sonsbeek 93*, Ghent 1993, pp.238–54.
7 Aliaga 1994, p.146.

fig.19 Pyke Koch, 'Nocturne' 1930. Oil on canvas. *Gemeentemuseum Arnhem*

fig.20 'Untitled (With or Without You)' 1993. Paper and mixed media. *Galería La Máquina Española*

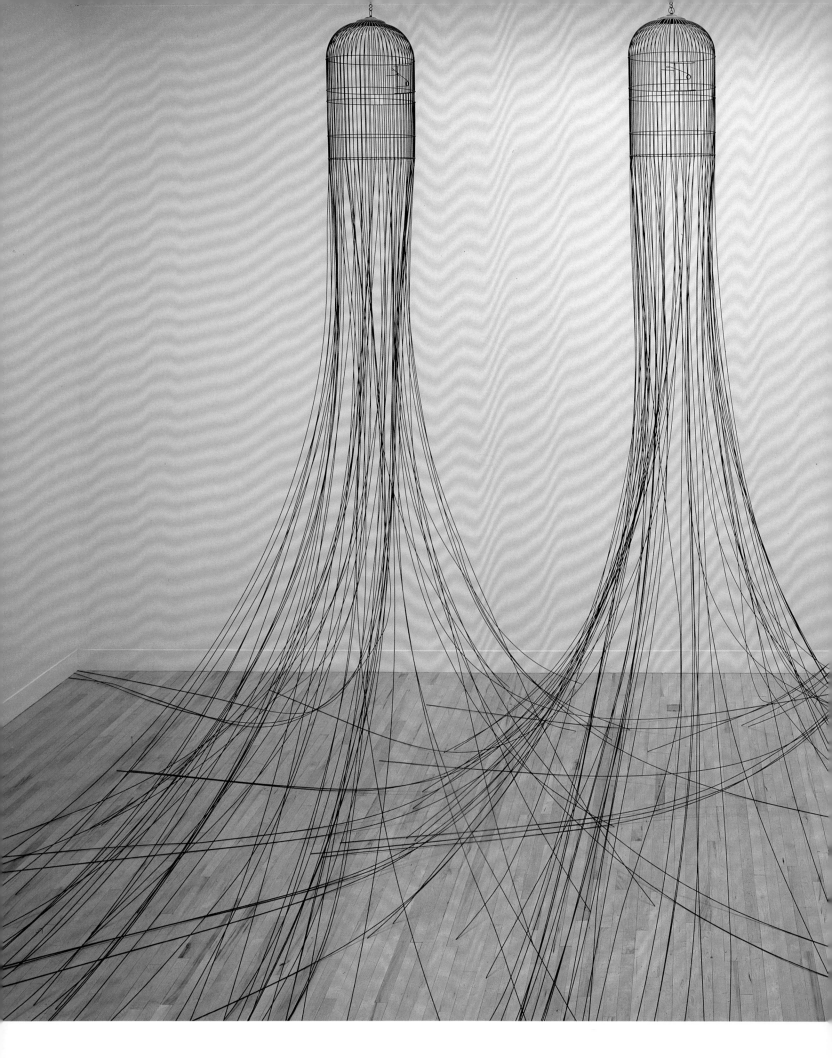

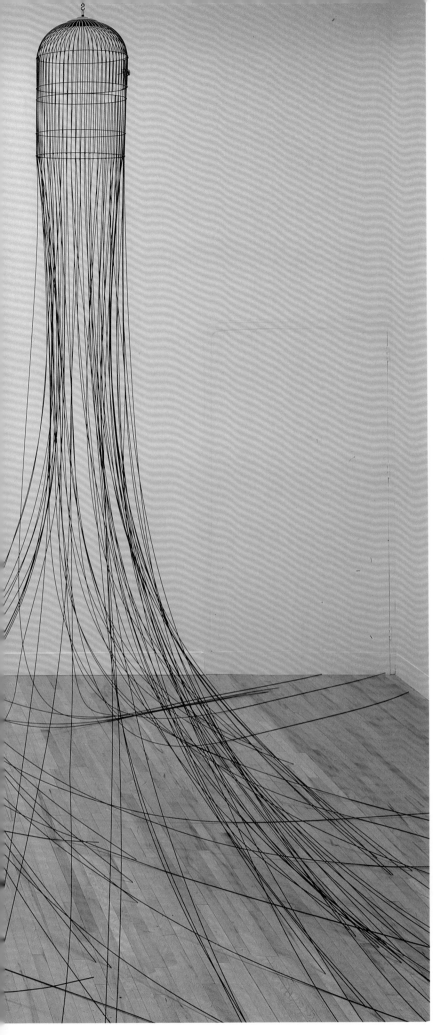

no.24

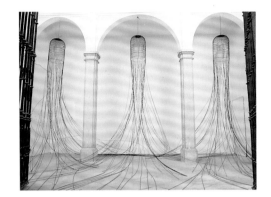

'Untitled' 1992 Installation at the Hospital
de la Venerable Orden III in Madrid

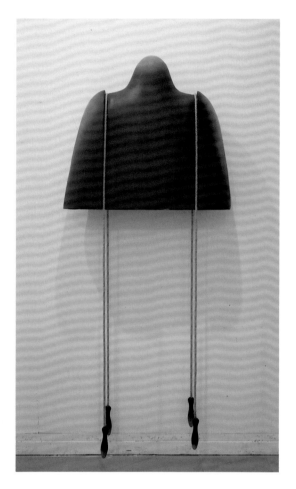

no.22

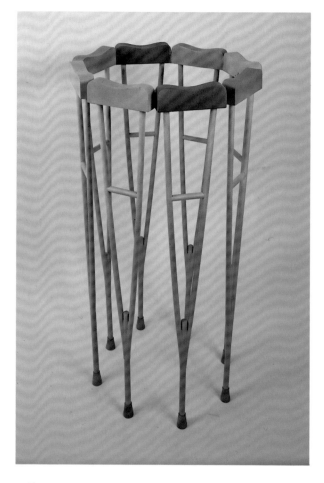

no.25

no.23

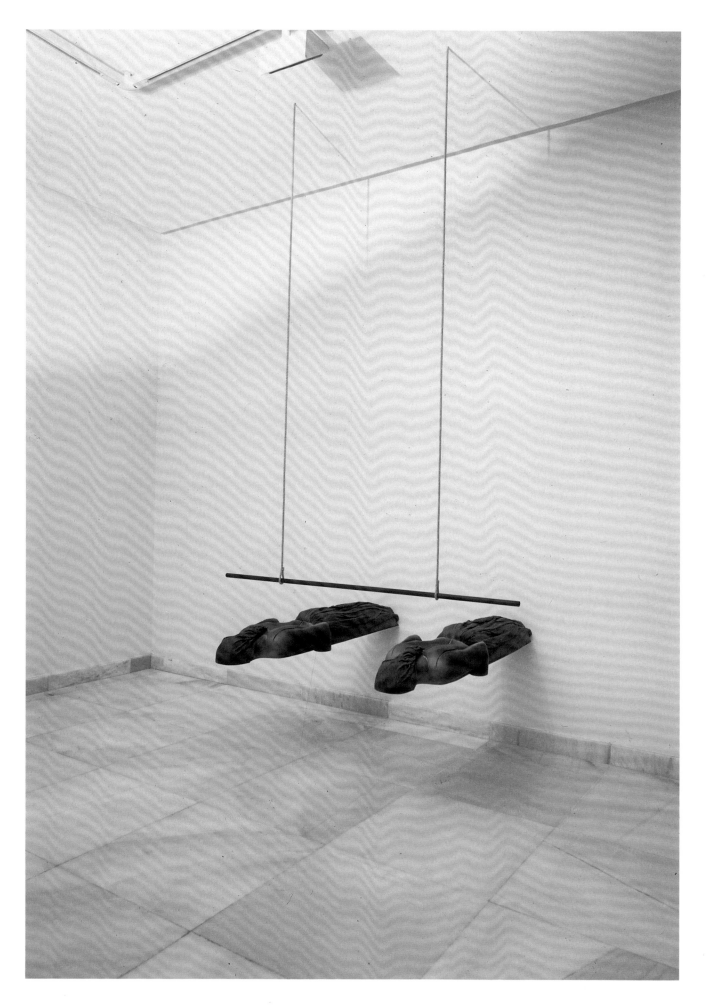

Robert Gober

'Formally rigorous but emotionally messy'[1] is how Robert Gober describes his work. From his first interest in making sculpture – which he came to through carpentry – to his most recent installations, Gober's work has been conceived and executed with the clean contours and precision engineering of a skilled craftsman. At the same time each work has carried a psychological and increasingly political charge, excavating the fissures of pain, anger and resentment embedded in the surface of contemporary American society.

One of the artist's most recent works draws attention to a multitude of neglected corners in modern-day America. The lobby to the elaborate installation he made at New York's Dia Center for the Arts in 1992 (no.26) is, in formal terms, among Gober's most minimal works but it is also, like a side chapel in a great cathedral, the location for a condensation of feeling and, in this case, a heightening of psychological tension. There is a space like this one on the floors of every apartment building, at the back of every office block, within every gallery complex, at the corner of every warehouse. It is a transitory space, emphatically internal, yet set aside from the comfortable environments we create to live and work in. Historically, such spaces were by-products of the transition from systems of circulation designed around the staircase to those embracing the elevator. The image of the staircase, a spiralling stage for social interchange, is replaced by the lift shaft, moving its passengers with effortless speed and within the privacy of its compartment. Staircases demand landings, elevators require lobbys. Gober's lobby – the term itself has come a long way from its medieval, probably monastic, origin – is an unloved and neglected space. Its walls are unadorned. Along one wall is a doorway, with light slipping under the threshold. Above the door is another source of light, a naked red bulb of the kind that, when illuminated, warns you not to enter – and at the same time tempts you to do so – because something is going on inside. In Gober's work the bulb is glowing. Our curiosity is inevitably aroused.

fig.21 'Door with Lightbulb'. Installation at Dia Center for the Arts, New York, September 1992 – June 1993. *S. & J. Vandermolen, Ghent*

Like the victims of mortality pacing out eternity in Jean-Paul Sartre's brilliant portrayal of hell, *No Exit*, we are drawn to light and life. The door, however, is closed.

On both sides of the doorway are bundles of newspapers, purveyors of yesterday's news, left out presumably for trash or recycling. There is little else.

The whole scenario is utterly plausible. But nothing is what it seems. The wall is a shallow box made of plasterboard, the doorway a nicely painted architrave, the newspapers handsomely printed facsimiles, their artificially reconstructed pages combining both real and fictional material. We are both audience and actor in a dimly lit drama of the human condition.

Before Gober started making art he made architectural environments. In the mid-1970s he earned his living, for a while, constructing dolls' houses, fancy timber structures epitomising the hopes and aspirations of middle-income Americans. Microcosms of the domestic realm, dolls' houses are where children encounter and challenge their fantasies and fears, using as their props the replica furniture and fittings that so closely mimic their real-life models. And it was through dolls' houses that Gober 'physically and symbolically stumbled'[2] on the vocabulary for his first sculptures: sinks, urinals,

fig.22 'Newspaper', 1992. Photolithography on paper

playpens, cots, beds and doors. As Gober explained, these are all 'objects you complete with your body, and they're objects that, in one way or another, transform you, like the sink, from dirty to clean, the beds, from conscious to unconscious, rational thoughts to dreaming; the doors transform you in the sense ... of moving from one space to another'.[3] These objects have in common a formal simplicity which is related to their function. Their function is in turn related to the way we live. To impair the functioning of the work is thus to handicap both the object and the subject. All of Gober's object-sculptures are radically impaired. The sinks have no taps, the urinals no drains. The playpens and cots are skewed from the orthogonal, the doors lead nowhere.

There is no theoretical basis for the choice of these objects. They are, for one reason or another, deeply embedded in the artist's memory. The sink, for example, recalls the porcelain sink in Gober's first studio which itself reminded him of identical porcelain sinks, one used by his grandmother, another installed by his father in his basement workshop. Such objects were psychologically charged emblems of memory, signifying the traumas of growing up aware of his homosexuality in a rigidly Catholic, suburban nuclear family. The strategy was simple but powerful: if what we think of as right and proper and simple and true is demonstrably false and illogical, subjective and deceptive, what is the normal and familiar beyond a flimsy social construct designed to endorse and maintain a particular view of society? Gober therefore was both deconstructing the particular view of society imparted by his parents and peers and clearing the ground on which to build afresh. For him the two are intimately linked, for if you 'reject how you were

brought up, the rest of your life becomes a redefinition'.[4]

Gober is one in a long line of artists, beginning before Duchamp with Picasso and Braque in their collages, who have appropriated items from everyday life and thus attempted, in some way, to bridge the gulf between art and life. Gober's 'Three Urinals' 1988 (private collection, New York), and other images such as the 'Wedding Gown' 1989 (Rudolf and Ute Scharpff Collection), are surely some kind of homage, but they also constitute a radical departure from Duchamp and all those who followed him, because these works are decoys, handcrafted *trompe-l'oeil*, remakes as opposed to readymades. Their link to the artist who made them, and thus to autobiography or psychology, is thereby brought to the fore.

Nowhere is Gober's charged hyperrealism more disturbing than in the body fragments he has made since 1990 (fig.23). The first was a wax cast of his own leg, cut off at thigh height and dressed in trouser leg, sock and one of his own shoes. In the gap between sock and trouser hem the wax skin was implanted with hairs. Then followed a series of works of increasingly fantastic and yet utterly literal body fragments: a man's naked bottom inscribed with a musical score, legs and bottoms pierced with drain holes, legs sprouting candles, a hermaphroditic torso. Most recently Gober has made a

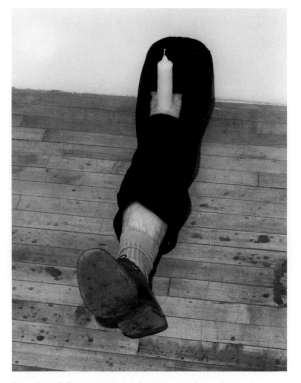

fig.23 'Untitled' 1991. Wood, wax, leather, cotton, human hair.
Private Collection, Europe

work comprising the upper thigh and lower torso of a naked female. From her overstretched perineum she gives birth to an adult male leg and foot which are perfectly attired as if for a day in the office. These are difficult and disturbing works, weaving an intricate tissue of meanings, but they too derive from an image lodged in Gober's memory: 'I remembered that my mother, before she had children, used to work as a nurse in an operating room, and she used to entertain us as kids by telling stories about the hospital. One of her first operations was an amputation. They cut off a leg and handed it to her'.[5] This memory was then overlaid with the experience that became the direct inspiration for his first leg pieces: 'I was in this tiny little plane sitting next to this handsome business man and his trousers were pulled above his socks and I was transfixed in this moment by his leg. I came home knowing that I wanted to make a sculpture of that part of the leg.'[6] In the aftermath of this erotic encounter the amputated limb of childhood memory became imbued for him with the most diverse contemporary meanings.

The move to making installations enabled Gober to shift the register of his work from the object to the environment, from the artefact to culture. In an exhibition at Paula Cooper's New York gallery in 1989 Gober constructed two rooms, one with male and the other with female characteristics. The 'male' room was wallpapered in images of genitalia, both male and female. Pewter drains perforated the walls at intervals and a bag of handmade donuts was placed on a plinth in the centre: the whole suggests a trio of bodily destinations for sexual gratification. At the centre of the 'female' space was a large wedding gown. Wedding gowns denote virginity, purity, femininity, but they also signify the ritualistic passage of the bride from maidenhood to an adult sexual relationship. It is a ritual that affirms, for its participants and witnesses, a set of values that are Christian and heterosexual.

Gober made the dress himself, perfecting the traditionally feminine craft of needlework. Taking no shortcuts, he prepared a practice version in muslin before the final satin. The dress was modelled to his body, its bust provided by a bra Gober adopted to give himself an appropriately curvaceous profile. The 'Wedding Gown' is thus an act of appropriation. Gober colonises the female identity, and in subverting the notion of heterosexual union at the moment of its apotheosis he invests transvestitism with a political dimension.

The trajectory of Gober's career to date, from objects to installations, and from a personal symbolism to one of wider resonance, could be seen as a move from the private to the public domain. While the roots of Gober's work continue to reside in personal experience, his ambition to place the 'personal narrative ... within perhaps an historical perspective, a broader American view'[7] accounts for the increasing complexity in the network of associations at play in any single work and an increasing politicisation of the artist's stance. The fact and experience of Aids and the culture of disquiet that pervades America's institutional response to it has sharpened Gober's sense of alienation from straight society and his identification with other minority and oppressed groups.

In 1991 Gober printed his first newspaper. A single page from the *New York Times*, dated 4 October 1960, contained a selection of miscellaneous marriage notices accompanying smiling portrait photographs and a half-page regular feature on the weather. Inserted into the right-hand column of the top half was a brief news item reporting the tragic death of one young Robert Gober. And just as the reporter deftly casts suspicion on the boy's mother, so too the inclusion of this decoy article casts suspicion on the institution of marriage as purveyed by the press. Against the image of sanctified bliss that marriage evokes there is the 'reality' of child abuse and neglect that lurks beneath the surface of a regular American family.

Newspapers make private affairs public, and in the hectic cycle of making and consuming news the media is able also to parade lies as truths at least until today's edition is succeeded by tomorrow's.

Quantities of these papers, ranged around the walls, linked the separate spaces of Gober's exhibition at the Dia Center for the Arts in New York in 1992, of which the lobby space described above was the threshold to the installation. The main room (fig.21) was a dramatic and entirely perverted illusion of a woodland glade, in which the walls were handpainted from photographs. At regular intervals along the walls large double sinks provided endlessly flowing water and sound effects appropriate to the rushing brooks for which, presumably, they were stand-ins. Here was a vision of nature tamed, sanitised, sham. As if to drive the point home, *trompe l'oeil* cartons of rat poison were placed here and there, and the walls of this painted arcadia were punctured high up by barred prison windows: where has our natural freedom gone?

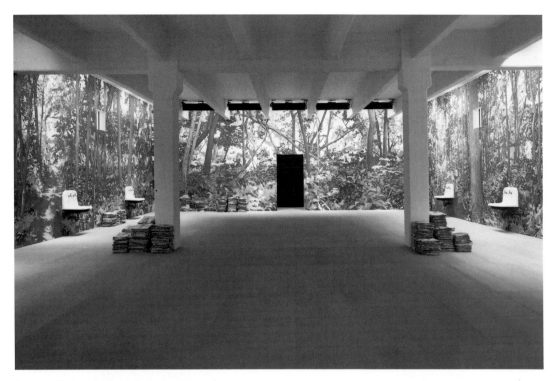

fig.24 Installation at Dia Center for the Arts, New York,
September 1992 – June 1993

As if in answer to this rhetorical question we look to the bundled newspapers for enlightenment. Their litany of abuse and betrayal is chilling: stories of discrimination against gays, neglect of children, of untimely death, of official incompetence and ignorance of Aids. These in turn are set against a background of everyday ordinariness which itself harbours the sexual stereotyping and cultural conformism that underpins society's passive response to injustice and discrimination. But, as in all Gober's work, things are not necessarily as they seem; perversion and subversion go hand in hand in his work. This is humourously conveyed by the recurrence, in these newspapers, of Gober's 'Wedding Gown' image, which now, resplendently advertising Saks in a full-page spread, is modelled by the artist himself.

The sense of alienation and estrangement that seeps through all of Gober's art seems to weigh most heavily in those works which most closely approximate to a vision of 'normality'. It is in these works that the gay agenda becomes part of a much wider concern for enfranchisement in a world where we all face the possibility of disenfranchisement by the realities of late twentieth-century life. The doorway installation is a microcosm of life now, of 'post-industrial despair'.[8] In the catalogue to the Dia exhibition Dave Hickey argued that the locked door drew attention to the fact that the mind can go where the body cannot. Certainly it brings us back to our bodies and to the question of what it is to inhabit a human body. But it also draws attention, critically, to the cultural structures that govern the way we, as bodies, function. It is, however, the mind and our mental structures that provide the means of deconstructing these structures. Surely Robert Gober would not make the art he makes without believing that eventually, somehow, the mind can open the door and let the body in?

Frances Morris

Notes

1 Robert Gober, quoted by Lynne Cooke, 'Disputed Terrain', in *Robert Gober*, exh. cat., Serpentine Gallery, London, and Tate Gallery Liverpool 1993, p.21.
2 Robert Gober, quoted by Joan Simon in 'Robert Gober and the Extra Ordinary', in *Robert Gober*, exh. cat., Museo Nacional Centro de Arte Reina Sofía, Madrid 1992, p.17.
3 Ibid., p.20.
4 Robert Gober, interviewed by Craig Gholson, *Bomb*, Fall 1989, p.34.
5 Gary Indiana, 'Success', *Interview*, May 1990, p.72.
6 Robert Gober, interviewed by Richard Flood in Serpentine Gallery and Tate Gallery Liverpool 1993, p.13.
7 Gholson 1989, p.32.
8 Dave Hickey, 'Robert Gober: In the Dancehall of the Dead', in *Robert Gober*, exh. cat., Dia Center for the Arts, New York 1992, p.18.

no.26

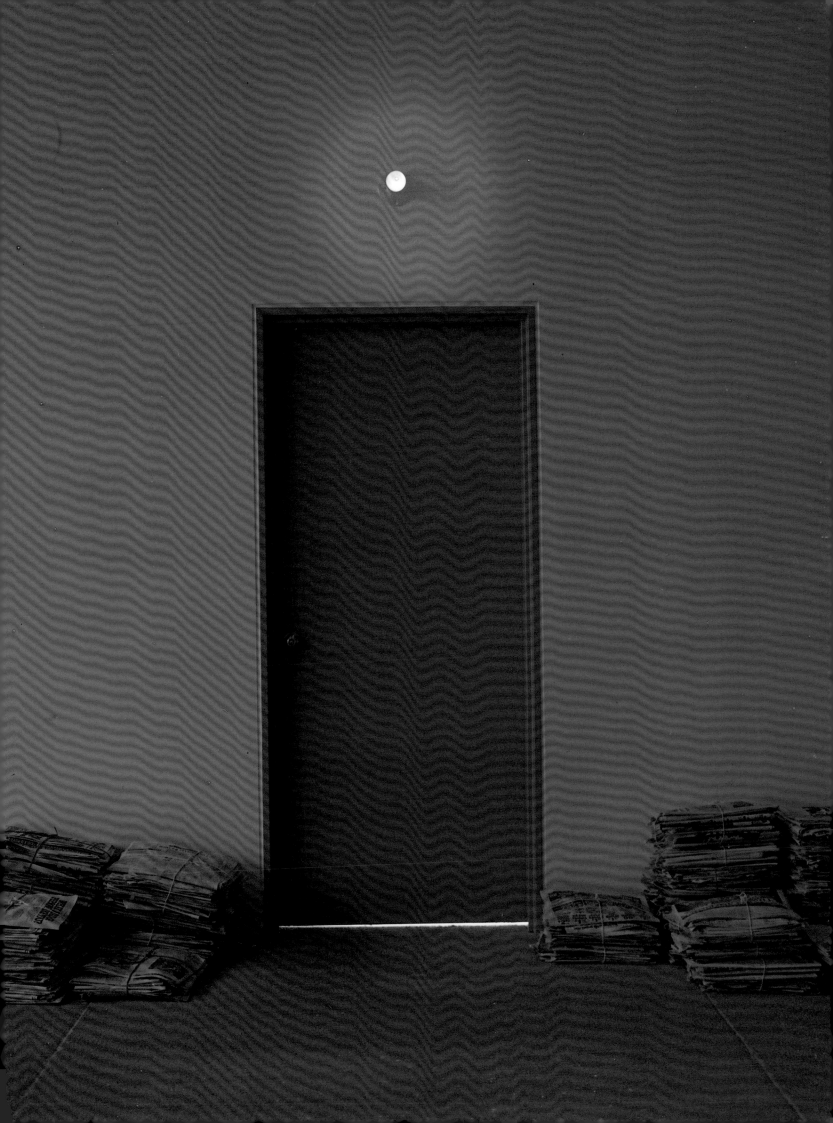

Mona Hatoum

Mona Hatoum's strange compulsion to explore the world beneath the flesh derives from vivid imaginative experiences in her childhood. Brought up in Beirut, as a child she would often play on the balcony of her parents' flat. High up and across the way were other flats with balconies; secretly Hatoum would observe her neighbours preoccupied with their own affairs. With a pair of binoculars she watched closely and as she followed their movements she would imagine that her binoculars were magical. In her mind's eye the layers of clothing were stripped back, then the skin and flesh.

Years later, as an art student in London, this childhood fantasy surfaced in several projects. In 1980 Hatoum performed at Battersea Arts Centre as part of a 'Five Days' festival of performance, installation and film. Equipped with a video camera, she filmed her passive audience and the images of their faces and clothed bodies were relayed onto a video monitor. Suddenly parts of naked bodies appeared on the screen – hidden behind the screen were two naked performers and images of their bodies were carefully montaged by a third helper. The same year she realised another performance at the London Film Makers' Co-op (fig.25). This began in much the same way with Hatoum scanning the audience with a video camera and a close-up lens. The camera moved slowly, dwelling on details; hands folded or a frayed cuff. At the front was a video monitor relaying enlarged details of the camera's scrutiny. Then, quite suddenly, the action shifted to the artist. Hatoum seated herself at the front, excluding herself from the audience and the outside world by inscribing a circle, in chalk, around her 'space'. She then turned the camera to her temple and began to survey her own body: subject became object, observer became observed, torturer became victim. Then, without warning the imagery unfolding on the monitor shifted from the clothed body to a naked body as if, again, the camera had x-ray vision.

Both projects depended on the presence of fantasy, sleight of hand and the active collusion of her audience.

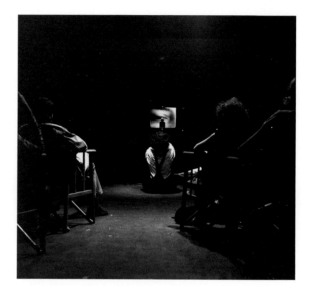

fig.25 Video performance with live video and pre-recorded tape at the London Film Makers' Co-op, London 1980

Fifteen years on Hatoum has returned to the same territory in 'Corps étranger' (Foreign Body) (no.27), a work that eschews fantasy and trickery in favour of realism and scientific procedure and yet, like the best science fiction, pushes our appetite for the fantastic to the very limits. 'Corps étranger' is a specially constructed tubular room in which a video is projected onto a circular screen on the floor. The video was complex to produce, employing two invasive imaging processes used quite routinely in medicine today: endoscopy which uses fibre optics to scan the upper part of the digestive system, and coloscopy which is a way of examining the colon and intestines. Hatoum's video documents the skin of the body as the camera moves slowly across its landscape; the image is grossly distorted by the scale of its transmission. As the camera encounters an orifice it enters, and the interminable forested landscape of the surface gives way to glowing subterranean tunnels lined with pulsating animate tissue, moist and glistening. The camera slowly lurches on downwards until it can go no further. Emerging once again onto the surface of the

body, it seeks another way in. All orifices are explored in turn. The visual sequence is accompanied by an eco-graphic sound track made by recording the heartbeat as heard from various points of the body. When the camera surfaces the rhythm of the heart is intercut with the sounds of Hatoum breathing.

In contrast to the visual complexity of the video sequence the housing of the work is of the utmost simplicity. The viewing chamber is a pure white cylinder pierced by two slender vertical apertures through which the viewer enters. A narrow margin between screen and wall allows the viewer to stand at the perimeter of the image, back to the wall, in the classic pose of victim. Movement is severely restricted, and communal proximity to other viewers also complicates the experience of intimacy. The chamber is lined with soft black acoustic fabric. The viewer is embraced within a dark, circular chamber and enveloped in the soft rhythms and noises that emanate from speakers enclosed in the perimeter walls.

Over a decade and a half Hatoum has made a seemingly disparate body of work, in video, performance, sculpture and installation. Her concerns are not random, however, and a venture like 'Corps étranger' is deeply rooted in earlier projects. 'The Light at the End' 1989 (fig.26) marked a radical transition from Hatoum's earlier performance and video work in which the spectator was empowered – often as voyeur – to a situation in which the spectator was entrapped. It comprised a dark room lit only by the glow of a barred panel of electrical elements. The work involved the spectator in a physical and imaginative encounter with the object. Like a moth attracted to a single light source the viewer was drawn to its dangerous incandescence: on approach light mingled with heat, source of both comfort and potential catastrophe.

This and other installations, most notably 'Light Sentence' 1992 (fig.27), employed linear structures and grid formats, throwing forth inescapable references to fences, cages, compartments and racks, as well as to the aesthetic formula of the grid as a neutral ordering device. Hatoum had experimented over a long period with a minimalist language prior to her more politically engaged performance work; however, this legacy of minimalism remained, resurfacing in the grid, and more recently in the pure white cylinder of 'Corps étranger'.

The encasing of this later work in one of Le Corbusier's primary solids, a keystone of classical architec-

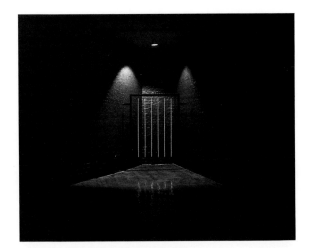

fig.26 'The Light at the End' 1989. Mixed media. Installation view at The Showroom, London

ture, is of interest. Inside, the overt references to the body reinforce links between the body and architecture – from Vitruvius to Venturi. The cylinder creates a space that is both inside and part of, yet also separate from the space of the museum. Is it perhaps an ironic reference to the 'white cube', suggesting the impossibility of a neutral stance in architecture as elsewhere? The very 'neutrality' of Hatoum's column creates its own metaphors: its clean surfaces are sophisticated and speak of advanced technology. Its associations are modern, even futuristic – a Tardis for the next century perhaps?

Once the viewer has entered the chamber the notion of journeying comes to the fore as the moving image catches and holds the attention. Witnessed vertiginously from above, it is a strange and moving experience, revealing a world as yet unfamiliar to the lay viewer. Bypassing the conventions of narrative film in which continuity is given to a sequence of disparate images by ingenious editorial devices – cuts, dissolves and fades, which we, through custom, read as natural – Hatoum's video proceeds in the manner of an unblinking eye, relentlessly moving onwards, never straying from its forward momentum, controlled by the necessity to follow a given course, in pursuit of an unknown goal. From the Renaissance until our own faithless age the body has been regarded as housing something of spiritual significance. Hatoum reveals a body that is, if anything, dispossessed. No governing agency, no mind, no soul, no centre is revealed. Hatoum's camera never reaches an end but careers on, continuously retracing its steps. Her viewer becomes vicariously involved, bound up in the hopeless adventure. Captivated by the film, ensnared by

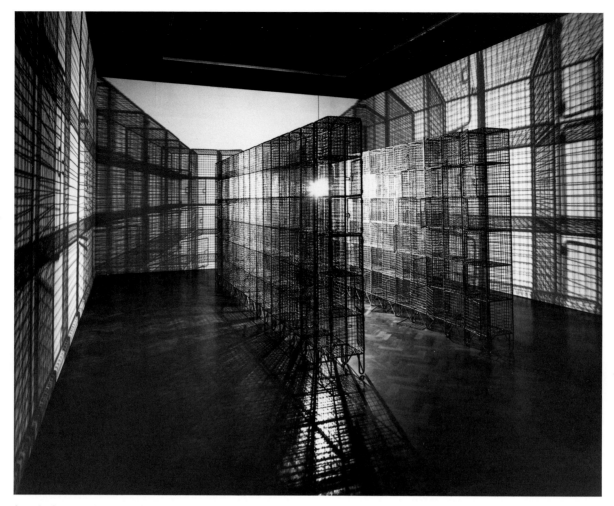

fig.27 'Light Sentence' 1992. Mixed media.
Installation view at Chapter, Cardiff

the structure, the viewer is both predatory explorer and innocent witness, voyeur and victim.

The body's interior has been mined progressively in the name of science, from the public dissections of the Renaissance through the first illustrated anatomy books of the early sixteenth century and on. In the sixteenth century the body was widely perceived as 'a microcosmic representation of the cosmos'[1] speaking of metaphysical truths. By the late seventeenth century it came to be looked on as an integral part of nature; biological and sexual. Those years saw a proliferation of elaborate anatomical drawings. Differences between people, of race, gender, mortality and intelligence, could seemingly be defined anatomically and physiologically. At the same time as medical technology grew more and more sophisticated, a 'civilising' process of hiding the body was also taking place: during the nineteenth century decorum demanded that private experiences, both painful and pleasurable, be kept from view.

Traditionally the whole, wholesome, nude body has been interpreted as an image of culture, embodiment of civic duty, heroism and patriotism. Countering this patriarchal view the French philosopher Georges Bataille, writing in the 1930s, attacked established notions of a mind/body dualism by counterposing the image of human control and dignity with the reality of a seething and chaotically fragmented physicality: 'Man willingly imagines himself to be like Neptune, stilling his own waves with majesty; nevertheless, the bellowing waves of the viscera, in more or less incessant inflation and upheaval, brusquely put an end to his dignity.'[2] For Bataille the real, living body offered radical alternatives to the traditional view of the nude body. Bataille's concept of 'base materialism' is not so far from more recent notions of abjection, defined most famously by Julia Kristeva as 'what disturbs identity, system, order. What does not respect borders, positions, rules. The in-between, the ambiguous, the composite.'[3] Kristeva's

writings have come to be associated with the making of art which transgresses social taboos and opposes traditional and often repressive notions of identity by calling attention to bodily elements and functions as well as degraded and contaminated materials. The body in 'Corps étranger' is abject, base matter, literally a foreign body. At first sight it is 'outside' culture, timeless, primitive, unchanged – virgin territory for the camera's 'imperialistic' eye. However the intrusion of medical equipment, the 'framing' of the sophisticated viewing chamber, establish co-ordinates that are modern, social, cultural and political: the terminology of colonialism is unavoidable. So too is the language of Gender.

Gender is rarely simply stated in Hatoum's work and what is seemingly depicted as an experience of oppression is often paradoxically a source of strength. In one sense the body as depicted by Hatoum is an anonymous body and thus implicates us all. This body could be any body and to experience the work is therefore an act of self-discovery. But the work also prompts a remarkable encounter with the female body, and vestigial references to female sexual parts, a breast or the vagina, make this clear if not outspoken. This gendering inevitably puts the spectator in an ambiguous position. As we penetrate the body, via the eye of the camera we are in turn haplessly sucked in and absorbed. Are these, perhaps, as Desa Philippi has argued, 'the two sides of the coin that constitutes the stereotype of femininity: on the one the passive victim and (natural) body submitted to the operations of science (culture), on the other hand the Sphinx, Preying Mantis, Vagina Dentata'?[4]

The ambition to recall us to our bodies is a driving force for a great number of artists working today. Perhaps this is because we now live in an age of physical constraint: few demands may be made on our physical selves beyond the need for reproduction and desire for pleasure, yet we are allowed little room to exercise our freedom. References in contemporary art to bodily fluids, waste and other low materials as well as the fashion for images of human organs, dismembered limbs and mutilated bodies, are often seen as means of opposing networks of repression currently operating between the body and the world. Mona Hatoum's 'Corps étranger' engages in this discourse but in a way which is distanced from her peers and which simply bypasses current psychoanalytic 'body part' theories. Jacques Lacan's 'mirror stage' described the crucial moment of self-recognition for the infant as, when catching sight of itself in the

mirror, it perceives the self as a unified whole for the first time. For Lacan this was a natural rite of passage in the formation of an individual's identity. This is the concept of the self continually threatened by Kristeva's notion of abjection. Although Hatoum deals with abject material she is neither concerned with shoring up a cohesive unity nor with exploding the boundaries of the body. Yet she *is* keen to enforce a moment of self-recognition. Within the charged environment of her circular chamber the implosive drive of 'Corps étranger' takes its audience through the looking glass. It involves them in an alternative rite of passage, one which combines experiences which are both frightening and moving, and from which they emerge irrevocably changed.

Frances Morris

Notes

1 Thomas Lacquer, 'Clio Looks at Corporal Politics', in *Corporal Politics*, exh. cat., List Visual Arts Centre, MIT, Massachusetts 1992, p.18.
2 Georges Bataille, *Visions of Excess: Selected Writings, 1927–1939*, ed. Allan Stoekl, Manchester 1985, p.22.
3 Julia Kristeva, *Powers of Horror: An Essay on Abjection*, trans. Leon S. Roudiez, New York 1982, p.4.
4 Desa Philippi, 'Some Body', unpublished English text, translated in *Mona Hatoum*, exh. cat., Centre Georges Pompidou, Paris 1994, p.26.

no.27

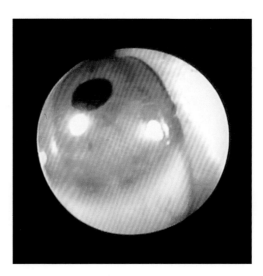

no.27

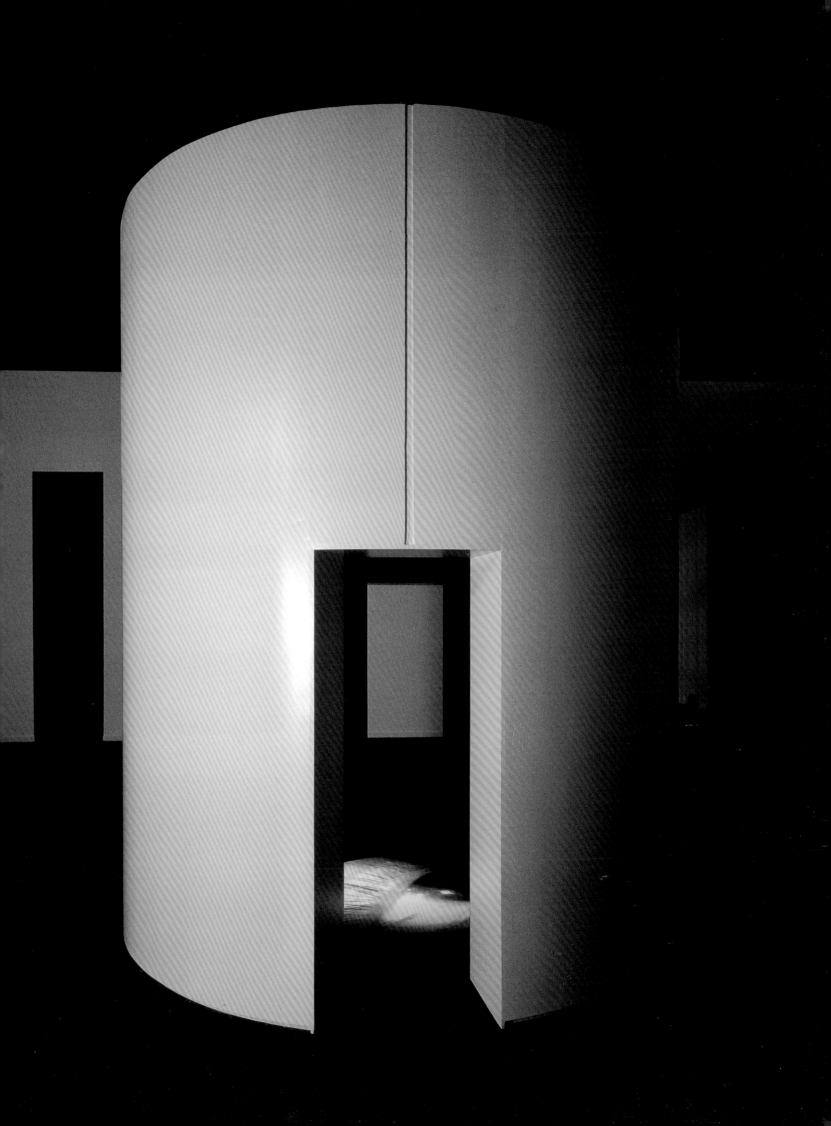

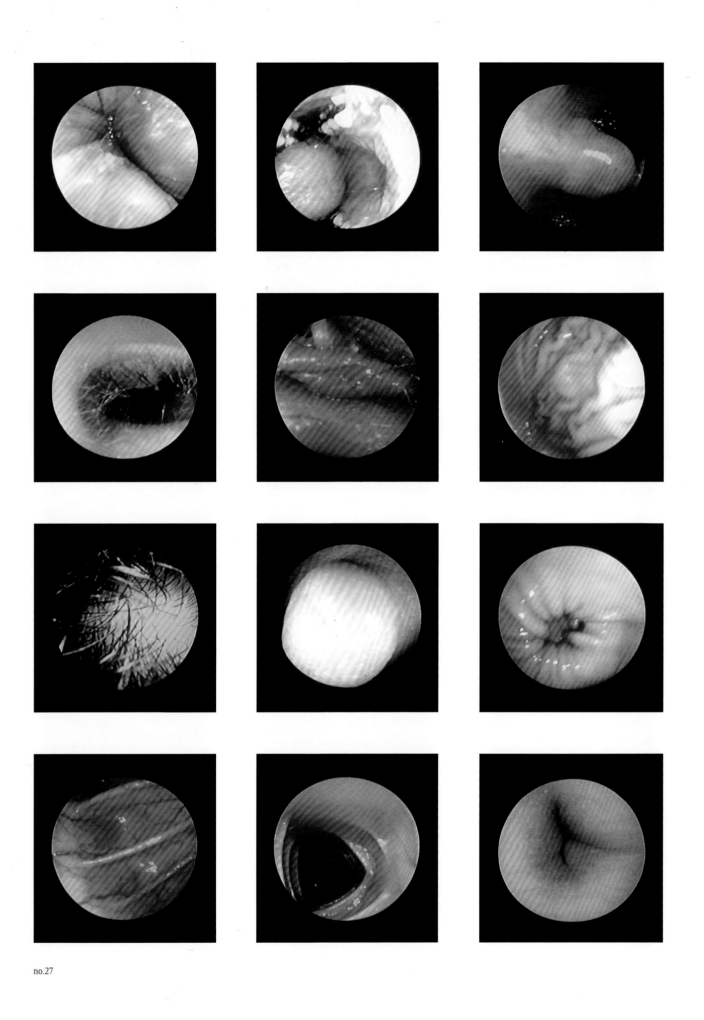

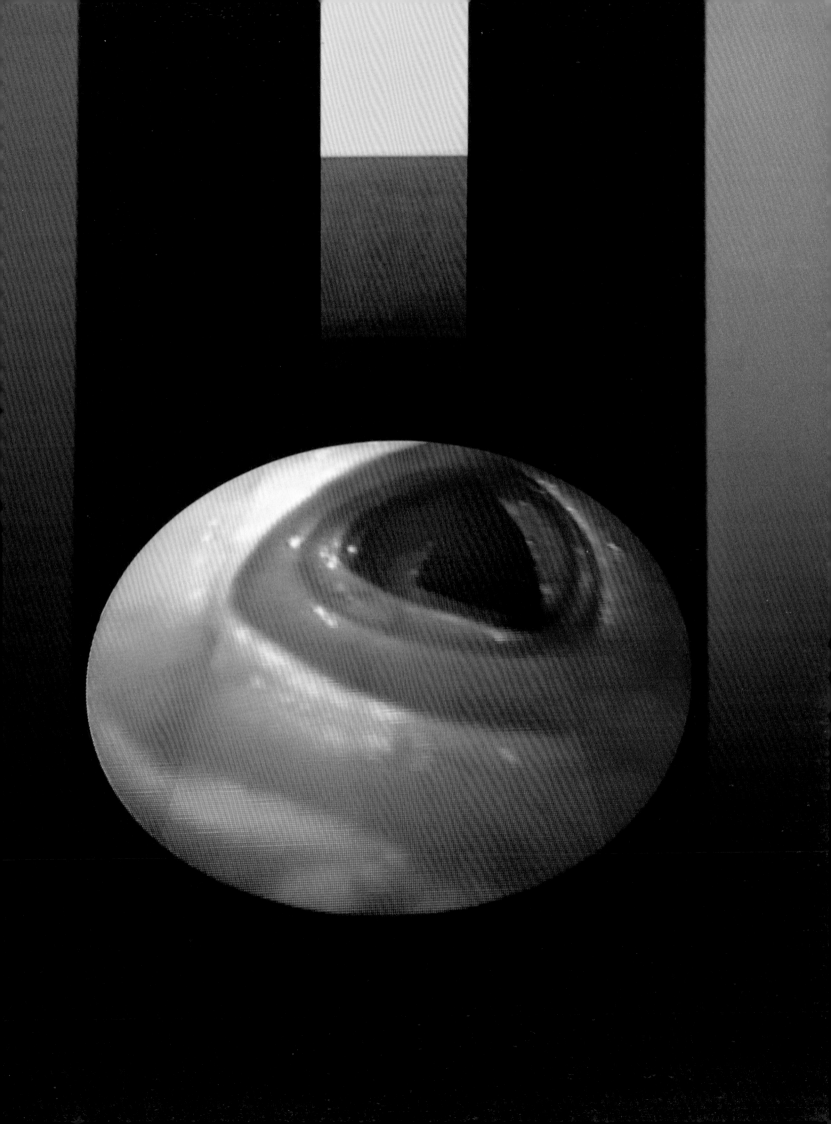

Susan Hiller

All culture is a form of curtailment, all language is a form of partial picturing. There is no culture that isn't a defamation.

Susan Hiller[1]

In Susan Hiller's 'Magic Lantern' 1987 (first shown at the Whitechapel Art Gallery, London; collection of the artist), the viewer entered a darkened room in which projected circles of coloured light — red, yellow and blue — appeared, swelled, diminished and overlapped, leaving afterimages: vestiges of one colour registered as another. The soundtrack consisted partly of chanting by the artist herself, partly of sounds recorded by the Latvian psychologist Konstantin Raudive, who claimed to have captured voices of dead people — German, English, Italian, Latvian — simply by leaving a tape-recorder switched on in an empty room. ('Churchill', Raudive's own voice informs the listener, 'Mayakovsky' — and because we want those voices to belong to the famous figures mentioned, whether they do or not, our disbelief is suspended for a while.) The leap of faith this demands is the prerequisite of all art; for Hiller it is crucial that viewers collaborate in the act of production. Even her first works were collaborative. In 'Dream Mapping' 1974 (private collection), participants worked together to develop a system for the notation of dream events. Emphasis on collaboration is fundamental to Hiller's practice. 'Because I come from a conjunction of Minimalism and Fluxus,' she has explained, 'the interactive and the non-theatrical suddenly turn into another thing, which insists on the position of the viewer as essential to the work.'[2] Indeed, the viewer is not only part of the work; he or she also collaborates in its making. So in the video 'Belshazzar's Feast, The Writing on your Wall' 1983–4 (Tate Gallery) images of flames were seen while a soundtrack included a child describing Rembrandt's painting and talk of apparitions which would appear on television screens when no other image was being transmitted.

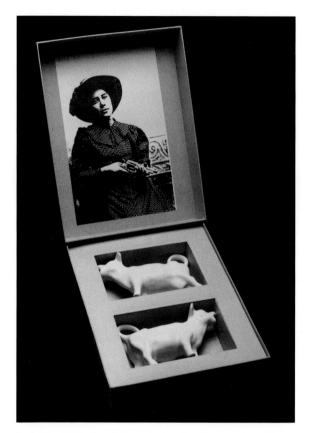

fig.28 'Cow Girl/cow-gurl'. Customised cardboard box containing china milk jugs in the form of cows and photocopy of American outlaw Jennie Metcalf. Installation detail at the Freud Museum, London 1994

If being haunted in your own living-room or making contact with the dead are events which resemble headlines from the gutter press, this is no accident. Hiller sees her work as a reclamation of a kind of culture that is overlooked. She studied anthropology, with spells of fieldwork in Mexico, Guatemala and Belize, but abandoned it in the early 1970s because of fundamental objections. Slowly she realised that information about tribal peoples was being used by the governments of powerful countries, to serve their own interests. Knowing this, it was hard to accept anthropology as a scientific practice. Despite this, Hiller's training continues to be relevant; she still attempts, like any anthropologist, 'to read the

world as a series of marks to be deciphered'.[3] In 'Dedicated to the Unknown Artists' (various collections) she displayed her own large collection of seaside postcards, all featuring images of large waves breaking over the shore. Her large, elegiac, installation 'Monument' 1980–1 (fig.31) also celebrates unsung heroes, this time ordinary men, women and children who lost their lives in acts of courage, saving others. The work brought together memorial plaques from a London park, a bench for sitting on, and headphones playing a commentary in which the artist speaks of memory and death. 'Monument' not only extended the practice of research and retrieval but also, importantly, asserted personal experience and reaction as valid subjects for art, after a period in which Conceptual procedures had tended to mask the personal.

At the Freud Museum in London over a decade later, she showed milk jugs in the shape of cows (fig.28). In other words, she exhibited items considered to be financially, even culturally worthless. For as a feminist, her retrieval of material which, in her own words, was 'repressed, suppressed, unknown, rendered invisible, erased'[4] constituted a deliberate political act. As for her

fig.29 '—/who is this one/I am this one/Menon is'. From *Sisters of Menon*, Coracle Press for Gimpel Fils, 1983

use of Raudive, she has stated 'Identity is a collaboration, the self is multiple, "I" am a location, a focus.'[5] It was a belief she acted upon. In 'Sisters of Menon' (private collection), for example, the artist's 'self' was taken over while practising automatic writing; from 1972 to 1979 a group of speakers/writers guided her hands. The sisters were eager to involve her in their play. 'Who is this one / I am this one / Menon is this one/ you are this one/ last night we were three sisters now we are four sisters/ you are the sister of Menon/ we are three sisters/ we live on the air in the water/ Menon/ we three sisters are your sister/ this is the nothing that we are/ the riddle is the sister of the zero'. Critical apparatus can be brought to bear on this. As in Monique Wittig's novel *Les guerrieres*, the figure zero may signify the vagina, for example. Or, because some of the automatic writing was done in France, the word Menon could pun on the words 'Mais non'. Questioned about the entire episode, Hiller has said 'These spontaneous experiences may well be the superego stepping aside for a moment to let something come through, but I don't know and I don't see them that way because although I don't dismiss mysticism as a problem, I'm not a mystic … It's a question of allowing space for the other in my work. And since the other is me as well, that's where multiplicity can come in.'[6]

The metaphor of research has also persisted. 'I have seen all this as an archeological excavation', Hiller has stated, 'not in the Freudian sense but rather in literal terms: uncovering something so it is available.'[7] Yet in her work uncovering and covering happen simultaneously, and insides and outsides are confused. 'We think that we have an inner life', she has said, 'that somewhere inside the body something is going on, that dreams happen in the head. I see that there is a network of meanings, external meanings, which are cultural, social and so forth, which is also a space where we place ourselves.'[8] Questions of, for example, where a dream occurs, as well as questions of madness, normality and permission are broached by the works involving automatic writing and wallpaper, both seamless wholes, which do not 'mean' in a related or acceptable way. For though covering a surface can be understood as decoration, it could also be read as obliteration or simply change of state, as could another of Hiller's activities: the long-term recycling plan which resulted in 'Hand Grenades' 1969–72 (private collection) or 'Measure by Measure' (1973–92; collection af the artist). These involve burning her own drawings and canvases and displaying the ashes in glass

fig.30 'Work in Progress' (detail) 1980. Eight paintings unwoven and remade into eight objects. *Collection of the artist*

spheres or burettes, a practice that has continued for more than twenty years. The point, perhaps, is continuity. (Hiller once titled a work 'Sometimes I Think I'm a Verb instead of a Pronoun'.) In an installation called 'Work in Progress' (fig.30), she unwove the canvas of one of her paintings, hung the strands on the wall and at the end of the first week remade them into 'doodles' – her own word – and cut the rest into rectangles, then the following week showed them in piles on a shelf. As happens so frequently in Hiller's work, change of state seems inbuilt, an inevitability, and the most obvious metaphor for the production of the work in general is of a palimpsest, a constant obliteration or revision, searching and re-searching at the same time.

'An Entertainment' (no.28) consists of a video installation in which scenes taken by Hiller from over thirty English Punch and Judy shows are projected onto immense screens which surround and dwarf the viewer. The normal conditions of viewing, in which the audience is at a distance from the box-like theatre, are thus dramatically reversed. The violence of Punch and Judy never loses its power to shock. Mr Punch terrorises and beats his wife Judy and her baby, flouts law and order and finally even defies death itself. Traditionally a crooked figure with an elongated, curved nose and chin, exaggerated by his cap, Punch may relate to English jesters or to the French (perhaps originally Arabic) *guignol* puppets. However, black humour for its own sake does not exhaust the significance of a lord of misrule

who seems possessed by an urge not only to challenge authority but also to overthrow the universe, its conditions and laws. How strange that Punch survived the centuries as an anarchic force. Perhaps Hiller is right when she points out that 'The baby-battering, wife-beating, homicidal violence of the central character too clearly reflects the actual conditions of patriarchy, and the emphatic centrality of the nuclear family and domestic setting emphasise what is commonly known but universally denied.'[9] His triumphant '*That's* the way to do it!' and his constant denials of guilt – 'Oh no, I didn't!' followed immediately by the cry from the audience of 'Oh yes, you did!' – make him a master of effrontery, neither an individual nor a type but simply a force to be reckoned with. All in all, a bad influence: a liar and a psychopath, useful only for terrifying grown-ups while delighting children. (Not all of them, however; one is heard bursting into tears.) Hardly surprisingly, at one point the puppet representing Judy's baby is tossed high into the air, no longer with a hand inside it, and therefore dead. No doubt it is all thoroughly 'wicked' and 'naughty', as Punch reminds us. One problem is that nothing can be done about it. Another is that Punch, a kind of Tamburlaine, dominates anyone and everyone, forcing them to do his bidding. Whereas Tamburlaine the Great, Christopher Marlowe's Scythian shepherd hero, changes as the play goes on, Punch is and remains a grotesque. In fact, his role is simply to *exist*: as a malign force, a terrifying, one-dimensional figure with no real reasoning skills or sympathy, above all no humanity. While Mr Punch behaves like the effigy he is, we, thrilled by his capacity for simultaneously resisting arrest and raising the stakes, suspend not only our disbelief but also the operations of our moral apparatus. This is barbaric ritual slaughter but at the same time light-hearted picaresque: a Tom and Jerry cartoon before such things existed.

Underlying Hiller's entire enterprise, a series of forays into unknown territory, is a powerful sense of art as a kind of story-telling. The darkness of 'An Entertainment'; the emphasis on imagery summoned by the viewer in response to the flickering flames in 'Belshazzar's Feast', a work of fiction as well as an examination of the conditions for fiction; the power of hearing in 'Monument'; all serve to direct attention towards a conditional state of mind: that 'as if' terrritory in which the subject is happy to relinquish control. This zone could be described as social rather than individual; it emphasises

fig.31 'Monument' (detail) 1980–1. Photographs, audio tape and park bench. *Tate Gallery*

what people have in common, notably their dreams and fantasies. Little wonder that Hiller has researched the respective potential of the right and left sides of the brain, masculine and feminine, Punch and Judy, and, most recently, forgetting and remembering (Lethe and Mnemosyne) in her exhibition at the Freud Museum in London, which included her own work among the other objects on display.

Just as she refused to ignore the traditional role of sibyl in her automatic writing, and recognises that conventional theories of time or even of individual identity may be mistaken and that dream plays a crucial role in our lives, so she constantly winds these strands together, disparate though they might seem.

Stuart Morgan

Notes

1 Unpublished interview with the author, 27 March 1995.
2 Ibid.
3 Susan Hiller, *Sisters of Menon*, London 1983 [n.p.].
4 'Looking at New Work: An Interview with Rozsika Parker, 20 December 1983', in *The Muse My Sister: Susan Hiller 1973–83*, Derry 1984, p.25.
5 Ibid., p.19.
6 Unpublished interview with the author, 27 March 1995.
7 Ibid.
8 Ibid.
9 Susan Hiller, 'Hand Text', unpublished notes for 'An Entertainment' 1990, quoted by Guy Brett, 'Susan Hiller's Shadowland', *Art in America*, April 1991, p.143.

following six pages: no.28

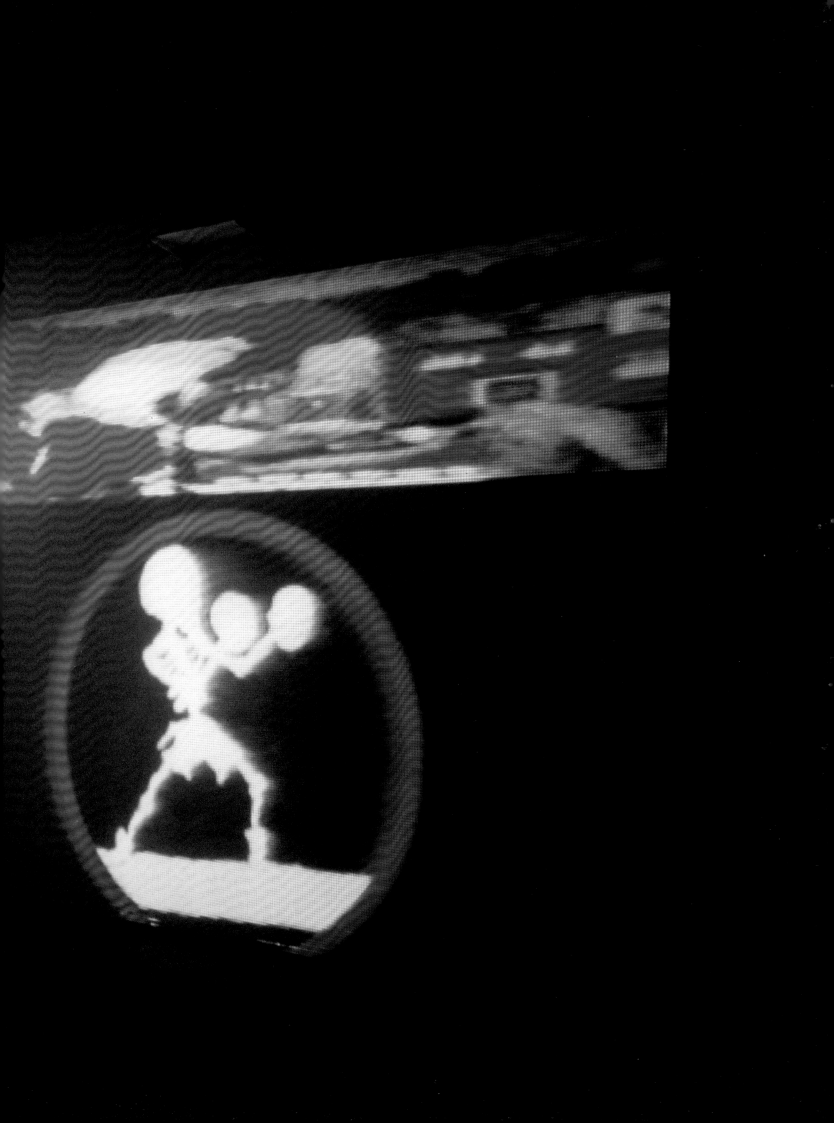

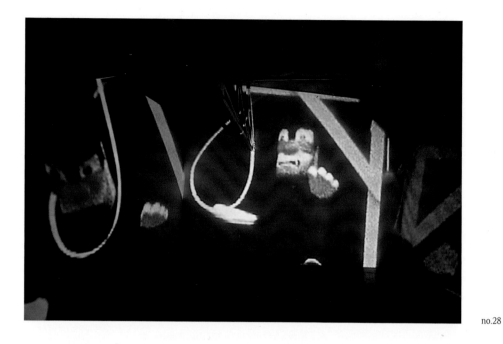

no.28

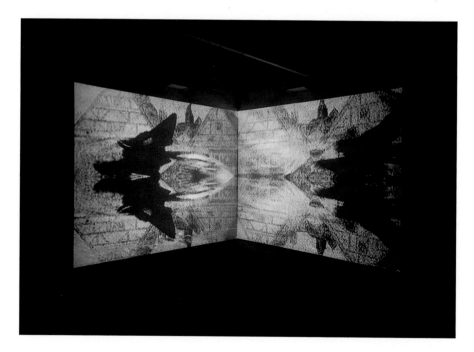

no.28

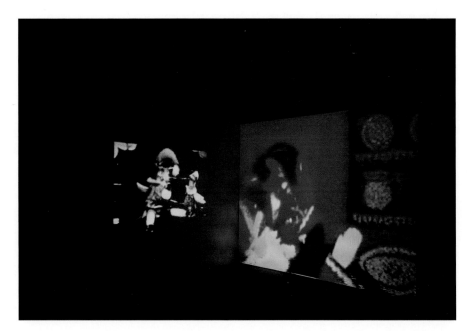

no.28

no.28

Jana Sterbak

In Franz Kafka's short story 'Metamorphosis' Gregor Samsa, the ineffectual hero whose hopeless inadequacies provoke in him both guilt and self-loathing, wakes up one morning to find that he has been transformed into an insect. This condition accurately reflects his self-image. He swiftly gives up all pretence at hope or ambition and dies. Ironically, the pathetic Gregor symbolises the idea of the artist as all-powerful creator, for unbeknown even to himself, he has the power to make metaphor reality, and to transform himself into what he really is – a creature whose alienation from the real world is total.

The idea of metamorphosis is an attractive one to Jana Sterbak. Her work has continually demonstrated an interest in the boundaries between different states, and in particular the network of relationships at play between our cultured existence and our biological make-up. These relationships are explored in her most recent work, an iconoclastic homage to Josef Beuys entitled 'Absorption' (no.31). The work was inspired by the true story of how one of the edition of felt suits or 'Filzanzug' made by Joseph Beuys in 1970 had been damaged by moth infestation while in museum storage in 1986. Sterbak's work brings together a Beuys suit and a small text with an accompanying photograph. The photograph is of herself bound from head to foot in paper and supported by a friend. From this makeshift cocoon she imagines herself metamorphosed as a moth. Progressively the moth consumes the fabric of the felt suits, which are distributed between museum and private art collections around the world. Yet unlike Kafka's terminally useless insect-man, Sterbak's moth is triumphant, finding a parasitic support system in the man-made world, eating through the very stuff – culture – that supposedly raises humanity above the animal world. Misguided conservators, culture's own 'doctors', may attempt to stop the rot, but death is inevitable. Sterbak's 'Absorption' is therefore a kind of *memento mori*, highlighting the nightmarish truth that all of us are at one and the same time,

parasites and hosts, involved in a ceaseless cycle of growth and decay.

In Beuys's conception the 'Filzanzug' was closely related to the felt sculptures that he had made during performances such as 'Infiltration-Homogen for Grand Piano, the Greatest Contemporary Composer is a Thalidomide Child', performed at the Staatliche Kunstakademie in Düsseldorf on 7 July 1966. For Beuys the substance of felt, made from the compressed hair of hare or rabbit, was an element which denoted both isolation and warmth, rather like fat which he also employed frequently in his work. Beuys later explained that what he meant by warmth was something spiritual: 'I'll call it the process of evolution, which goes way back – light, warmth, corporeality and finally in corporeality the spiritual activity – so that man is characterised as a creative being.'[1]

Much of Jana Sterbak's work explores subjects that lie at the interface between our bodies and our selves. On one side is our demonstrable animality, our corporal being, and on the other are the things that we make and do, that seem to transcend the limitations of our physicality. Creation myths have, throughout history from Prometheus to Frankenstein, been a way in which people have sought to discover the secret of life, to express the mystery of inspiration, to escape the limits of the physical. Even Kafka's dark tale is a kind of creation myth, and one in which the destructive tendency inherent in any creative act is brought to the fore. Jana Sterbak is fascinated by the prevalence and meaning of such stories, and has explored the tradition in a number of important works.

One of the earliest of these was 'Golem: Objects as Sensations' 1979–82 (fig.32). The Golem, which means 'unformed' in Hebrew, is a character from Jewish folklore who was modelled from clay by a certain rabbi Jodah Low Ben Bezalel in sixteenth-century Prague. The Golem story is linked to medieval alchemical tradition and to ancient myths of resurrection and birth. The

objects in Sterbak's installation are roughly fashioned versions of human organs, laid out like the eviscerated remains of a postmortem examination, or funerary or votive offerings. Particular psychological states are evoked by her combination of a surrogate organ and a particularly symbolic material substance. Sterbak has always been interested in materials and the ways in which they can convey emotional and cultural values as well as communicate psychological states. She relates this to the fact that she started making art at a time when artists were beginning to question Minimalism's adherence to neutral materials. As Sterbak recalls, 'I was educated at a time when minimalism was being expanded to include the psychological realm. I wanted to expand this discourse to include the specific properties of the material I was using, to the point where the physical properties of the material world inform the content of the work as much as the shape the material assumed.'[2] In 'Golem' the heart, for example, is made of lead and inevitably suggests a notion of heavy-heartedness or melancholy. The spleen is painted fiery red, the stomach is tightly knotted. Sterbak's notebook records her dual ambition in 'Golem' to make us identify material metaphors for sensations and investigate the ways in which we try to re/create ourselves: 'In making the sensations / I build my insides / I make myself / I am at once the Golem & its maker.'[3]

Ideas of the double and of colonising another's identity are ways of escaping from the dread of human isolation, of avoiding our fate, of duping mortality. Both are dangerous and destructive games. 'I Want You to Feel the Way I Do... (The Dress)' 1984–5 (no.29), refers, in the first instance, to the story told by Euripides of Medea, daughter of Aeëtes, king of Colchis and keeper of the Golden Fleece. Medea, skilled in magic and sorcery, married Jason and helped him to get the Fleece, flinging the dismembered body of her brother Apsyrtus into the sea in order to delay her father's pursuit. When Jason later fell in love with Glauce from Corinth, Medea took revenge, sending Glauce a poisoned garment and killing her own two sons before fleeing to Athens. Sterbak was drawn to this tale of passion and revenge, and fashioned a strange free-standing garment from wire mesh: its wide central area is bound with an electrical filament which, when activated by the viewer's presence, glows with a heat that is both attractive and repellent. The arms of the dress are raised as if in greeting, yet all the mesh skin of the dress reveals is an empty inside. The element of heat might symbolise the trajectory of love growing from a keen young flame to a fiery rage, then dampening to embers and finally ashes, or the binary play of possession and rejection; the accompanying text, which in literal terms tells a bitter tale of parasitic self-destruction, explores the dangerous games we all play in creating and projecting our own personas: 'I want you to feel the way I do ... I want to slip under your skin; I will listen for the sound you hear, feed on your thought, wear your clothes. Now I have your attitude and you're not comfortable any more. Making them yours you relieved me of my opinions, habits, impulses. I should be grateful but instead... you're beginning to irritate me ...'.

When Prometheus fashioned men in the image of the Gods from clay and water, he gave fire to Man to make him superior to Nature. Sterbak is interested in those things which, in our own day, fire us, which make us distinct from the natural world in which we are inevitably

fig.32 'Golem: Objects as Sensations' 1979–82. Lead, bronze and gelatin silver prints. *National Gallery of Canada, Ottawa*

enmeshed through our physical being. This fire is our cultural life and it is in particular to art, science and technology that Sterbak addresses herself.

'I Want You to Feel the Way I Do … (The Dress)' was the first in a continuing series of work using clothing to explore our encultured state. Clothing is after all a universal symbol of human culture. It is also a complex means by which we try to create, and then project, our self-image within a set of conventions which convey our age, nationality, class and gender.

Sterbak mocks our obsessive concern with self-image in her powerful, shocking 'Vanitas, Flesh Dress for an Albino Anorectic' 1987 (no.32). In the best tradition of *vanitas* painting, the work of art – here a dress fashioned from cuts of flank steak – draws our attention to the inevitable decay of all animate things and thus to the transience of earthly pleasures. Seventeenth-century *vanitas* painting combined simple objects in still-life tableaux to serve as allegories of the human condition. Objects which decay, wilting flowers, over-ripe foodstuffs and flickering candles were all motifs that served to evoke the fragility of human existence and the brevity of our stay on earth. The intention of the genre was to induce contemplation of the eternal, spiritual realm. Such images were premised on the notion of an absolute divide between the body and soul, a notion enshrined in Western philosophy since Plato. In horrific contrast to the mildly moralising tone of her forebears, Sterbak's work refuses to privilege the spiritual over the carnal. Here the spiritual is simply absent. Beyond the feminist readings that the work inevitably inspires, 'Vanitas' is a truly obscene work – not merely because dessicating meat is disgusting but because it transgresses the tacit line between what is and what is not representable; the artist refuses to veil her message in allegory.

According to Sterbak much of our cultural life is a doomed attempt to escape the vanity of the flesh. Technology might seem to liberate but it also ensnares. 'Remote Control' 1989 (fig.33) is a skeletal garment, modelled on the mid nineteenth-century crinoline, and a fantastic vehicle for propelling a person across the ground. The passenger/wearer sits in a fabric harness and is able to guide the movement of the dress through a small control unit. Here technology is seen liberating the body from its weakness, conferring freedom of movement, empowering its passenger and offering seemingly limitless mobility. But passenger and driver need not be the same person and as soon as control is passed to an outside agent the realities of our technological world are brought sharply into focus. Instead of freedom we have control, in place of power we have dependency.

Sterbak was brought up in Prague under a restrictive Marxist regime. After the Soviet invasion of Czechoslovakia her family emigrated to Canada, and North America's high-tech version of liberal capitalism replaced one set of certainties with another. Thus was born the artist's cynicism and her distrust for systems bound by rules. What interests her is the space we all, as individuals, negotiate for ourselves: what we might call our character and what might still be called our soul. In Sterbak's work there is no simple division between body and soul, between the physiological and the psychic realms. She does not subscribe to the view offered by contemporary cognitive psychologists that there is no distinction between consciousness and the biochemistry of the brain, but she is certain that we are less individual than we like to think. Some years ago she explained: 'I do not think of myself as a discrete entity. In fact, I think there is no such thing, on the emotional, social, economic, even

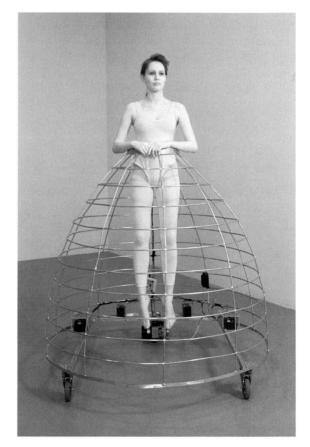

fig.33 'Remote Control' 1989. Aluminium, motorised wheels, batteries. *Donald Young Gallery, Seattle*

the atomic level. Only in the most narrow sense are we discrete entities.'[4] It is perhaps for this reason that Sterbak is fascinated by those individuals who are demonstrably more individual than the rest of us, who are moved by inspiration. A part of 'Golem' referred to this elusive and often self-destructive gift. One of the framed images included was subtitled 'Malevolent Heart'. The material cited as a medium was radioactive fermium. According to Sterbak it was 'a portrait of someone who burns the candle at both ends'[5] and was intended to demonstrate the paradox that creation so often involves destruction. Accordingly 'The object is the heart and the material destroys itself every 100 days (its half-life) so that in being very dangerous to its environment, it is also diminishing and dying, consuming itself.'

Other works of Sterbak's use metaphors of fire, energy and light to invoke the idea of inspiration. These elements are incorporeal, cannot be embodied as such, and thus perfectly express the idea of a divine spark, originating who knows where. For this idea Sterbak quotes Rimbaud: 'I am present at the birth of my thought. I look at it and listen.'[6] A work she dedicated to Stephen Hawking, whom Sterbak sees as a modern version of the *poète maudit*, is entitled 'I Can Hear you Think' (fig.34).

Sterbak's diverse subject matter is the result of a vivid and occasionally demonic imagination; it is fuelled by her passion for literature and art, ancient and modern. She has the ability to think mythologically, finding in stories of the lives of people and gods patterns and meanings that transcend the literal. Little of her work springs from a desire to deconstruct her own autobiography: art is not for her a personal form of exorcism. Her work is less the embodiment of passion than a cool and considered dissection of what it means to be both passionate and embodied.

Frances Morris

fig.34 'I Can Hear you Think (Dedicated to Stephen Hawking)' 1984–5. Cast iron, copper wire, transformer, magnetic field, electrical cord. *National Gallery of Canada, Ottawa*

Notes

1 Joseph Beuys, quoted in J. Schellmann and B. Klüser (eds.), *Joseph Beuys: Multiples*, Munich 1980, [p.9].
2 Jana Sterbak, Artist Text, in *The Impossible Self*, exh. cat., Winnipeg Art Gallery 1988, p.70.
3 Jana Sterbak, notebook, quoted by Diana Nemiroff in *Jana Sterbak: States of Being*, exh. cat., National Gallery of Canada, Ottawa 1991, p.25.
4 Winnipeg 1988, p.67.
5 Ibid., p.70.
6 Ottawa 1991, p.25.

I want you to feel the way I do: There's barbed wire wrapped all around my head and my skin grates on my flesh from the inside. How can you be so comfortable only 5″ to the left of me? I don't want to hear myself think, feel myself move. It's not that I want to be numb, I want to slip under your skin: I will listen for the sound you hear, feed on your thought, wear your clothes.

Now I have your attitude and you're not comfortable anymore. Making them yours you relieved me of my opinions, habits, impulses. I should be grateful but instead … you're beginning to irritate me: I am not going to live with myself inside your body, and I would rather practice being new on someone else.

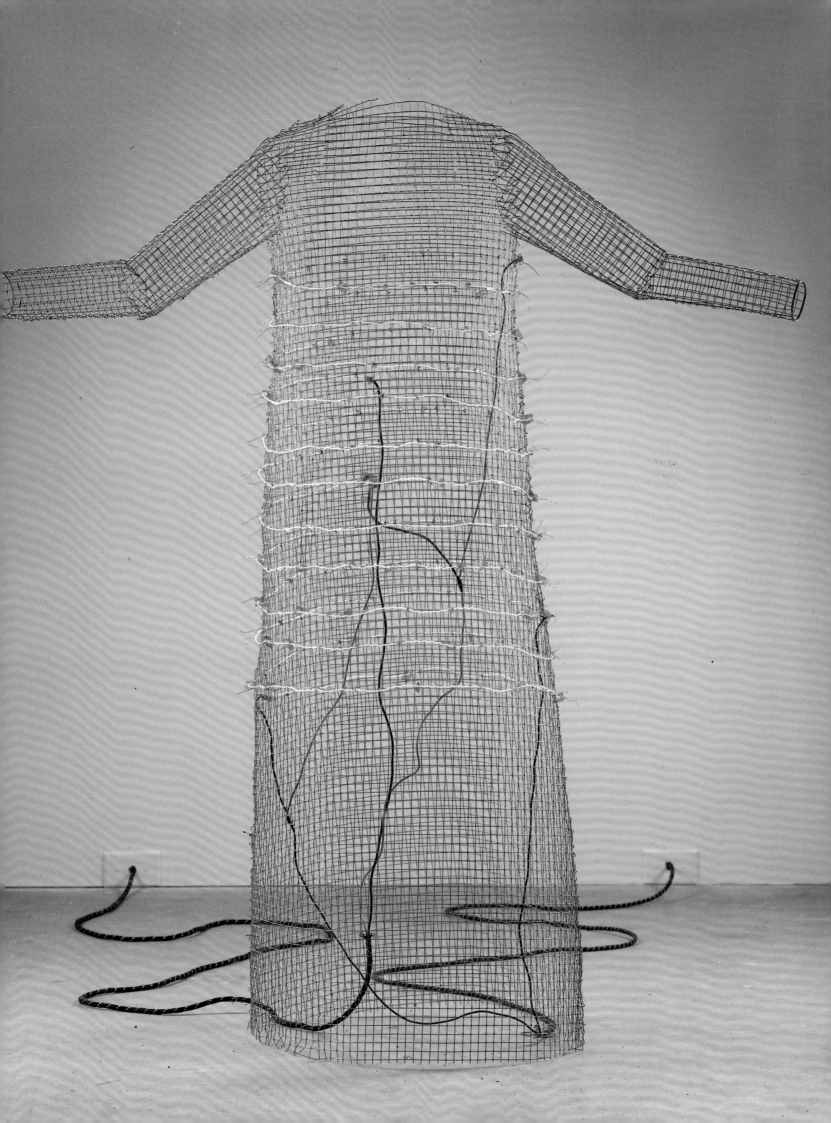

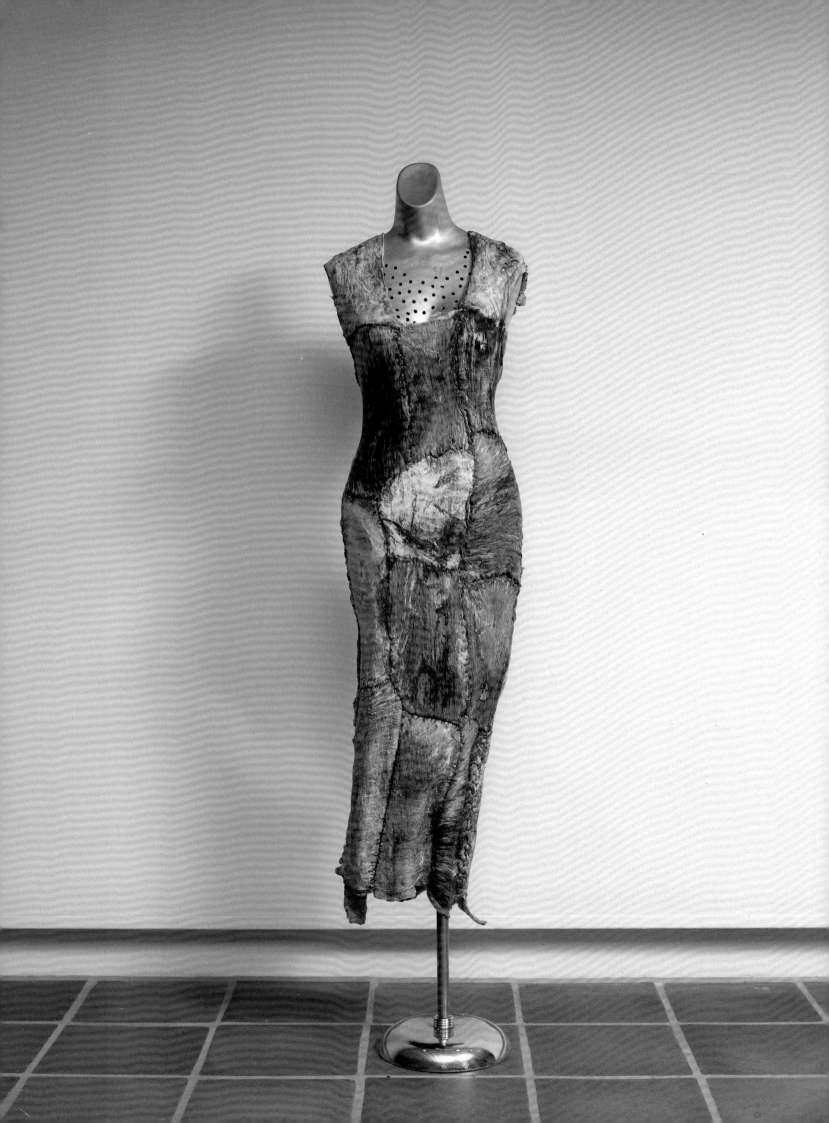

no.30

The method

INSIDE A GLASS CASE, in the repository of the Museum of American Indian, stands the shrunken body of a Portuguese sailor, made in the manner of the shrunken heads of the Shuara indians. The body was most probably subjected to evisceration and removal of bones prior to boiling. It was then stuffed with hot stones and sand to preserve its shape.

The object

INSIDE A GLASS CASE, in the Lenin mausoleum on Red Square, lies the embalmed body of Vladimir Illych Ulyanov.

The example

A woman's leather glove, size 7 was put through the wash and dry cycle.

following double page: no.31

Absorption, Work in Progress

In 1970, nine years before my first wearable pieces, Joseph Beuys created
the first of his felt suits.

I became aware of it in 1986 and its existence has bothered me ever
since... At the beginning of the nineties I conceived of a solution: the
absorption of the suit. To this end I have metamorphosed myself into a
moth, (see photo) have proceeded systematically to eat one after another
of the 100 suits Beuys sold to private and public collections around the
world.

In some cases, my activity was temporarily disrupted by misguided
conservation efforts... Nevertheless, it would not be immodest or
inaccurate to state that I have already put more than one suit out of its
exhibition condition.

My work is not easy, but it's not without reward, and, most important,
it continues.

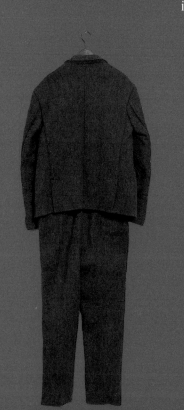

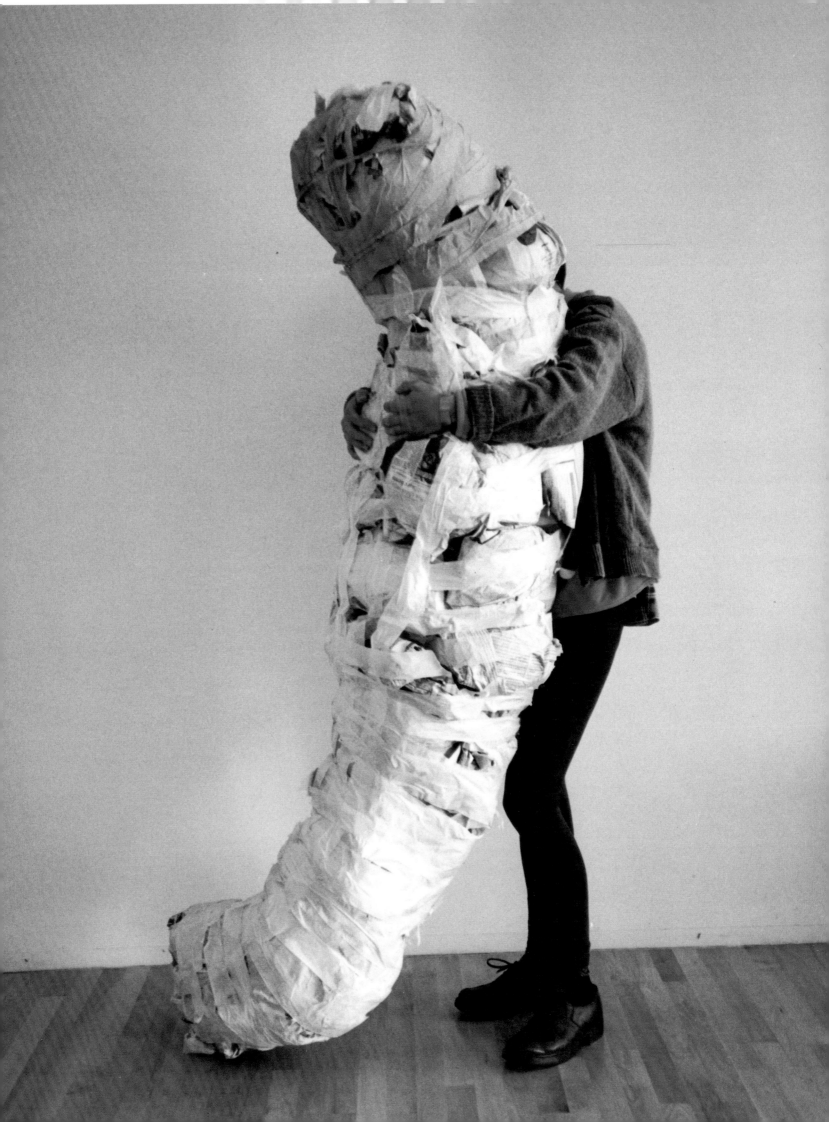

Bill Viola

The larger struggle we are witnessing today is not between conflicting moral beliefs, between the legal system and individual freedom, between nature and human technology; it is between our inner and our outer lives, and our bodies are the area where this belief is being played out. It is the old philosophical 'mind-body' problem coming to a crescendo as an ecological drama where the outcome rests not only upon our realisation that the natural physical environment is one and the same as our bodies, but that nature itself is a form of mind.

Bill Viola[1]

Alone and awake for three consecutive days at his home in Syracuse, Bill Viola allowed the camera to record him sitting, scratching, pacing up and down... The result could have been documentary. Instead – for both viewer and protagonist – it was a study in endurance, exile and altered consciousness. 'Making strange', the Russian theorist Viktor Shklovski called this technique, proposing it as a prime motive of art. The phrase implies a particular distance between actor and audience, reader and text: a heightened feeling for the grain of wood or the *timbre* of a voice that can be appreciated only by a diversion from more usual kinds of attention. Viola has based entire works on that principle; in 'Chott el-Djerid (A Portrait in Light and Heat)' (fig.35) the motionless camera registers what resemble bundles of flame advancing towards it. (Finally the mystery is solved; they are vehicles, and currents of hot air rising from the desert cause the distortions.) Viola's alienation effects are symptomatic of his work in general; extended periods of watching and passive registration of images, culminate in a critique of vision itself. Taping in the desert was 'like physically being in someone else's dream', Viola recalls.[2] Parallel experiences recur throughout his work. (For example, in 'Hatsu Yume (First Dream)' 1981 what resembles a massive rock, which every figure has to negotiate, turns out to be only a small boulder. Similar-

ly, in the video installation 'Passage' 1987 (first installed in the Museum of Modern Art, New York), a tunnel through which the viewer approaches a screen showing vague, slow-motion loomings like giants doing battle, finally gives onto a high space in which the viewer realises the truth: expanded to massive proportions and slowed down to funereal pace, this is simply a home-movie of a child's birthday party.) The result never disappoints; wonder ousts common sense. Are we capable of standing and watching, powerless, as a woman gives birth? This is what is demanded of viewers of the 'Nantes Triptych' (fig.36). Is it possible to wait without flinching as a woman dies, which the 'Triptych' also shows? Similar images occur in 'The Passing' 1991 (fig.38), a summation of one period of Viola's work: a meditation on states of consciousness and being in which dream and reality are indistinguishable but where what lingers in the mind is an interstitial zone in which confusion reigns, in terms not only of what is seen but also of the registration of external data. States of vision and states of mind are one and the same, Viola demonstrates.

fig.35 'Chott el-Djerid (A Portrait in Light and Heat)' 1979. Videotape, colour, mono sound. Photo: Kira Perov

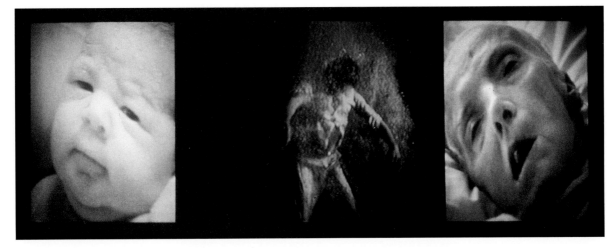

fig.36 'Nantes Triptych' 1992. Video/sound installation. *Edition 1: Musée des Beaux-Arts, Nantes. Edition 2: Tate Gallery*

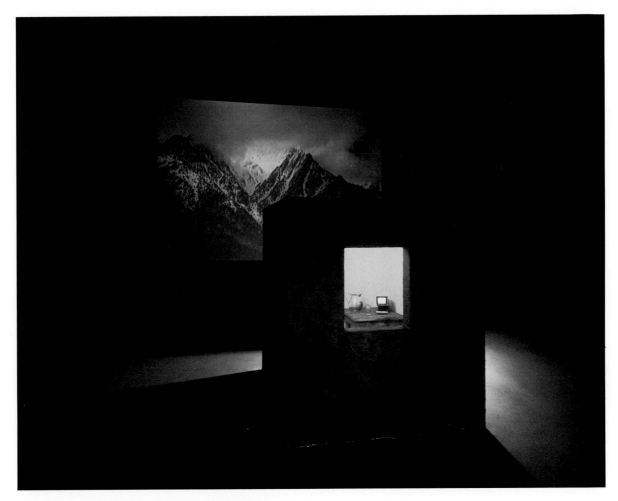

fig.37 'Room for St John of the Cross' 1983. Video/sound installation.
*Museum of Contemporary Art, Los Angeles. The El Paso Natural Gas
Company Fund for California Art.* Photo: Kira Perov/Squidds & Nunns

Traditionally, seeing has been considered an 'out of the body' event. Viola disagrees. 'Art has always been a whole-body, visual experience,' he argues in a recent interview.[3] A representative work is 'Room for St John of the Cross' 1983 (fig.37), in which the physical and mental situation of the sixteenth-century mystic and poet was evoked by a space in which images of high, bare mountains appeared, surrounding the viewer. An already stark setting was made unbearable by the movement of the mountains on each wall; the camera registering the image was lurching from side to side, suggesting loss of control, desperation, but also freedom. (This was what a bird might see as it is in flight.) Wandering in this large, dark space, the visitor eventually discovered the second element of the installation. Stable and meditative, visible from only one side and lit from within, it was a scale-model of the cell from which John prayed and wrote during his incarceration – sometimes in ecstasy, sometimes despair. Though his teachings were denounced and his body imprisoned, captivity failed to break his spirit. Inside was a dirt floor, a wooden table, a glass of water, a metal jug. A voice could just be heard reading his poetry. From hour to hour the light changed. Oddest of all, a tiny video monitor showed mountains, no longer in monochrome but now in vivid colour. John was tortured for his belief in the possibility of direct communication with God, but also for his friendship with St Teresa, with whom he revolutionised the Carmelite order, turning its worldly attitude to one of contemplation. The single hawk seen flying free, buffeted by wind, resembled the embattled soul of John himself.

Marie Luise Syring has suggested a narcissistic phase in Viola's work from 1973 to 1979.[4] From 1979 onwards he continued to feature in his own works but turned his attention to dreams, apparitions and symbols. The eighty-six minute 'I Do Not Know What It Is That I Am Like' 1986, for example, is a disorienting anthology of transformation. The title, taken from the Sanskrit *Rig Veda*, stresses the compulsion to discover oneself. (The assumption is that human beings have lost touch with the cycles and significances of the natural world.) The genre is the quest, which takes us underwater, through caves, to a sequence of wonders. Flies cover the carcass of a dead buffalo. We look into the eyes of live buffalo as they graze. In a strange, nocturnal sequence the artist is seen eating a fish; an episode in which the camera is attacked is followed by a sequence in which we seem to be in India where wailing pipe music accompanies men

fig.38 'The Passing' 1991. Videotape, black and white, mono sound. Photo: Kira Perov

who walk across hot coals, and a procession of men with grotesquely pierced faces takes place on the bank of a river. The work ends with an impossibility: a fish seems to fly through the air before landing and decomposing on the shore. This is what the early film-maker Georges Méliès dreamed of: a cinema of miracles. An ornament turns out to contain a live, decorated snail, a buffalo walks through a man's living-room. As in so much of Viola's work, the result is a running attack on our attitude to the rest of creation. And since creation itself is honoured, caste systems of any kind no longer apply. Most remarkable of all is Viola's refusal to explain. 'A fully understood idea is a dead idea', he has written. 'My work has taught me that places of shadow are far more interesting than fully illuminated rooms. The creative process has its roots in the state of confusion, unclarity and non-understanding that precedes all insights. This "Cloud of Unknowing", to quote the title of a thirteenth-century classic book on Christian mysticism, is for me the highest state and most energised time. It is the still turbulence of three-thirty in the morning – nothing happening on the surface but everything going on underneath. It is the time of risk and the point of unification between art, science and all creative activities. Its centre is personal transformation. Not only is this awareness necessary for the genesis of new thoughts but it is this process that all works of art must actively re-create in the viewer if they are to move us beyond the confines of time and place.'[5]

In recent years, Viola has turned to his private life for inspiration. The key work from this stage of his career is 'The Passing', not only a film in its own right but also a portmanteau to be unpacked in other, related pieces.

(The gigantic 'Arc of Ascent' 1992, for example, (first shown at Documenta IX in Kassel), consists of a giant screen and on it a vast figure submerged in water.) In and out of water; asleep and awake; inhabiting or surrendering one's body, literally or not; in and out of control... Though the contrasts become as regular as the systole-diastole rhythm of the heart, each shift demands an entire revision. In sleep, nothing can be taken for granted. States of panic alternate with states of tranquility, yet the triggers for either are unexpected, sometimes shockingly so. Birth and death are intertwined. What does it mean for a small child to emerge from water and burst back into a world of noise and sun? What does it mean to dream of drowning, to be dropped into a room with tables and vases of flowers only to find you are dead? What does it mean when even death – a motionless, airless, submarine sanctuary – can be blown to smithereens? We can die anywhere and be reborn. Or remain in purgatory, undelivered. Whether we have any choice remains unclear. Increasingly, Viola's work is a matter of life and death.

Entering a black space, the viewer is surrounded by the kind of interference that afflicts televisions when no image is being transmitted. On the walls of the gallery, not black but deep grey, like large monochrome paintings, there is something to see, but not quite enough. The sound is equally incoherent: noise without words, issuing from a number of people, their voices blurry, their implied abjection very great. Emphasis on mumbling and its visual equivalent proves disconcerting, as if loss of sight and hearing prevails and perception has become a test (at least), an ordeal (at most). Only desire for meaning and the anticipation of incident keep visitors involved. Then one of the screens bursts into sense. A person materialises, occupying a shallow space, preoccupied in some cases, outgoing in others. A man in a baseball cap, pensive, his gaze averted; a woman in white who is equally involved with her own thoughts and who raises both arms slightly; a sick looking man with a stick. Their images gain in power and focus, but as this happens they flare up and disappear at the very point when we want more of our new acquaintances. Haunted by after-images, we feel cheated. Those muffled voices frighten us. Do people burn out like fireworks? Or are they present always, if not in corporeal or even visible form? Why should corporeality be the only token of human presence in which we place our trust? Much of Viola's recent work is drawn from imagery used in 1991

in 'The Passing'. The image of a flaring light in particular recalls the candles and lamps in that work, the image of cars moving down desert roads in the distance, like balls of fire in the night or the strange, flame-like phantoms approaching us in 'Chott el-Djerid'. Yet in this work might each of the 'tiny deaths' be the white interference marks on the screen: the spawn or husks of the people who burst into view? On the walls, vestiges of figures remain as after-images. Or are they ghosts haunting the room, waiting to appear? Emphasis on brilliance or its opposite, a looming shadow, seems to negate our usual idea of death, whether rebirth is part of the cycle or not. Instead, it hints at a previous life as well as an afterlife, and a category of potential people waiting for a body to occupy. Characteristically, Viola insists on the eternal return, the wheel of rebirth and the need for different views of death and its meaning.

Stuart Morgan

Notes

1 Bill Viola, 'The Body Asleep', in *Pour la suite du monde*, exh. cat., Musée d'Art Contemporain de Montréal, 1992.
2 *Bill Viola*, exh. cat., Paris: Musée d'Art Moderne de la Ville de Paris 1983, p.29.
3 Otto Neumaier and Alexander Puhringer, 'Putting the Whole Back', in *Bill Viola*, exh. cat., Salzburger Kunstverein 1994, p.138.
4 Marie Louise Syring (ed.), *Bill Viola: Unseen Images*, exh. cat., Stadtisches Kunsthalle, Düsseldorf 1992, p.21.
5 Bill Viola, unpublished notes on 'The Passing'.

following double page: no.33

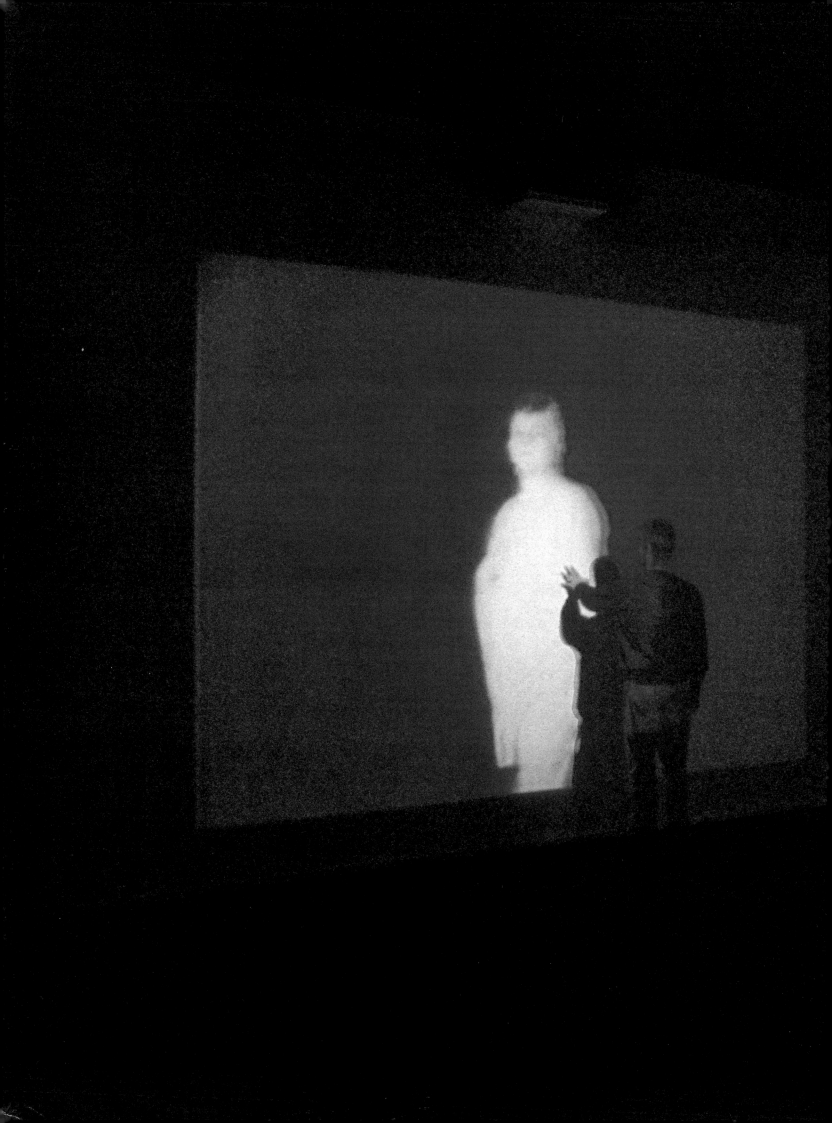

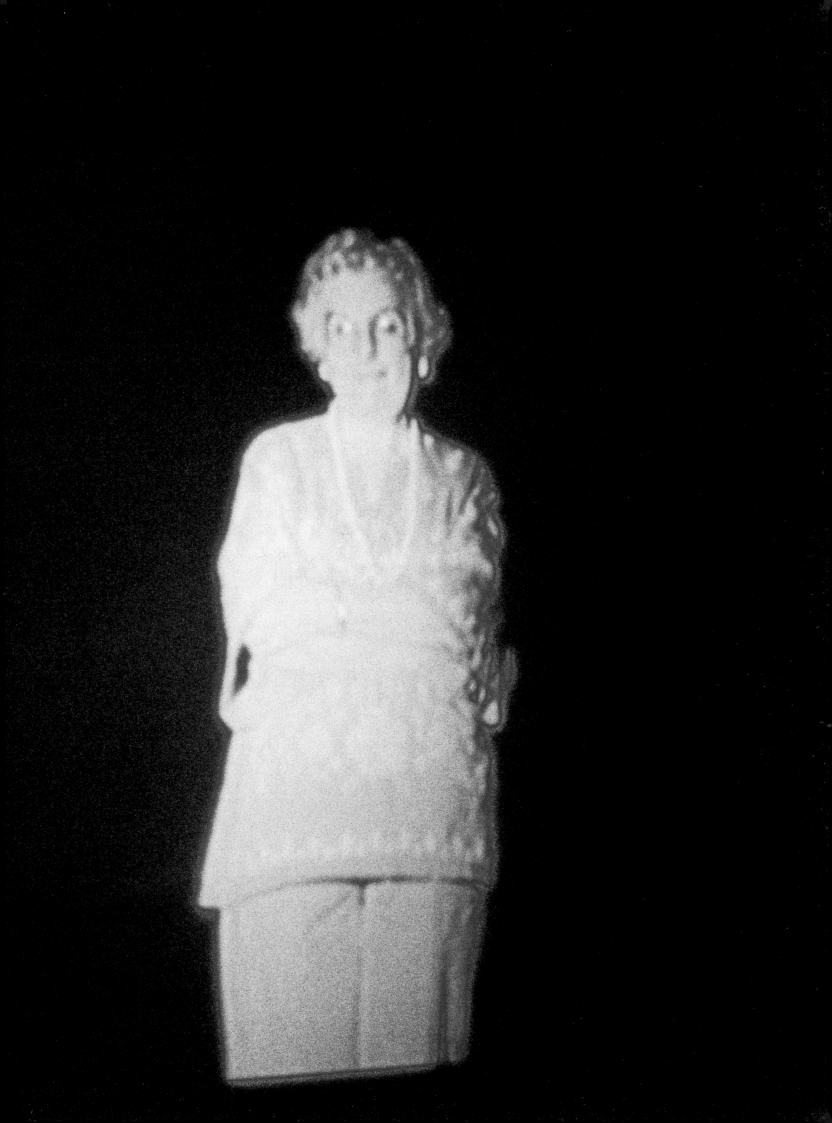

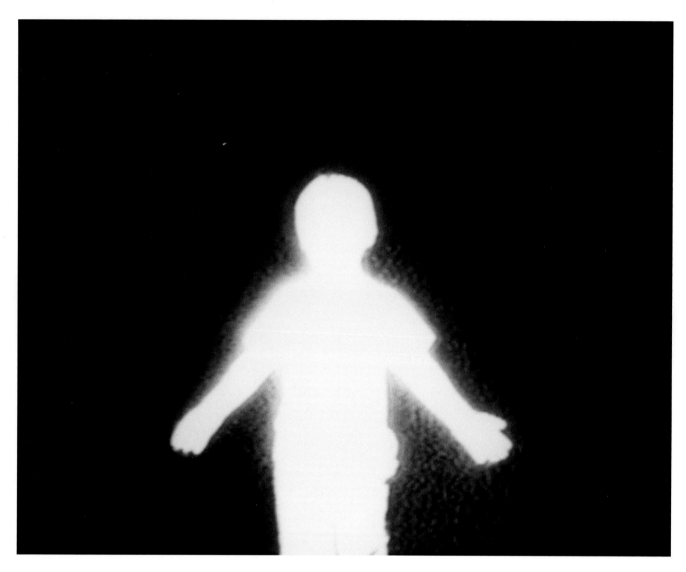

no.33

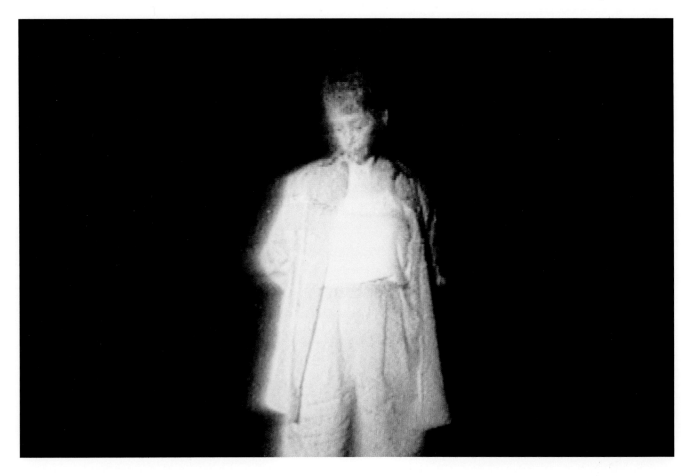

no.33

Artists' Biographies and List of Works

Biographies Compiled by
Michela Parkin

Measurements are given in centimetres,
followed by inches in brackets,
height before width before depth.
Where no measurements are given,
this is because installation size varies.

Miroslaw Balka born 1958

Miroslaw Balka was born in Warsaw, Poland, in 1958. He grew up in Otwock, near Warsaw, in the house which since 1992 he has used as his studio. He studied sculpture at the Academy of Fine Arts in Warsaw, graduating in 1985 with his diploma piece 'Remembrance of the First Holy Communion' (no.1). The work refers to a real event in the artist's life, his First Communion, and marks the passage from childhood to adolescence.

In 1986 and 1987 Balka carried out a number of actions relating to public holidays and festivals. He returned to figurative sculpture in the late 1980s, using materials such as sack cloth. Works like 'River' 1988–9 (no.3) relate to Balka's personal experiences, as well as to known cultural figures, such as Cain and St Adalbert, who suffered uncommon fates. In 1990 Balka turned away from figuration. In an exhibition in Warsaw entitled *Good God* he exhibited austere pieces, made of old, weathered boards, which resemble everyday objects such as beds, doorways or shelves, but which are deprived of any functional role. Each work was titled with its dimensions, a practice which the artist has continued to use.

In a series of exhibitions in Warsaw, Cologne and Los Angeles in 1991, Balka exhibited metal objects based on the measure of his own body. Successive international exhibitions were titled *36,6* and *37,1*, after the Celsius norms of body and subfebrile temperature respectively. In them Balka combined his earlier interest in the body with the inspiration provided by his inherited family home where he currently works.

Balka was chosen to represent Poland at the Venice Biennale in 1993. He lives and works in Warsaw.

1 *Remembrance of the First Holy Communion* 1985
 Steel, cement, marble, textile, wood, ceramic and photo
 $170 \times 90 \times 105$ ($66\frac{7}{8} \times 35\frac{3}{8} \times 41\frac{3}{8}$)
 Muzeum Sztuki, Lodz
 Illustrated on p.36

2 *Fire Place* 1986
 Wood, plaster, bricks, newspaper, blanket and electric light
 $110 \times 230 \times 205$ ($43\frac{1}{4} \times 90\frac{1}{2} \times 80\frac{3}{4}$)
 Tate Gallery. Purchased 1995
 Illustrated on pp.38–9

3 *River* 1988–9
 Steel, wood, jute, neon and ashes
 Stedelijk van Abbemuseum, Eindhoven
 [Not exhibited]
 Illustrated on pp.40–1

4 *Shepherdess* 1988–9
 Concrete, glass, wood and wire $217 \times 55 \times 62$:
 separate head 11cm high ($85\frac{3}{8} \times 21\frac{5}{8} \times 24\frac{3}{8}$: $4\frac{3}{8}$)
 The Schyl Collection, Malmö Konsthall, Sweden
 Illustrated on p.37

Joseph Beuys 1921–1986

Joseph Beuys was born in Krefeld, Germany, in 1921. Soon after, his family moved to Kleve where Beuys grew up and attended school. After embarking on the study of medicine, Beuys was drafted into the German army and served as a radio-operator and pilot in the Second World War. He was shot down over the Crimea in 1943, a fact which has assumed near-legendary status in accounts of his life because of the influences it brought to bear on his art in later life. Having crash-landed, Beuys was rescued by the Tartars who saved him from freezing to death in the arctic wastes by wrapping him in fat and felt. These two life-saving materials featured prominently in Beuys's work until his death in 1986.

In 1947 Beuys entered the Staatliche Kunstakademie in Düsseldorf to study sculpture. Nearly fifteen years later he was appointed Professor of Monumental Sculpture there, teaching until 1972 when he was dismissed for refusing to restrict the numbers of students in his classes. Throughout his life Beuys made sculpture, drawings and installations (or 'environments'), as well as films and performances. Much of his work took the form of 'actions' in which he would debate publicly, often for days on end. He was also an active political campaigner, founding a number of groups which advocated democratic reform.

As a teacher and an artist Beuys was an inspiration and mentor to a whole generation of younger practitioners. He redefined accepted notions of what constituted art with his concept of 'social sculpture', in which art pervaded all aspects of human life.

5 *Terremoto in Palazzo* 1981
 (Earthquake in the Palazzo)
 Mixed media 500 × 700 (196¾ × 275½)
 Fondazione Amelio, Naples, Italy
 Illustrated on pp.46–53

Louise Bourgeois born 1911

Louise Bourgeois was born in Paris in 1911. Her parents were tapestry restorers and it was as a child in their studio that Bourgeois first began to draw. After studying mathematics at the Sorbonne she spent a short time at the Ecole des Beaux-Arts, before furthering her training in several of the Paris studios. She also studied art history and acted as a voluntary guide at the Louvre.

In 1938 Bourgeois moved to the United States where she continued her art education. She had her first solo exhibition of paintings in 1945 but soon after abandoned painting in favour of sculpture, on which she has focused ever since.

Bourgeois's career has spanned almost half a century. In the late 1940s she produced a series of standing figures in wood which, though abstract, were endowed with a psychological presence. She went on to experiment with plaster, making a series of organic objects before pioneering the use of latex rubber in the 1960s. Her work has a strongly autobiographical content; many of her sculptures feature parts of the body, in particular the eyes. In the 1980s Bourgeois created a series of installations called 'Cells' which refer to the most basic human organism and explore themes of imprisonment and pain.

Louise Bourgeois took American citizenship in 1951 and lives and works in New York. Her first major American retrospective was held in 1982 at the Museum of Modern Art, New York, and in 1993 she represented the United States at the Venice Biennale. She is currently the subject of a large retrospective exhibition which has toured from the Brooklyn Museum, New York, to Washington (1994–5) and Prague (1995), before opening at the Musée d'Art Moderne de la Ville de Paris (June 1995) and proceeding to Hamburg (1995–6).

6 *J'y suis, j'y reste* 1990
 (Here I Am, Here I Stay)
 Pink marble, glass and metal
 88.9 × 102.8 × 78.7 (35 × 40½ × 31)
 Galerie Karsten Greve
 Illustrated on p.9

7 *Red Room (The Child)* 1994
 Mixed media 210.8 × 353 × 274.3 (83 × 139 × 108)
 Musée d'Art Contemporain de Montréal, Courtesy Peter Blum, New York
 Illustrated on pp.58, 60–1

8 *Red Room (The Parent)* 1994
 Mixed media 247.7 × 426.7 × 424.2 (97½ × 168 × 167)
 Robert Miller Gallery, New York and Peter Blum, New York
 Illustrated on pp.58–9

9 *Nature Study 5* 1995
 Pink marble and steel 50.8 × 92.7 × 58.4 (20 × 36½ × 23)
 Robert Miller Gallery, New York
 Illustrated on p.63

10 *Cell (Hands and Mirror)* 1995
 Marble, painted metal and mirror
 160 × 121.9 × 114.3 (63 × 48 × 45)
 Robert Miller Gallery, New York
 Illustrated on p.62

Hamad Butt 1962–1994

Hamad Butt was born in Lahore, Pakistan, in 1962 and moved with his family to Britain in 1964. He went to school in London, apart from a two-year stretch at the Sacred Heart School in Lahore. As a young man Butt developed parallel interests in art and science, taking A levels in biology, chemistry, mathematics and art.

Between 1980 and 1987 Butt attended a number of art schools, including Central St Martin's College of Art and Design. He made paintings, sculptures, prints and installations. In 1987 Butt began a degree course at Goldsmiths' School of Art, graduating in 1990 with one of the highest grades ever achieved by a student there.

At Goldsmiths' Butt concentrated on making installations. 'Transmission' was exhibited in London in 1990 and 'Familiars' (nos.11–13), which was commissioned by the John Hansard Gallery, Southampton, was first shown in 1992. This three-part work makes use of industrial and alchemical imagery, combining Butt's interest in science with his desire to make art.

In 1991 Butt exhibited a group of his paintings, largely abstract works and self-portraits. During the last year of his life he became interested in working with film and sound, but became too ill to follow this through. Hamad Butt died in London in September 1994.

11 *Familiars Part 1: Substance Sublimation Unit* 1992
 Iodine under vacuum, glass, infra-red lamps, timing device,
 steel sheets and white paint
 Jamal Butt
 Illustrated on pp.72–3

12 *Familiars Part 2: Hypostasis* 1992
 Bromine, glass, steel tubing, steel wire and white paint
 Jamal Butt
 Illustrated on p.71

13 *Familiars Part 3: Cradle* 1992
 Chlorine, glass, steel wire and white paint
 Jamal Butt
 Illustrated on pp.68–70

John Coplans born 1920

John Coplans was born in London in 1920, but a large part of his childhood and youth was spent in Africa and South Africa. After serving with the British armed forces during the Second World War, he attended art schools in Paris and London and became a painter.

In 1960 Coplans moved to the United States where he has lived ever since. He taught at the University of California at Berkeley, before becoming a founding editor of the magazine *Artforum* in 1962. After his last exhibition of paintings in 1963, Coplans concentrated on his work as an art critic and museum curator. He moved to Ohio in 1978 to take up the post of director of the Akron Art Museum. During the 1960s and 1970s he wrote extensively, publishing monographs on Cézanne, Warhol, Lichtenstein, Kelly and the photographer Weegee, as well as numerous articles.

At the end of the 1970s, while living in Ohio, Coplans began taking photographs, experimenting with his own body as his model. In 1980 he moved back to New York and in 1984, at the age of sixty-four, he took up photography full-time. Since then his naked body has served as the sole subject of his work.

Coplans has had one-person exhibitions throughout America and Europe. His 1988 exhibition *A Body of Work: Photographs by John Coplans* toured from San Francisco to New York (the Museum of Modern Art), Kansas City and Chicago. His subsequent exhibitions include Rotterdam (1990), Lisbon (1992) and the Centre Georges Pompidou, Paris (1994). He lives and works in New York.

14 *Self-Portrait (Standing, Side View, Three Panels, No.1)* 1993
 Silver print photographs cold mounted on Sintra board
 342.9 × 144.8 (135 × 57)
 Ludwig Forum für Internationale Kunst, Aachen. Ludwig
 Stiftung, Aachen
 Illustrated on p.78

15 *Self-Portrait (Standing, Side View, Three Panels, No.5)* 1993
 Silver print photographs cold mounted on Sintra board
 342.9 × 144.8 (135 × 57)
 Ludwig Forum für Internationale Kunst, Aachen. Ludwig
 Stiftung, Aachen
 Illustrated on p.79

16 *Self-Portrait (Frieze No.1, Two Panels)* 1994
 Silver print photographs cold mounted on Sintra board
 190.5 × 157.5 (78 × 68)
 The artist
 Illustrated on p.80

17 *Self-Portrait (Frieze No.2, Four Panels)* 1994
 Silver print photographs cold mounted on Sintra board
 190.5 × 315 (78 × 136)
 The artist
 Illustrated on pp.82–3

18 *Self-Portrait (Frieze No.3, Two Panels)* 1994
 Silver print photographs cold mounted on Sintra board
 190.5 × 157.5 (78 × 68)
 The artist
 Illustrated on p.81

19 *Self-Portrait (Frieze No.4, Three Panels)* 1994
 Silver print photographs cold mounted on Sintra board
 190.5 × 236.2 (78 × 102)
 The artist
 Illustrated on pp.84-5

20 *Self-Portrait (Frieze No.5, Two Panels)* 1994
 Silver print photographs cold mounted on Sintra board
 190.5 × 157.5 (78 × 68)
 The artist
 Illustrated on p.86

21 *Self-Portrait (Frieze No.6, Two Panels)* 1994
 Silver print photographs cold mounted on Sintra board
 198 × 172 (78 × 67¾)
 The artist
 Illustrated on p.87

Pepe Espaliú 1955–1993

Pepe Espaliú was born in Cordoba, Spain, in 1955. He studied at the School of Fine Art in Seville and, apart from brief periods abroad, lived in Spain until his death in 1993. After concentrating on painting in the mid-1980s, he began to exhibit sculpture, drawings and installations. He also became known for performance work and for his poetry and writings for the Seville-based art magazine *Figura*.

Much of Espaliú's work relates to the experience of being homosexual and, later, HIV-positive. In 1992 he made a series of installations and sculptures using steel cages which drew simultaneously on images of containment and protection. The same year he performed a number of actions entitled 'Carrying' which led to a group of sculptures with the same title. These works play upon the dual notions of being carried and being a carrier, as well as of caring for the sick.

Espaliú's work has been shown throughout Europe and in the United States. In 1994 the Museo Nacional Centro de Arte Reina Sofía in Madrid inaugurated its project room with a posthumous exhibition of his work. In the same year he was commemorated by a one-person exhibition at the Institute of Contemporary Arts in London.

22 *Untitled* 1990
 Bronze and rope 190 × 70 × 20 (74¾ × 27½ × 7⅞)
 La Máquina Española Collection, Seville
 Illustrated on p.94

23 *Untitled* 1990
 Bronze and rope 286 × 200 × 136 (112¼ × 78¾ × 53½)
 Juan Luis Libano
 Illustrated on p.95

24 *Untitled* 1992
 Steel
 La Máquina Española Collection, Seville
 Illustrated on pp.92-3

25 *The Nest* 1993
 Painted iron 125 × 65 × 65 (49¼ × 25⅝ × 25⅝)
 Fundacion Coca-Cola España
 Illustrated on p.94

Robert Gober born 1954

Robert Gober was born in Wallingford, Connecticut, in 1954. From 1972 to 1976 he attended Middlebury College in Vermont, studying literature before graduating in fine art.

On leaving college, Gober moved to New York. During his early years there, he supported himself through carpentry, making dolls houses and stretchers for artists. He also performed with a multimedia dance company. In 1978 he turned to making his own objects, beginning with plaster figures and small-scale models of houses crafted from real building materials. He also worked as a painter. Many of the images which appeared in his early painted work, such as 'Slides of a Changing Painting' 1982–3, re-emerged later in his three-dimensional work.

In 1984 Gober began to produce handmade replicas of household objects such as sinks, drains, doors and children's playpens. He also experimented with making casts of parts of his own body. He went on to site these objects in specific room installations and since 1988 has been making what he has described as 'natural history dioramas about contemporary human beings'. In his earlier room installations Gober collaborated with other artists before working alone on installations for exhibitions at the Paula Cooper Gallery, New York (1989), the Jeu de Paume in Paris (1992) and the Dia Center for the Arts, New York (1992–3). In 1993 he had one-person exhibitions at Tate Gallery Liverpool and the Serpentine Gallery, London. He lives and works in New York.

26 *Door with Lightbulb* 1992
Paper, twine, metal and light bulb
244 × 305 × 81 (96 × 120 × 32)
S. and J. Vandermolen, Ghent
Illustrated on pp.100–1

Mona Hatoum born 1952

Mona Hatoum was born in Beirut in 1952, to a Palestinian family. She settled in London in 1975, after coming on a visit and then being forced to stay by the outbreak of civil war in Lebanon.

Hatoum studied at the Byam Shaw School of Art from 1975 to 1979 and at the Slade School of Art from 1979 to 1981. Throughout the 1980s, she held a number of artist's residencies in Britain, Canada and the United States. Until 1988 she worked mainly in video and performance. Since 1989 Hatoum has concentrated on making installations, the first group of which were exhibited in 1992 at Chapter in Cardiff. She has created a number of works using metal grids which allude to physical violence and imprisonment, notably 'Light Sentence' 1992. She has also explored these themes in a number of smaller sculptures based on items of furniture, such as 'Incommunicado' 1993 in which a child's cot, symbol of innocence and vulnerability, is transformed into a vessel for suffering.

Hatoum has occupied part-time teaching positions in London, Maastricht, and Cardiff, where she was Senior Fellow at Cardiff Institute of Higher Education from 1989 to 1992. She currently teaches at the Ecole des Beaux-Arts in Paris but continues to work from her studio in London. She has had solo exhibitions in Cardiff (1992), at Arnolfini, Bristol (1993) and at the Centre Georges Pompidou, Paris (1994), as well as a number of venues across Canada.

27 *Corps étranger* 1994
(Foreign Body)
Video installation 350 × 300 × 300 (137¾ × 118⅛ × 118⅛)
Musée National d'Art Moderne, Centre Georges Pompidou, Paris 1994 (Artist's copy)
Illustrated on pp.106–9

Susan Hiller born 1940

Susan Hiller was born in the United States in 1940. She studied for a PhD in anthropology and conducted field research in Central America, until she experienced what she has described as a 'kind of crisis of conscience' which led her to turn away from a career as an anthropologist. At the end of the 1960s she moved to Europe and travelled extensively before settling in London, where she had her first solo exhibition in 1973.

Hiller's art practice centres around her investigation of the overlooked significance of certain common cultural artefacts such as old postcards, domestic wallpapers, television fantasies and memorial plaques to forgotten heroes, which she uses as basic materials. Many of her works directly employ processes related to the subconscious mind, including dreaming, states of reverie, automatic writing and improvised vocalisation. Her use of these techniques evokes the uncanny, suppressed aspects of our collective cultural production. Death, desire and language are major themes in her practice.

Hiller has worked in a wide range of media – painting, sculpture, video, photography, installation and artist's books. She has had one-person exhibitions at the Serpentine Gallery, London (1976), the Museum of Modern Art, Oxford (1978), the Institute of Contemporary Arts, London (1986), Matts Gallery, London (1980, 1991) and the Freud Museum, London (1994), as well as at numerous venues across Europe and the United States. In 1996 a major survey of her work will be held at Tate Gallery Liverpool.

Hiller is the co-author of *Dreams: Visions of the Night* (London, Paris and New York 1976, revised 1991), which examines the relationships between art and dreams, and is the compiler of *The Myth of Primitivism* (London and New York 1991), an anthology of texts by artists, critics and anthropologists.

28 *An Entertainment* 1990
Installation using 4 video projectors, quadrophonic sound and 4 interlocking 26 minute video programmes
Tate Gallery
Illustrated on pp.114–21

Jana Sterbak born 1955

Jana Sterbak, originally Stěrbáková, was born in 1955 in Prague, Czechoslovakia. Together with her family, she emigrated to Canada in 1968. Sterbak studied at Vancouver School of Art from 1973 to 1974 and the University of British Columbia, Vancouver from 1974 to 1975, before graduating in Fine Art from Concordia University, Montreal, in 1977. She had her first solo exhibition in Vancouver in 1978, then moved to Toronto to study at the University from 1980 to 1982. In 1982 she exhibited her first major installation, 'Golem – Objects as Sensations', in Toronto.

The same year she exhibited in Montreal, showing an assortment of early work in which she transformed everyday materials such as tape measures and plasticine into evocative sculptures. Since then Sterbak has used sculpture, drawing, photography, video, installation and performance in her work. Her interest lies in exploring the theme of the body as indicator of psychological and social experience. In exploring this metaphor, she has focused on the relationship between the physical properties of the materials she uses and the psychological states of human individuals.

Sterbak has had solo exhibitions in Barcelona (1993), Denmark (1993) and New York (1990, 1992) as well as throughout Canada. She first showed her work in Europe in *Aperto* at the 1990 Venice Biennale. An exhibition of her work is currently showing at the Musée d'Art Moderne, St Etienne before travelling to Barcelona and the Serpentine Gallery, London. She lives and works in Montreal.

29 *I Want You to Feel the Way I Do... (The Dress)* 1984–5
Live, uninsulated nickel-chrome wire mounted on wire mesh, electrical cord and power with slide-projected text
144.8 × 121.9 × 45.7 (57 × 48 × 18)
National Gallery of Canada, Ottawa
Illustrated on pp.126–7

30 *Shrinking Lenin* 1991
Glass and leather (text engraved in the glass, glove)
4.3 × 35.5 × 17 (1¾ × 14 × 6¾)
Reesa Greenberg
Illustrated on p.129

31 *Absorption, Work in Progress* 1995
Installation incorporating photograph, text and 'Felt Suit' 1970 by Joseph Beuys (lent by the Froehlich Collection, Stuttgart)
Courtesy the artist
Illustrated on pp.130–1

32 *Vanitas, Flesh Dress for an Albino Anorectic* 1987
Tailor's dummy and flank steak
Courtesy René Blouin
Illustrated on p.128

Bill Viola born 1951

Bill Viola was born in New York in 1951. Between 1969 and 1973 he studied art at Syracuse University, New York, graduating from the Experimental Studios of the Department of Visual and Performing Arts. He made his first experiments with Super-8 film and black and white video in 1970 moving on to produce single-screen videos, video installations and sound-based installations.

During the 1970s and early 1980s, Viola held a number of residencies and fellowships in video, as well as technical positions in video studios in Europe and America. During 1980–1 he spent a year in Japan studying new developments in video technology. He also pursued experiments using electronic music. At the same time he developed an interest in ethnography, travelling extensively to record traditional forms of music and dance, and becoming interested in native forms of mysticism and shamanism.

In 1981 Viola moved to Southern California where he taught video at the California Institute for the Arts. In 1988 he produced his first works using computer-controlled discs, combining his interest in the spiritual with state-of-the-art technology. Much of Viola's work explores the realm of the subconscious and he has likened the darkened rooms of his video installations to the dark spaces inside our heads. Throughout the 1980s and the early 1990s Viola has continued to produce large installation works. He has had one-person exhibitions at the Museum of Modern Art, New York (1987), and the Contemporary Arts Museum, Houston (1988). In 1993–4 a major exhibition of his work toured to five European venues, including the Whitechapel Art Gallery, London. He is currently representing the United States at the Venice Biennale. He lives and works in California.

33 *Tiny Deaths* 1993
 Video-sound installation
 Edition 1: Musée d'Art Contemporain de Lyon
 Illustrated on pp.136–141

Further Reading

MIROSLAW BALKA
Anda Rottenberg, Maria Morzuch, Selma Klein Essink *et al.*, *Miroslaw Balka*, exh. cat., Van Abbemuseum Eindhoven/Muzeum Sztuki Lodz 1994
Peter Schjeldahl and Julian Heynen, *Miroslaw Balka: 36,6*, exh. cat., The Renaissance Society at The University of Chicago 1992
Miroslaw Balka interviewed by Iwona Blazwick, in *Possible Worlds: Sculpture from Europe*, exh. cat., Institute of Contemporary Arts/Serpentine Gallery, London 1990

JOSEPH BEUYS
Fabrice Hergodt (ed.), *Joseph Beuys*, exh. cat., Centre Georges Pompidou, Paris 1994
Heiner Stachelhaus, *Joseph Beuys*, New York 1991
Caroline Tisdall, *Joseph Beuys*, exh. cat., Solomon R. Guggenheim Museum, New York 1979

LOUISE BOURGEOIS
Charlotta Kotik, Terrie Sultan and Christian Leigh, *Louise Bourgeois: The Locus of Memory, Works 1982–1993*, exh. cat., The Brooklyn Museum, New York 1994
Peter Weiermair (ed.), *Louise Bourgeois*, exh. cat., Rijksmuseum Kröller-Müller, Otterlo 1991
Deborah Wye, *Louise Bourgeois*, exh. cat., The Museum of Modern Art, New York 1981

HAMAD BUTT
Stephen Foster (ed.), *Familiars*, Institute of International Visual Arts in association with John Hansard Gallery, Southampton 1995 (forthcoming publication)

JOHN COPLANS
John Coplans interviewed by Jean-François Chevrier, *John Coplans: Self Portraits*, exh. cat., Galerie Lelong, New York 1991
Jean-François Chevrier, *John Coplans, Self Portrait: Hand/Foot*, exh. cat., Museum Boymans van Beuningen, Rotterdam 1990
John Coplans interviewed by Jean-François Chevrier, in *Another Objectivity/Un'altra obiettività*, exh. cat., Centro per l'arte contemporanea Luigi Pecci, Prato 1989

PEPE ESPALIÚ
Juan Vicente Aliaga, *Pepe Espaliú: 1986–1993*, exh. cat., Junta de Andalucía 1994
Adrian Searle, *Pepe Espaliú*, exh. cat., Institute of Contemporary Arts, London 1994

ROBERT GOBER
Richard Flood and Lynne Cooke, *Robert Gober*, exh. cat., Tate Gallery Liverpool/Serpentine Gallery 1993
Karen Marta and Dave Hickey, *Robert Gober*, *exh. cat.*, Dia Center for the Arts, New York 1993
Joan Simon and Catherine David, *Robert Gober*, exh. cat., Museo Nacional Centro de Arte Reina Sofía, Madrid 1992

MONA HATOUM
Nadia Tazi, Desa Philippi and Jacinto Lageira, *Mona Hatoum*, exh. cat., Centre Georges Pompidou, Paris 1994
Desa Philippi and Guy Brett, *Mona Hatoum*, exh. cat., Arnolfini, Bristol 1993
Guy Brett, *Dissected Space: Mona Hatoum, New Installations 1990–1992*, exh. cat., Chapter, Cardiff 1992

SUSAN HILLER
Barbara Einzig (ed.), *Thinking About Art: Conversations with Susan Hiller*, Manchester University Press 1995 (forthcoming publication)
Jean Fisher, 'The Revenants of Time', in *Susan Hiller*, exh. cat., Matt's Gallery/Mappin Art Gallery, Sheffield/Third Eye Centre, Glasgow 1990
Lucy Lippard, *Susan Hiller*, exh. cat., Institute of Contemporary Arts, London 1986

JANA STERBAK
Per Jonas Storsve, *Jana Sterbak*, exh. cat., Louisiana Museum for Modern Art, Humlebæk, Denmark 1993
Diana Nemiroff (ed.), *Jana Sterbak: States of Being/Corps à corps*, exh. cat., National Gallery of Canada, Ottawa 1991
Cindy Richmond and Jessica Bradley, *Jana Sterbak*, exh. cat., Mackenzie Art Gallery, Regina, Saskatchewan 1989

BILL VIOLA
Alexander Pühringer, *Bill Viola*, Salzburger Kunstverein 1994
Marie Luise Syring (ed.), *Bill Viola: Unseen Images*, exh. cat., Kunsthalle Düsseldorf 1992
Barbara London (ed.), *Bill Viola: Installations and Videotapes*, exh. cat., The Museum of Modern Art, New York 1987

Lenders

Private Collections

Fondazione Amelio, Naples 5
Galerie René Blouin 32
Jamal Butt 11–13
John Coplans 16–21
Froehlich Collection, Stuttgart 31 (Beuys's 'Felt Suit')
Fundacion Coca-Cola España 25
Reesa Greenberg 30
Galerie Karsten Greve 6
La Máquina Española Collection, Seville 22, 24
Juan Luis Libano 23
Ludwig Forum für Internationale Kunst, Aachen. Ludwig Stiftung, Aachen 14,15
Robert Miller Gallery, New York 9, 10
Robert Miller Gallery, New York and Peter Blum, New York 8
Jana Sterbak 31
S. and J. Vandermolen, Ghent 26

Public Collections

Lodz, Muzeum Sztuki 1
London, Tate Gallery 2, 28
Lyon, Musée d'Art Contemporain 33
Malmö, The Schyl Collection, Malmö Konsthall 4
Montreal, Musée d'Art Contemporain, Courtesy Peter Blum, New York 7
Ottawa, National Gallery of Canada 29
Paris, Musée National d'Art Moderne, Centre Georges Pompidou 27

Photographic Credits

Ways of Giving to the Tate Gallery

The Tate Gallery attracts funds from the private sector to support its programme of activities in London, Liverpool and St Ives. Support is raised from the business community, individuals, trusts and foundations, and includes sponsorships, donations, bequests and gifts of works of art. The Tate Gallery is an exempt charity; the Museums & Galleries Act 1992 added the Tate Gallery to the list of exempt charities defined in the 1960 Charities Act.

DONATIONS

There are a variety of ways through which you can make a donation to the Tate Gallery.

Donations All donations, however small, will be gratefully received and acknowledged by the Tate Gallery.

Covenants A Deed of Covenant, which must be taken out for a minimum of four years, will enable the Tate Gallery to claim back tax on your charitable donation. For example, a covenant for £100 per annum will allow the Gallery to claim a further £33 at present tax rates.

Gift-Aid For individuals and companies wishing to make donations of £250 and above, Gift-Aid allows the gallery to claim back tax on your charitable donation. In addition, if you are a higher rate taxpayer you will be able to claim tax relief on the donation. A Gift-Aid form and explanatory leaflet can be sent to you if you require further information.

Bequests You may wish to remember the Tate Gallery in your will or make a specific donation In Memoriam. A bequest may take the form of either a specific cash sum, a residual proportion of your estate or a specific item of property, such as a work of art. Certain tax advantages can be obtained by making a legacy in favour of the Tate Gallery. Please check with the Tate Gallery when you draw up your will that it is able to accept your bequest.

American Fund for the Tate Gallery The American Fund was formed in 1986 to facilitate gifts of works of art, donations and bequests to the Tate Gallery from the United States residents. It receives full tax exempt status from the IRS.

INDIVIDUAL MEMBERSHIP PROGRAMMES

Friends

Friends share in the life of the Gallery and contribute towards the purchase of important works of art for the Tate.

Privileges include free unlimited entry with a guest to exhibitions; *tate: the art magazine*; previews, events and art courses; 'Late at the Tate' evening openings; exclusive Friends Room. Annual rates range from £22 to £30.

Tate Friends Liverpool and Tate Friends St Ives offer local events programmes and full membership of the Friends.

Fellows

Fellows support the acquisition of works of art for the British and Modern Collections of the Tate Gallery. Privileges include invitations to Tate Gallery receptions, curatorial talks and behind-the-scene tours, complimentary catalogues and full membership of the Friends. Annual membership ranges from £100 to £500.

The Friends of the Tate Gallery are supported by Tate & Lyle PLC.

Further details on the Friends and Fellows in London, Liverpool and St Ives may be obtained from:

Friends of the Tate Gallery
Tate Gallery
Millbank
London SW1P 4RG

Tel: 0171-887 8752

Patrons of the Tate Gallery

Patrons of British Art support British painting and sculpture from the Elizabethan period through to the early twentieth century in the Tate Gallery's collection. They encourage knowledge and awareness of British art by providing an opportunity to study Britain's cultural heritage.

Patrons of New Art support contemporary art in the Tate Gallery's collection. They promote a lively and informed interest in contemporary art and are associated with the Turner Prize, one of the most prestigious awards for the visual arts.

Annual membership of the Patrons ranges from £350 to £750, and funds the purchase of works of art for the Tate Gallery's collection.

Privileges for both groups include invitations to Tate Gallery receptions, an opportunity to sit on the Patrons' acquisitions committees, special events including visits to private and corporate collections and complimentary catalogues of Tate Gallery exhibitions.

Further details on the Patrons may be obtained from:

The Development Office
Tate Gallery
Millbank
London SW1P 4RG

Tel: 0171-887 8743

CORPORATE MEMBERSHIP PROGRAMME

Membership of the Tate Gallery's Corporate Membership Programme offers companies outstanding value-for-money and provides opportunities for every employee to enjoy a closer knowledge of the Gallery, its collection and exhibitions.

Membership benefits are specifically geared to business needs and include private views for company employees, free and discount admission to exhibitions, discount in the Gallery shop, out-of-hours Gallery visits, behind-the-scenes tours, exclusive use of the Gallery for corporate entertainment, invitations to VIP events, copies of Gallery literature and acknowledgment in Gallery publications.

Tate Gallery Corporate Members

Partners
British Gas plc
The British Petroleum Company p.l.c.
Ernst & Young
Glaxo p.l.c.
Manpower PLC
J.P. Morgan & Co. Incorporated
Reed Elsevier
Unilever

Associates
BUPA
Channel 4 Television
Drivers Jonas
Global Asset Management
Lazard Brothers & Co Limited
Linklaters & Paines
Merrill Lynch
Refco Overseas Ltd
Salomon Brothers
Schroders plc
S.G. Warburg Group
THORN EMI

CORPORATE SPONSORSHIP

The Tate Gallery works closely with sponsors to ensure that their business interests are well served, and has a reputation for developing imaginative fund-raising initiatives. Sponsorships can range from a few thousand pounds to considerable investment in long-term programmes; small businesses as well as multi-national corporations have benefited from the high profile and prestige of Tate Gallery sponsorship.

Opportunities available at Tate Gallery London, Liverpool and St Ives include exhibitions (some also tour the UK), education, conservation and research programmes, audience development, visitor access to the Collection and special events. Sponsorship benefits include national and regional publicity, targeted marketing to niche audiences, exclusive corporate entertainment, employee benefits and acknowledgment in Tate Gallery publications.

Tate Gallery London: Principal Corporate Sponsors
(alphabetical order)

The British Land Company PLC
 1993, *Ben Nicholson**
The British Petroleum Company plc
 1990–6, *New Displays*
Channel 4 Television
 1991–6, *The Turner Prize*
Ernst & Young
 1994, *Picasso: Sculptor/Painter**
J.P. Morgan & Co. Incorporated
 1995, *Willem de Kooning*
Nuclear Electric plc
 1993, *Turner: The Final Years*
 1994, *The Essential Turner*
 1995–7, *The Nuclear Electric Turner Scholarships*
Pearson plc
 1992–5, Elizabethan Curator Post
Reed Elsevier
 1994, *Whistler*
Tate & Lyle PLC
 1991–5, Friends Marketing Programme
Volkswagen
 1991–6, The Volkswagen Turner Scholarships

Tate Gallery London: Corporate Sponsors (alphabetical order)

ABN AMRO Bank
 1994, *Turner's Holland*
AFAA, Association Française d'Action Artistique, Ministère de Affaires Etrangères, The Cultural Service of the French Embassy, London
 1993, *Paris Post War: Art and Existentialism 1945–55*
Agfa Graphic Systems Group
 1992, *Turner: The Fifth Decade**

Beck's
1994, *Rebecca Horn*
1992, *Otto Dix*
1995, *Rites of Passage*
Blackwall Green Ltd
1994, *Frames Conservation*
The British Printing Company Ltd
1994–5, sponsorship in kind
Calor Gas
1994, *Turner's Holland*
CDT Design Ltd
1995–6, *Art Now*
Classic FM
1995–6, Regional tour of David Hockney's
'Mr and Mrs Clark and Percy' (in kind)
Clifton Nurseries
1991–4, Christmas Tree (in kind)
Deutsche Bank A.G.
1994, *Rebecca Horn*
Digital Equipment Co Limited
1993, Library and Archive
Computerisation
Alfred Dunhill Limited
1993, *Sir Edward Burne-Jones:
Watercolours and Drawings*
The German Government
1992, *Otto Dix*
The Guardian
1995, *Rites of Passage* (in kind)
Häagen-Dazs Fresh Cream Ice Cream
1995–6, *Art Now*
The Hiscox Group
1994, *Friends Room*
The Independent
1992, *Otto Dix* (in kind)
1993, *Paris Post War: Art and
Existentialism 1945–55*
1994, *Rebecca Horn* (in kind)
J.R.F. Panels
1994, *Christmas Tree* (in kind)
Makro
1994, *Turner's Holland*
Pro Helvetia
1995, *Through Switzerland with Turner*
Russell & Chapple Ltd
1994, *Christmas Tree* (in kind)
W.H. Smith Ltd
1994, Sponsorship-in-kind
SRU Limited
1992, *Richard Hamilton**
Sun Life Assurance Society plc
1993, *Robert Vernon's Gift*
Swiss National Tourist Office
1995, *Through Switzerland with Turner*
THORN EMI
1993, *Turner's Painting Techniques*
TSB Group plc
1992, *Turner and Byron*
1992–5, *William Blake* display series

*Tate Gallery of Modern Art:
Corporate Sponsors*
(alphabetical order)

Ernst & Young
1995, *Tate Gallery of Modern Art:
Selecting an Architect*

*Tate Gallery Liverpool: Corporate
Sponsors* (alphabetical order)

American Airlines
1993, *David Hockney*
Beck's
1993, *Robert Gober*
Canadian High Commission, London and
Government of Canada
1993, *Elective Affinities*
Girobank plc
1995, *Primary Cooking* Education booklet

Ibstock Building Products Ltd
1993, *Antony Gormley*
Korean Air
1992, *Working with Nature* (in kind)
The Littlewoods Organisation plc
1992–5, *New Realities*
Merseyside Development Corporation
1992, *Myth-Making*
1992, *Stanley Spencer*
MOMART plc
1991–5, *The Momart Fellowship*
North West Water Group PLC
1994, Corporate Membership Brochure
David M Robinson Jewellery
1994, *Venus Re-Defined*
Samsung Electronics
1992, *Working With Nature*
Tate & Lyle PLC
1995, Tate Friends Liverpool membership
leaflet

*Tate Gallery St Ives: Corporate
Sponsors* (alphabetical order)

Barclays Bank PLC
1995, *Porthmeor Beach: 'A Century of
Images'*
First Class Pullman, InterCity*
1993–4, *Annual Displays*
Northcliffe Newspapers in Education
1995–6, Education Programme
South Western Electricity plc (SWEB)*
1993–4, Education Programme

*denotes a sponsorship in the arts,
recognised by an award under the
Government's 'Pairing Scheme' administered
by the Association for Business Sponsorship
of the Arts.

TATE GALLERY FOUNDING
BENEFACTORS (date order)

Sir Henry Tate
Sir Joseph Duveen
Lord Duveen
The Clore Foundation

TATE GALLERY PRINCIPAL
BENEFACTORS (alphabetical order)

American Fund for the Tate Gallery
Calouste Gulbenkian Foundation
Friends of the Tate Gallery
The Henry Moore Foundation
National Art Collections Fund
National Heritage Memorial Fund
The Nomura Securities Co., Ltd
Patrons of New Art
Dr Mortimer and Theresa Sackler
Foundation
St Ives Tate Action Group
The Wolfson Foundation and Family
Charitable Trust

TATE GALLERY
BENEFACTORS (alphabetical order)

The Baring Foundation
Bernard Sunley Charitable Foundation
Gilbert and Janet de Botton
Mr Edwin C. Cohen
The Eleanor Rathbone Charitable Trust
Esmée Fairbairn Charitable Trust
Foundation for Sport and the Arts

GEC Plessey Telecommunications
The Getty Grant Program
Granada Group plc
The Paul Hamlyn Foundation
John and Olivia Hughes
The John S. Cohen Foundation
The John Ellerman Foundation
The Kreitman Foundation
John Lewis Partnership
The Leverhulme Trust
Museums and Galleries Improvement Fund
Ocean Group plc (P.H. Holt Trust)
Patrons of British Art
Peter Moores Foundation
The Pilgrim Trust
Mr John Ritblat
The Sainsbury Family Charitable Trusts
Save & Prosper Educational Trust
SRU Limited
Weinberg Foundation

TATE GALLERY DONORS
(alphabetical order)

London

Professor Abbott
The Andy Warhol Foundation for the Visual
Arts, Inc
Lord Attenborough CBE
BAA plc
Friends of Nancy Balfour OBE
Balmuir Holdings
The Hon. Robin Baring
B.A.T. Industries plc
Nancy Bateman Charitable Trust
Mr Tom Bendhem
Mr Alexander Bernstein
Janice and David Blackburn
Michael and Marcia Blakenham
Miss Mary Boone
The Britwell Trust
Card Aid
Carlsberg Brewery
Mr Vincent Carrozza
Mrs Beryl Carpenter
Cazenove & Co Charitable Trust
Charlotte Bonham Carter Charitable Trust
Christie, Manson & Woods Ltd
The Claire Hunter Charitable Trust
The Clothworkers Foundation
Mrs Elisabeth Collins
Mr R.N. Collins
Giles and Sonia Coode-Adams
Mrs Dagny Corcoran
C.T. Bowring (Charitable Trust) Ltd
Cognac Courvoisier
Mr Edwin Cox
Anthony d'Offay Gallery
Mr and Mrs Kenneth Dayton
Mr Damon and The Hon. Mrs de Laszlo
Madame Gustava de Rothschild
Baroness Liliane de Rothschild
Deutsche Bank AG
Miss W.A. Donner
Mr Paul Dupee
Mrs Maurice Dwek
Elephant Trust
Eli Broad Family Foundation
Elizabeth Arden Ltd
European Arts Festival
Evelyn, Lady Downshire's Trust Fund
Roberto Fainello Art Advisers Ltd
The Flow Foundation
First Boston Corporation
Foreign & Colonial Management Limited
Miss Kate Ganz
Mr Henry Geldzahler
Mr and Mrs David Gilmour
The German Government
Goethe Institut

Sir Nicholas and Lady Goodison Charitable
Settlement
Mr William Govett
Mr and Mrs Richard Grogan
Gytha Trust
Mr and Mrs Rupert Hambro
Miriam and Peter Haas Foundation
Mrs Sue Hammerson
The Hon. Lady Hastings
The Hedley Foundation
Mr and Mrs Michael Heseltine
Mr Rupert Heseltine
Horace W. Goldsmith Foundation
Mr Robert Horton
Hurry Armour Trust
Idlewild Trust
The Italian Government
Sir Anthony and Lady Jacobs
Mrs Gabrielle Keiller
James and Clare Kirkman Trust
Knapping Fund
Mr and Mrs Richard Knight
Mr and Mrs Jan Krugier
The Leche Trust
Robert Lehman Foundation, Inc
The Helena and Kenneth Levy Bequest
Mr and Mrs Gilbert Lloyd
Mr and Mrs George Loudon
Mr and Mrs Lawrence Lowenthal
Mail on Sunday
Mr Alexander Marchessini
The Mayor Gallery
Midland Bank Artscard
Mr and Mrs Robert Mnuchin
The Monument Trust
Mr Peter Nahum
Mr and Mrs Philip Niarchos
Dr Andreas Papadakis
The Paradina Trust
Mr William Pegrum
Philips Fine Art Auctioneers
The Earl of Plymouth
Old Possum's Practical Trust
The Hon. Mrs Olga Polizzi
Paul Nash Trust
Peter Samuel Charitable Trust
Mr Jean Pigozzi
Sir Gordon Reece
Reed International P.L.C.
Richard Green Fine Paintings
Mrs Jill Ritblat
Rothschild Bank AG
Mrs Jean Sainsbury
The Hon. Simon Sainsbury
Sebastian de Ferranti Trust
Schroder Charity Trust
Ms Dasha Shenkman
South Square Trust
Mr A. Speelman
Standard Chartered Bank
Mr and Mrs Bernhard Starkmann
The Swan Trust
Sir Adrian and Lady Judith Swire
Mrs Barbara Thomas
Time-Life International Ltd
The 29th May 1961 Charitable Trust
Lady Juliet Townsend
Laura and Barry Townsley
The Triangle Trust
U.K. Charity Lotteries Ltd
Mrs Anne Uribe-Mosquera
Visiting Arts
Mr and Mrs Leslie Waddington
Waley-Cohen Charitable Trust
Mr Mark Weiss
Weltkunst Foundation
Mrs Alexandra Williams
Nina and Graham Williams
Willis Faber plc
Mr Andrew Wilton
Thomas and Odette Worrell
The Worshipful Company of Fishmongers
The Worshipful Company of Goldsmiths
The Worshipful Company of Grocers

The Worshipful Company of Mercers
Mrs Jayne Wrightsman

and those donors who wish to remain
anonymous

Tate Gallery of Modern Art Campaign: Start Up Costs
(Benefactors are also listed above)

Annenberg Foundation, Inc
Lord and Lady Attenborough
The Baring Foundation
Janice and David Blackburn
Mr and Mrs Anthony Bloom
Monsieur Alain Camu
Mr Edwin C. Cohen
The John S. Cohen Foundation
English Heritage
English Partnerships
Esmée Fairbairn Charitable Trust
Friends of the Tate Gallery
Hanover Acceptances Limited
Horace W. Goldsmith Foundation
Sir Anthony and Lady Jacobs
Mr and Mrs George Loudon
London Borough of Southwark
Mr and Mrs Dennis Stevenson
Mr and Mrs Ian Stoutzker
Mr John Studzinski
The 29th May 1961 Charitable Trust
Laura and Barry Townsley
Graham and Nina Williams

and those donors who wish to remain
anonymous

Liverpool (alphabetical order)

The Baring Foundation
David and Ruth Behrend Trust
Solomon and Isabel Blankstone Charitable
 Trust
Ivor Braka Ltd
The British Council
British Telecom plc
Calouste Gulbenkian Foundation
Mr and Mrs Henry Cotton
English Estates
European Arts Festival
Goethe Institut, Manchester
Mrs Sue Hammerson OBE
Mr John Heyman
Liverpool Council for Voluntary Services
Merseyside Development Corporation
Momart plc
The Henry Moore Foundation
Ocean Group plc (P.H. Holt Trust)
Eleanor Rathbone Charitable Trust
Tate Friends Liverpool
Bernard Sunley Charitable Foundation
Unilever
Visiting Arts

and those donors who wish to remain
anonymous

St Ives (alphabetical order)

Donors to the Appeal coordinated by the
Steering Group for the Tate Gallery St Ives
and the St Ives Action Group.

Viscount Amory Charitable Trust
Barbinder Trust
Barclays Bank PLC
The Baring Foundation
BICC Group
Patricia, Lady Boyd and Viscount Boyd
British Telecom plc

Cable and Wireless plc
Carlton Communications
Mr Francis Carnwath
Christie, Manson & Woods Ltd
Mr Peter Cocks
John S. Cohen Foundation
Miss Jean Cooper
D'Oyly Carte Charitable Trust
David Messum Fine Paintings
Dewhurst House
Dixons Group plc
Mr Alan Driscoll
The John Ellerman Foundation
English China Clays Group
Esmee Fairbairn Charitable Trust
Foundation for Sport and the Arts
J. Paul Getty Jr Charitable Trust
Gimpel Fils
Grand Metropolitan Trust
Ms Judith Hodgson
Sir Geoffrey and Lady Holland
Mr and Mrs Philip Hughes
Mr Bernard Jacobson
Mr John Kilby
Lloyds Bank plc
Lord Leverhulme's Trust
The Manifold Trust
The Mayor Gallery
Marlborough Fine Art
Mercury Asset Management plc
Meyer International plc
The Henry Moore Foundation
National Westminster Bank plc
New Art Centre
Pall European Limited
The Pilgrim Trust
The Joseph Rank (1942) Charitable Trust
Mr Roy Ray
The Rayne Foundation
Royal Bank of Scotland
The Sainsbury Family Charitable Trusts
Mr Nicholas Serota
Mr Roger Slack
Trustees of the Carew Pole Family Trust
Trustees of H.E.W. Spurr Deceased
South West British Gas
South West Water plc
South Western Electricity plc
Sun Alliance Group
Television South West
The TSB Foundation for England and Wales
Unilever
Mrs Angela Verren Taunt
Weinberg Foundation
Wembley plc
Western Morning News, West Briton,
 Cornish Guardian and The Cornishman
Westlake & Co
Mr and Mrs Derek White
Mr and Mrs Graham Williams
Wingate Charitable Trust
The Worshipful Company of Fishmongers
The Worshipful Company of Mercers
Mrs Monica Wynter

and those donors who wish to remain
anonymous